A Slice through America
A Geological Atlas

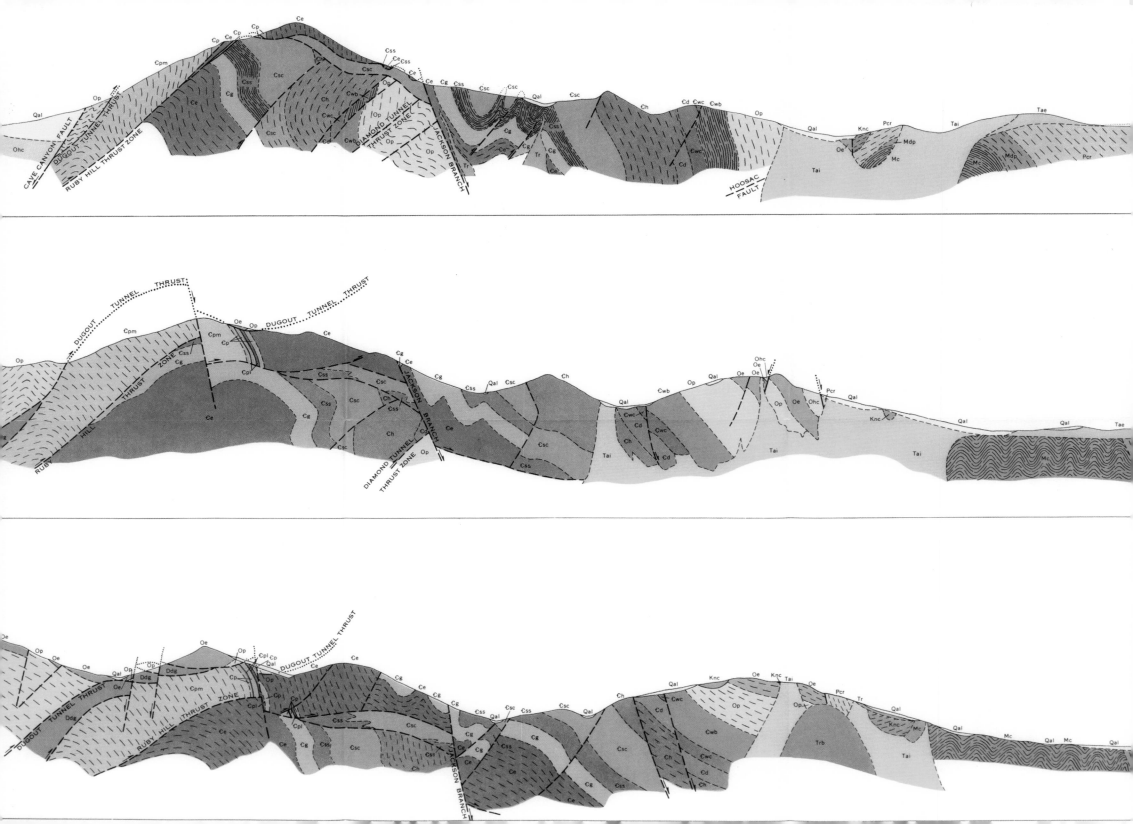

A Slice through America
A Geological Atlas

David Kassel

with an introduction by Joanne Bourgeois

Princeton Architectural Press
New York

Contents

NORTHWEST

1

MIDCONTINENT

2

3

NORTHEAST

4	8	12	16	20	24
5	9	13	17	21	25
6	10	14	18	22	26
7	11	15	19	23	27

SOUTHWEST

28	35
29	36
30	37
31	38
32	39
33	40
34	41

ROCKY MOUNTAIN

42	47	52
43	48	53
44	49	54
45	50	55
46	51	56

SOUTHEAST

57

Preface 7
David Kassel

Introduction 9
Joanne Bourgeois

Plates

NORTHWEST 16

MIDCONTINENT 18

NORTHEAST 22

SOUTHWEST 58

ROCKY MOUNTAIN 88

SOUTHEAST 126

Editor's Note 128
Acknowledgments 128
Contributors 128

Above and Below

David Kassel

I first discovered geological cross-section diagrams as an art student at the State University of New York in Purchase. The year was 1977, and I was rummaging for paper collage material at an old bookshop across the Hudson River in nearby Nyack, New York. The shop was selling original New York State Museum maps and diagrams—for ten cents!—and among them were two small geological cross-sections. I immediately responded to the lines and earth colors. The different layers were altered with barely visible parallel lines, brick patterns, or dots to differentiate, for example, sandstone and slate. The earth's many layers rendered in 2D.

The two cross-section diagrams I found that day were spared the collage scissors. Today, I have about two hundred cross-section and isometric diagrams, as well as topographical maps, that date from the mid-1800s to the 1980s.

In our time of climate catastrophe, I've begun to feel comforted by these stratigraphic views of the earth. They present the big picture—what's at stake—and all sorts of accidental poetry. They make the earth's layers look permanent, but they also reveal the great forces of the past. The vast landscapes below the surface reassure me that it'll all change, as it always has—oceans will take the place of deserts, mountains the place of swamps. But come what may, the earth's crust will continue to fold, incline, compress, and weather. Mixed in the upheavals of future geological events will be layers with aluminum and plastic.

I'm neither a professional nor an amateur geologist, so the sight of stratigraphic cross sections leaves me feeling both ignorant and liberated. I'm curious about what has been and what may be. I fantasize and daydream about tectonic plates,

about the impact that miles-thick glaciers, blasting winds, and decaying organic matter have had on what I see in these thin, layered strips.

I appreciate the metaphor of neat, categorized layers. I like to think that if somehow we could peel back the layers, the answer of when the die was cast would be revealed. Unfortunately, the layers are not necessarily in sequential order. There are huge forces at work disrupting a linear narrative.

Stratigraphic cross sections tell a story the same way road cuts do. When I drive by a road cut, I can see the swirls of rock layers as if they are liquid, caught as if solidified in midair. All these mixed-up layers and their ingredients are explained in these cross-section diagrams, and they show a dramatic past. They make it seem as though change has paused.

Those with legends are even more mesmerizing. Each layer is identified in a small colored and patterned box off to the side and listed in descending order. Some of the diagrams in this collection chronicle a long list of ingredients. Some of the layers are clearly related to geological epochs, some legends are natural resources. Many components feel like haiku poems. The print is small and the names of the surface landscape and sections are light, poignant, and beautiful. My associative brain assigns a random sequence of names to poetry.

Stratigraphic diagrams show the layers of previous epochs. Layers are caught between other layers. Our era's ending will leave a unique signature in our own layer. What of what exists will be preserved? I can imagine a huge hard plastic conglomerate and surviving fragments of aluminum soda cans. A reminder of all the carbon we blew through.

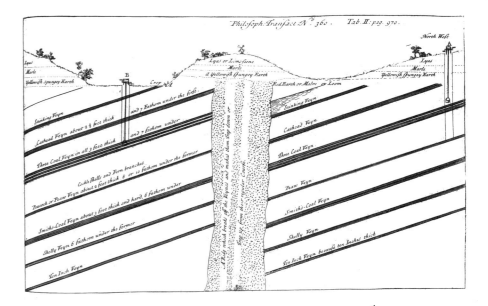

A History of Geologic Cross Sections, with Particular Reference to North America

Joanne Bourgeois

1
From *A curious description of the strata observ'd in the coal-mines of Mendip in Somersetshire*, John Strachey's 1719 cross section showing coal layers in Somersetshire; the coal layers are offset between the two dipping sections shown.*

Most images in this book are from publications of the US Geological Survey (USGS), founded in 1879 after four great federally sponsored surveys of the American West (1867–1878). Other images are from state geological surveys, many of whose origins predate the USGS.[1] Most images are geologic cross sections of geologically mapped parts of the United States. The means for making these maps and cross sections include fundamental principles of stratigraphy, established in the seventeenth century by Nicolaus Steno (Niels Stensen) (1638–1686)—the "laws" of superposition, original horizontality, and lateral continuity. These principles permit the relative dating and the correlation of stratigraphic units, which are fundamental to stratigraphy and geologic mapping. The historical origins of maps and cross sections have roots both in practical applications and in the practice of "geognosy"— knowing of the Earth. Cross sections appear first, independent of maps; these sections are a common feature of eighteenth century attempts to classify stratigraphic units, discussed below. They also include practical work, for example by John Strachey (1671–1743), who published cross sections of dipping strata associated with coal mines in England [**fig. 1**].[2]

By the mid-eighteenth century, the basic principles of super-position and correlation were practiced widely, but the work was only of local applicability without some formal subdivisions of stratigraphic units. In Europe, it became recognized that international correlation could be accomplished for some litho-logical units—e.g. the "Chalk," the "Old Red Sandstone," and the "Oolite." In this same period, several "geognosts" (the word geologist not yet in use) developed a more broadly applicable stratigraphy based on superposition (geologic time / age) and also on degree of lithification and deformation. Giovanni Arduino (1714–1795) remains the best known of these, perhaps because one period of his four-part system[3]—the Tertiary— survived until the twenty-first century. Stratigraphic classifica-tions by others—Torbern Bergman (1735–1784), Georg Christian Füchsel (1722–1773), and Johann Gottlob Lehmann (1719–1767) —led to the highly influential stratigraphy of Abraham Gottlob Werner (1749–1817). Several of these works provided strati-graphic cross sections, but not ones specific to a line (e.g., A-A' on a map), although they did represent specific regions such as Tuscany, Thuringia, and Saxony. This stratigraphic classification, and the idea that it might be global, impelled Werner's broadly travelling students to correlate rocks of Primitive, Transition, Flötz, and Recent (Alluvial) ages.[4]

The first maps of geologic features in the eighteenth century do not much resemble later geologic maps.[5] These earlier maps are more properly called "mineralogical maps" as they showed the distribution or occurrence of certain economically important

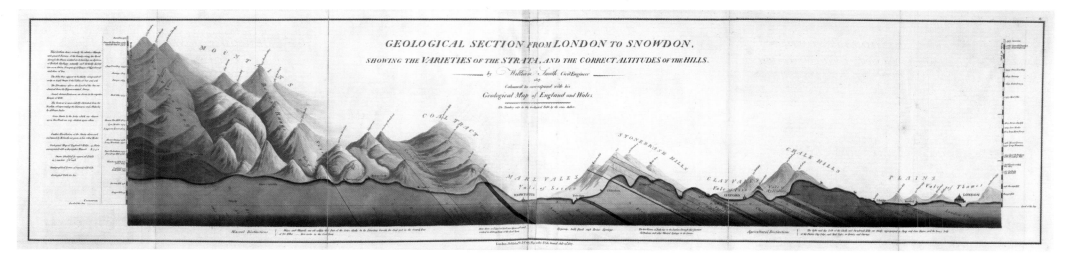

2

Geological section from London to Snowdon showing the Varieties of the Strata and the Correct Altitudes of the Hills, 1817, the first of William Smith's eight geological cross sections to accompany his map (published by John Cary). Reproduced by permission of the Geological Society of London.

geologic materials, without necessarily attempting to correlate or to represent the entire geology of the map area.[6] Thus the maps were not accompanied by cross sections. The best known of these maps are by Jean-Étienne Guettard (1715–1786), who with colleagues produced maps not only of parts of France, but also of French territory in North America. His 1746 *Carte Mineralogique* is widely regarded as a pioneering work because it correlated and mapped the distribution of "the Chalk" ("Craie") from France to southern Britain and across the English Channel, and showed the chalk formation as a continuous belt. Guettard mentored Antoine Lavoisier (1743–1794), who is credited with generating stratigraphic sections to accompany some of Guettard's maps, as well as with studying how geologic units could change laterally.[7]

The first half of the nineteenth century saw the maturation of geologic mapping, along with cross sections, the iconic examples being by William Smith (1769–1839) in England, Georges Cuvier (1769–1832) and Alexandre Brongniart (1770–1847) in France, and Leopold von Buch (1774–1853) in Germany.[8] Individual units, or formations, were represented by different colors and ordered by age, although most were not assigned formal geologic ages. In the years after his map was published, Smith published geologic cross sections, including topography, which can be tied to the map [**fig. 2**].[9] During this period, classification and colorization began to be systematized, although color assignments and symbols per stratigraphic age and lithology were not standardized until the late

nineteenth century—by the USGS in 1881 and by European bodies shortly thereafter. Updated versions of these standards are more or less conformable.[10]

The first geologic map of the United States (east of the Mississippi) was published in 1809 by William Maclure (1763–1840);[11] a larger version of the map was published in 1817,[12] along with five cross sections [**fig. 3**]. Following the Wernerian tradition, Maclure subdivided and colored geologic units as Primitive, Transition, Secondary, and Alluvial, also showing the "Old Red Sandstone"[13] and a region with salt and gypsum. Covering a vast area, Maclure's map was crude compared to contemporary European maps, which covered much smaller areas; in the following decades, US state geological surveys would begin publishing more detailed maps.

Even before the establishment of state geological surveys (first in North Carolina, in 1824), Amos Eaton (1776–1842) was generating detailed geological cross sections from Boston to the Catskills and beyond, the first published in 1818.[14] The excavation of the Erie Canal (1817–1821) led to a most remarkable geological cross section by Eaton from the Atlantic to Lake Erie, under the patronage of Stephen Van Rensselaer, published in 1825.[15] In 1830, Eaton published a colored map of this area in his *Geological Text-book*.[16]

During the same period as Eaton's work, Edward Hitchcock (1793–1864), later Massachusetts State Geologist, published a hand-colored map and cross section of parts of western Massachusetts, Vermont, and New Hampshire, in 1818.[17] Hitchcock

3
Plate II of Maclure's 1818 *Geological Map of North America*. Five cross sections, N to S (top to bottom) from the "great secondary basin of the Mississippi" River (left side) to the Atlantic seashore (right side). Colors correspond to those used on his map. From the collection of Princeton University Library.[†]

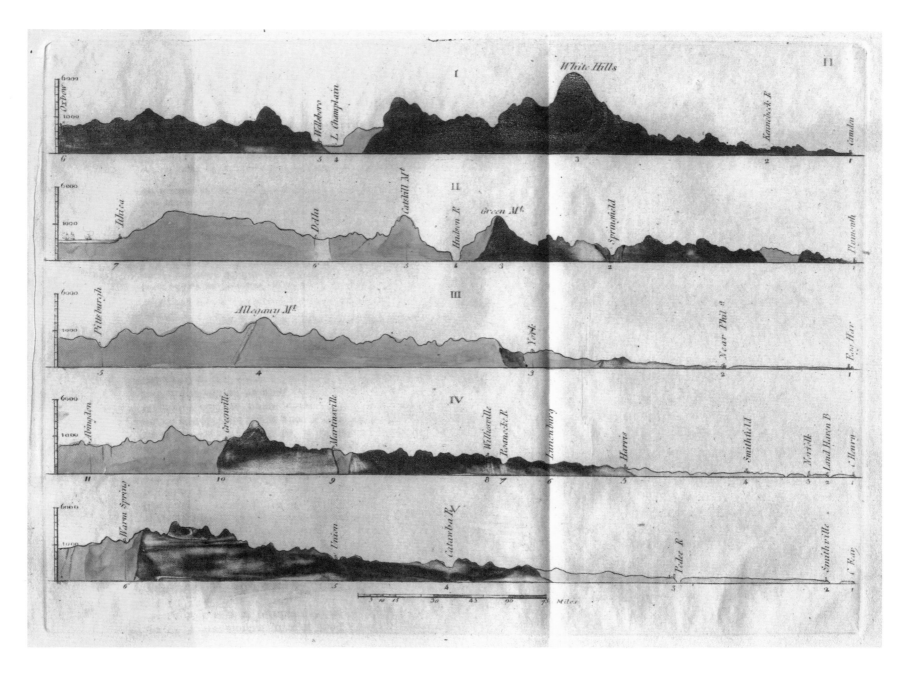

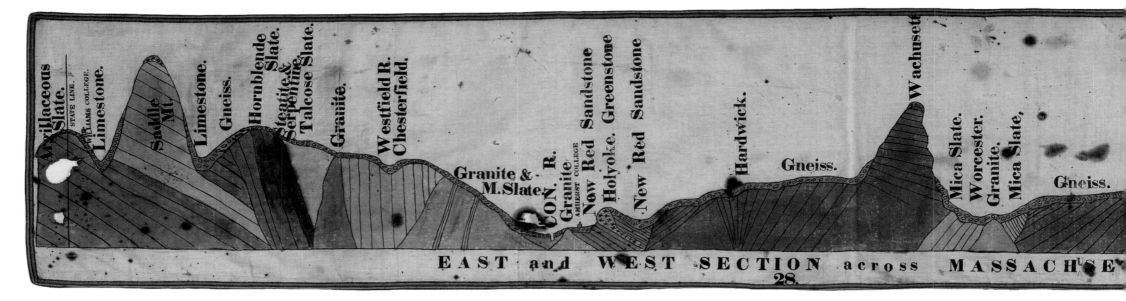

Artillaceous Slate.

STATE LINE.

WILLIAMS COLLEGE.

Limestone.

Saddle Mt.

Limestone.

Gneiss.

Hornblende Slate.

Steatite & Serpentine.

Talcose Slate.

Granite.

Westfield R. Chesterfield.

Granite & M. Slate.

CON. R.

Granite

AMHERST COLLEGE

New Red Sandstone

Holyoke. Greenstone

New Red Sandstone

Hardwick.

Gneiss.

Wachusett

Mica Slate.

Worcester.

Granite.

Mica Slate,

Gneiss.

EAST and WEST SECTION across MASSACHUSE[TTS]

28.

4
Two geological cross sections painted by Orra White Hitchcock based on mapping by Edward Hitchcock. Pen and ink on linen. Originals are in the Archives and Special Collections, Amherst College, Massachusetts.[‡]

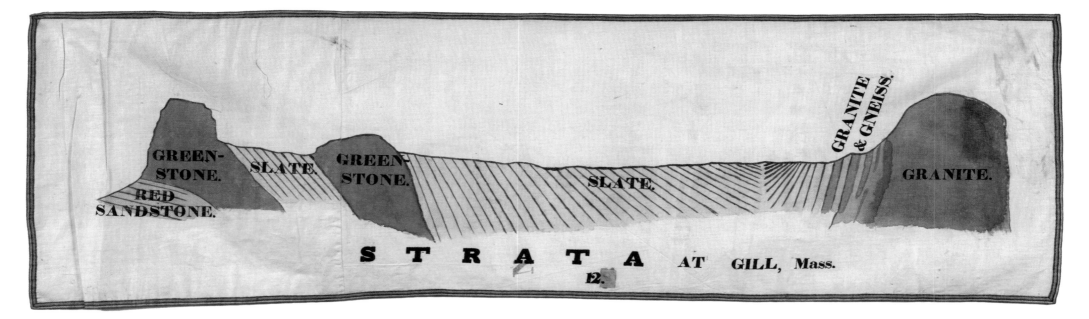

GREEN-STONE.

SLATE.

GREEN-STONE.

RED SANDSTONE.

SLATE.

GRANITE & GNEISS.

GRANITE.

STRATA AT GILL, Mass.

12.

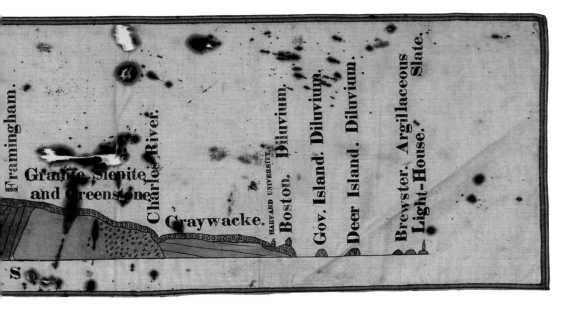

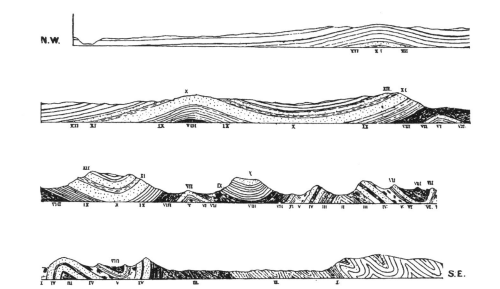

5
*Ideal section across
the Appalachian mountain
chain, accompanying
a paper by the Rogers
brothers* (plate XVI of the
Transactions of the
Association of American
Geologists and Naturalists,
v. 1, pp. 474–531, 1840–
1842). The different letters
and numbers are explained
in the text of their paper.

would continue to map the geology of Massachusetts, publishing the first (in the US) full state geologic map in 1833.[18] Orra White Hitchcock (1796–1863), Edward's spouse, drew many of his published illustrations and also painted illustrations for his classroom teaching [fig. 4].

Synthetic mapping crossing several of the United States led in the antebellum period to new geological insights and concepts. One of these cases involves the structure and origin of the Appalachian mountains, accomplished by the brothers Henry Darwin Rogers (1809–1866) and William Barton Rogers (1805–1882);[19] combined they had been state geologists of New Jersey, Pennsylvania, and Virginia. They used additional maps and observations to note, across and along the Appalachians, "a remarkable predominance of southeastern dips from Canada to Alabama" and that the "flexures" of these strata increased in intensity from northeast to southwest, with "a steeper…arching on the northwest than the southeast side of every convex bend…" In this study they produced an idealized section across the Appalachian chain [fig. 5], as well as a number of more detailed, specific cross sections. They discussed the possible origin of the lateral pressure to generate these structures and postulated that some more fluid zone must lie beneath the folded rocks, in order for the folds to propagate.

Focusing on the northeastern United States, James Hall Jr. (1811–1898) also considered the origin of the Appalachians, leading to the geosynclinal theory of mountain building.[20] A student of Amos Eaton, James Hall did detailed work on the geological survey of New York and participated in a number of other state and regional geological surveys. Hall used paleontology to correlate same-aged strata from the Midwest to New York—strata that increased in thickness toward the east, in the same direction as the increase in intensity of deformation. He published a *Geological Map of the Middle and Western States* in 1843,[21] which clearly shows the difference in deformation from west to east. He attributed the increased folding to deformation caused by the thicker sediments' subsidence and folding. Elaborated by James Dwight Dana (1813–1895), this theory would dominate US thinking until the 1960s.

In and around the mid-nineteenth century, and following the US Civil War, detailed, scaled cross sections led to a number of other important concepts, for example, the nature of large-scale overturned folds (nappes in the Alps) and the discovery of thrust faults. Western expansion and mineral surveys in the United States introduced new mountain belts—e.g. the Rockies and the Sierra Nevada—into discussions of geologic structure and history. These are the roots of the geologic studies represented in this book.

Plates

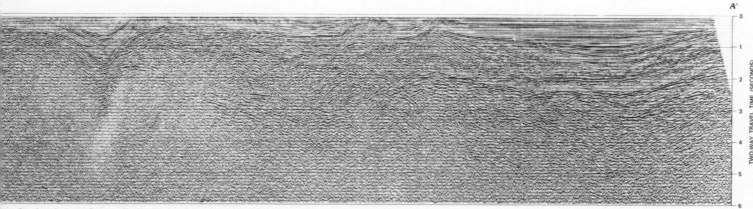

venty-four channel seismic-reflection profile along line A-A'. Collected aboard the U.S. Geological Survey's Research Vessel *S. P. Lee.*

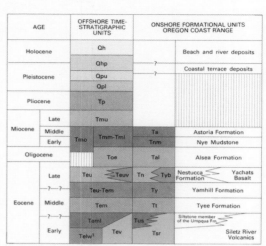

AGE		OFFSHORE TIME-STRATIGRAPHIC UNITS		ONSHORE FORMATIONAL UNITS OREGON COAST RANGE			
Holocene		Qh		Beach and river deposits			
Pleistocene		Qhp		Coastal terrace deposits			
		Qpu					
		Qpl					
Pliocene		Tp					
Miocene	Late	Tmu					
	Middle	Tmo	Tmm-Tml	Ta	Astoria Formation		
	Early			Tnm	Nye Mudstone		
Oligocene			Toe	Tal	Alsea Formation		
Eocene	Late	Teu	Teuv	Tn	Tyb	Nestucca Formation	Yachats Basalt
		Teu-Tem		Ty	Yamhill Formation		
	Middle	Tem		Tt	Tyee Formation		
		Teml	Tus		Siltstone member of the Umpqua Fm		
	Early	Telw[1]	Tev	Tsr	Siletz River Volcanics		

[1]Equivalents of Telw not recognized onshore

FIGURE 6.—Chart showing inferred correlation of offshore time-stratigraphic units and onshore formations. Intrusive rocks unit (unit Ti) composed of basalt, diabase, and gabrro dikes and sills is shown in cross section (fig. 5), but not shown on chart.

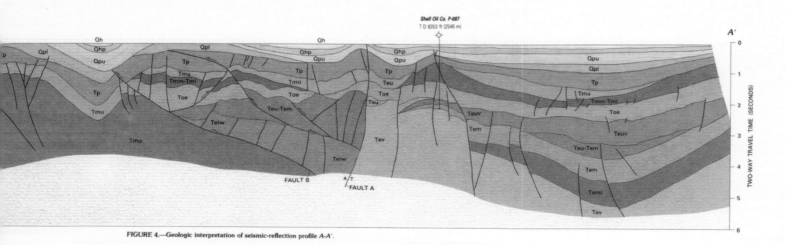

FIGURE 4.—Geologic interpretation of seismic-reflection profile A-A'.

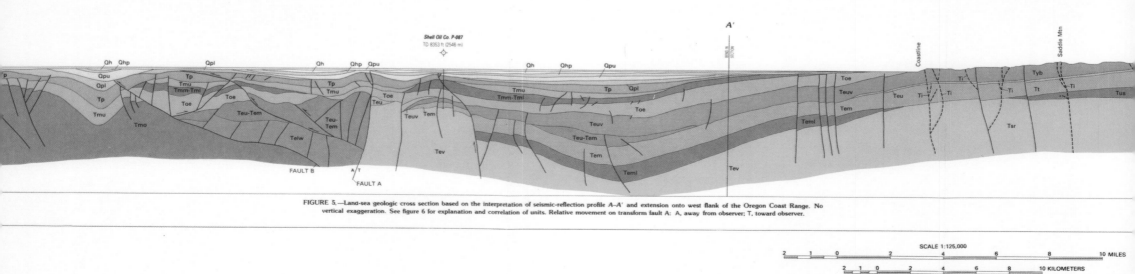

FIGURE 5.—Land-sea geologic cross section based on the interpretation of seismic-reflection profile A–A' and extension onto west flank of the Oregon Coast Range. No vertical exaggeration. See figure 6 for explanation and correlation of units. Relative movement on transform fault A: A, away from observer; T, toward observer.

SCALE 1:125,000

LAND-SEA GEOLOGIC CROSS SECTION OF THE SOUTHERN OREGO

LAND-SEA GEOLOGIC CROSS SECTION OF THE SOUTHERN OREGON CONTINENTAL MARGIN

By

P. D. Snavely, Jr., H. C. Wagner, and D. L. Lander

1985

1 Land-Sea Geologic Cross Section of the Southern Oregon Continental Margin

United States Department of the Interior Geological Survey, Miscellaneous Investigations Series I-1463,
P. D. Snavely Jr., H. C. Wagner, and D. L. Lander, Oregon, 1985

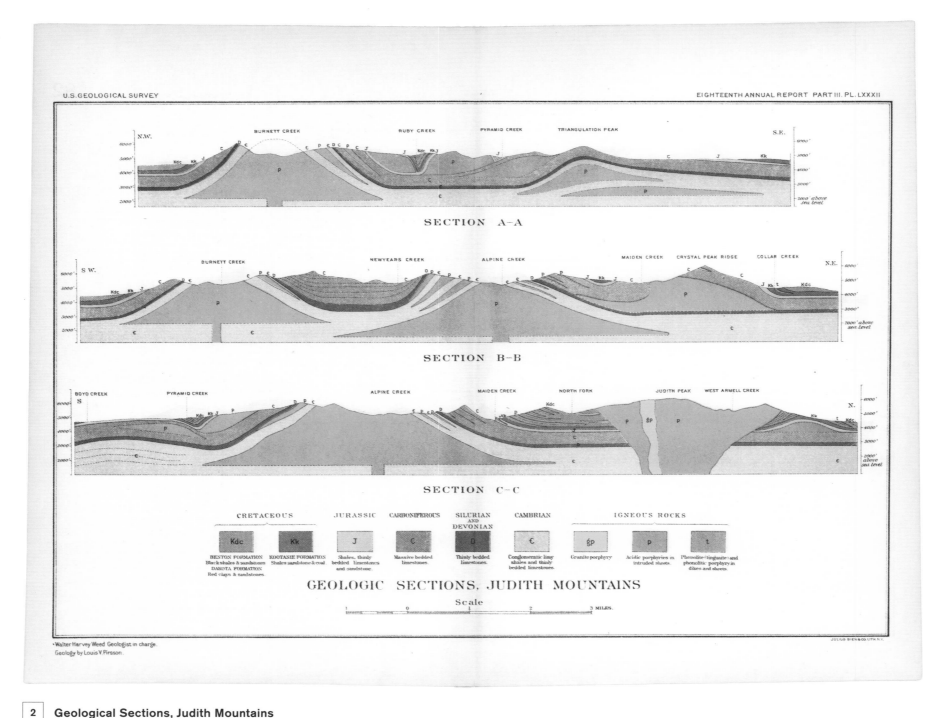

SECTION A–A

SECTION B–B

SECTION C–C

CRETACEOUS JURASSIC CARBONIFEROUS SILURIAN AND DEVONIAN CAMBRIAN IGNEOUS ROCKS

| Kdc | Kk | J | C | D | Ͼ | gp | p | t |

BENTON FORMATION
Black shales & sandstones
DAKOTA FORMATION
Red clays & sandstones.

KOOTANIE FORMATION
Shales sandstone & coal

Shales, thinly bedded limestones and sandstone.

Massive bedded limestones.

Thinly bedded limestones.

Conglomeratic limy shales and thinly bedded limestones.

Granite porphyry

Acidic porphyries in intruded sheets.

Phonolite (tinguaite) and phonolitic porphyry in dikes and sheets.

GEOLOGIC SECTIONS, JUDITH MOUNTAINS

Scale

1 0 1 2 3 MILES.

Walter Harvey Weed Geologist in charge.
Geology by Louis V. Pirsson.

JULIUS BIEN & CO LITH. N.Y.

2 Geological Sections, Judith Mountains

U. S. Geological Survey, Geology and Mineral Resources of the Judith Mountains of Montana,
Extract from the Eighteenth Annual Report Part III, Economic Geology. PL. LXXXII,
Walter Harvey Weed, Geologist in Charge, Geology by Louis V. Pirsson, Montana, c. 1868–98

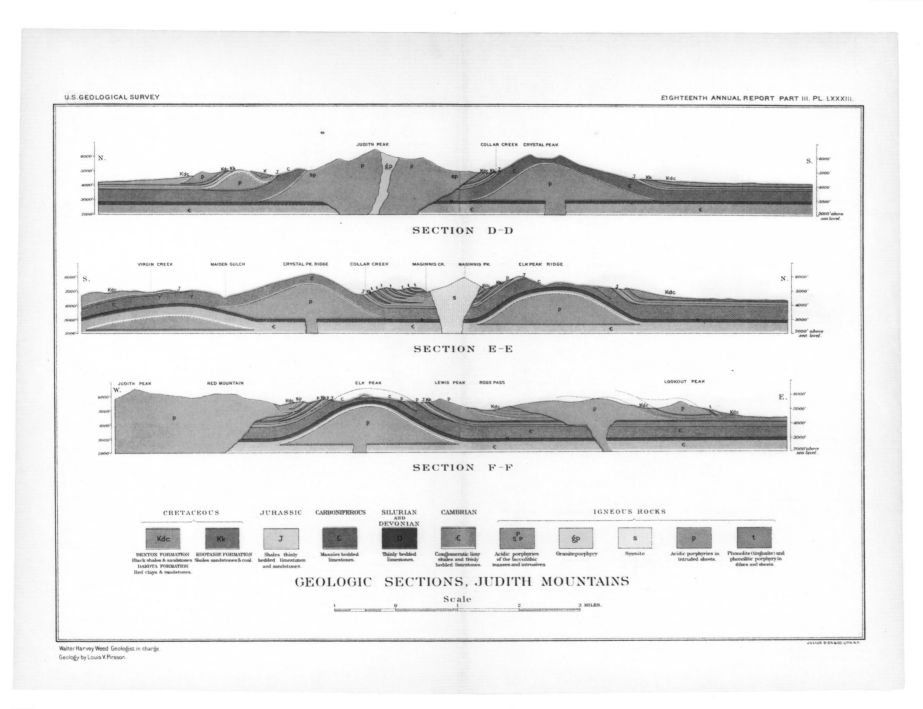

SECTION D-D

SECTION E-E

SECTION F-F

CRETACEOUS JURASSIC CARBONIFEROUS SILURIAN AND DEVONIAN CAMBRIAN IGNEOUS ROCKS

| Kdc | Kk | J | C | D | C | P SP | ép | s | p | t |

BENTON FORMATION
Black shales & sandstones
DAKOTA FORMATION
Red clays & sandstones.

KOOTANIE FORMATION
Shales sandstones & coal.

Shales thinly bedded limestones and sandstones.

Massive bedded limestones.

Thinly bedded limestones.

Conglomeratic limy shales and thinly bedded limestones.

Acidic porphyries of the laccolithic masses and intrusives

Graniteporphyry

Syenite

Acidic porphyries in intruded sheets.

Phonolite (tinguaite) and phonolitic porphyry in dikes and sheets.

GEOLOGIC SECTIONS, JUDITH MOUNTAINS

Scale

Walter Harvey Weed Geologist in charge.
Geology by Louis V. Pirsson.

JULIUS BIEN & CO. LITH. N.Y.

3 **Geological Sections, Judith Mountains**

U. S. Geological Survey, Geology and Mineral Resources of the Judith Mountains of Montana,
Extract from the Eighteenth Annual Report Part III, PL. LXXXIII, Walter Harvey Weed, Geologist in Charge,
Geology by Louis V. Pirsson, Montana, c. 1868–98

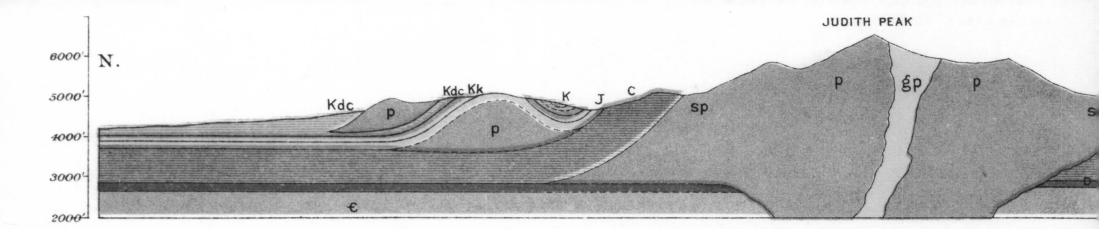

N.

JUDITH PEAK

Kdc Kdc Kk K J C sp p gp p s

6000'
5000'
4000'
3000'
Ꞓ
2000'

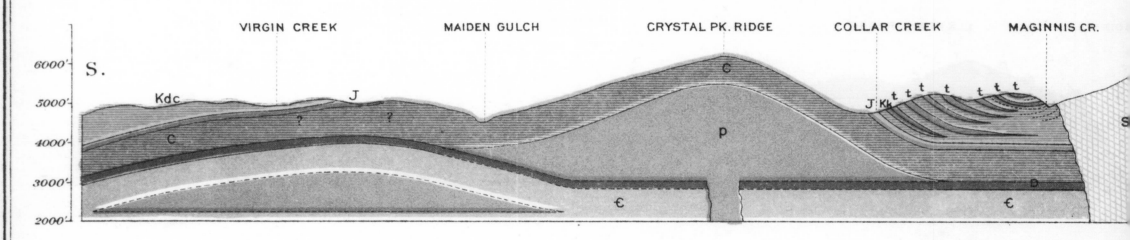

VIRGIN CREEK MAIDEN GULCH CRYSTAL PK. RIDGE COLLAR CREEK MAGINNIS CR.

S.

Kdc J C J Kk t t t t t t t s
Ꞓ ? ? p p
Ꞓ Đ Ꞓ

6000'
5000'
4000'
3000'
2000'

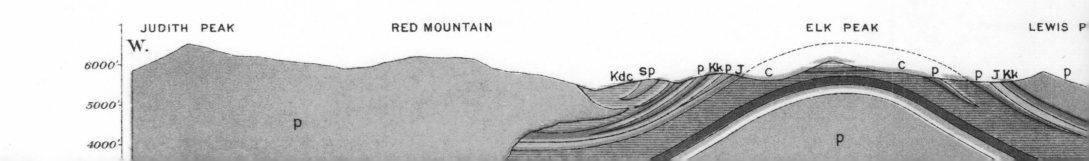

JUDITH PEAK RED MOUNTAIN ELK PEAK LEWIS P

W.

Kdc sp p Kk p J C c p p J Kk p
p p p

6000'
5000'
4000'

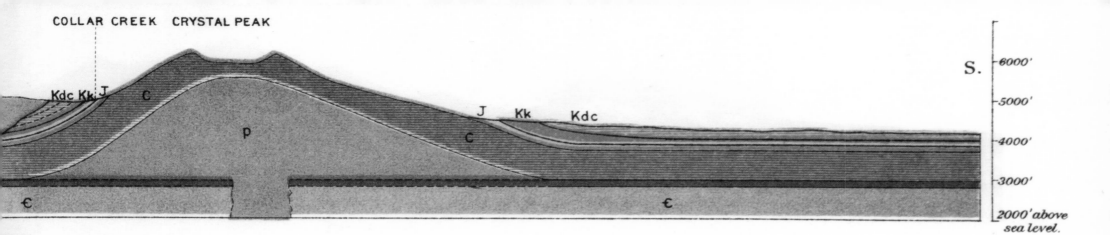

COLLAR CREEK CRYSTAL PEAK

Kdc Kk J C J Kk Kdc

p

C

€ €

S.

6000'

5000'

4000'

3000'

2000' above
sea level.

N D-D

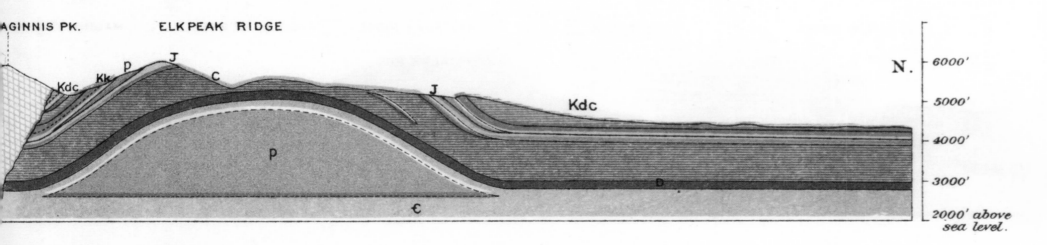

AGINNIS PK. ELK PEAK RIDGE

Kdc Kk p J C

J

Kdc

p

€

D

N.

6000'

5000'

4000'

3000'

2000' above
sea level.

N E-E

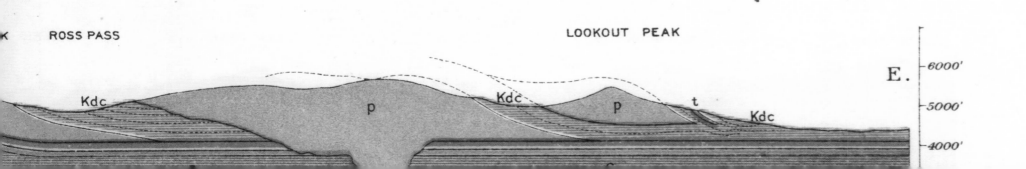

K ROSS PASS LOOKOUT PEAK

Kdc p Kdc p t Kdc

E.

6000'

5000'

4000'

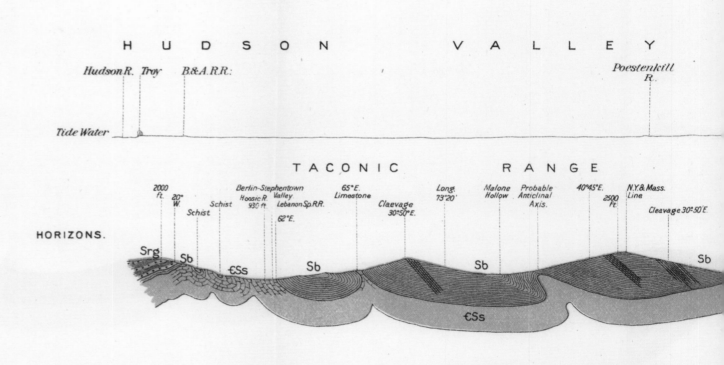

HUDSON VALLEY

Hudson R. Troy B.&A.R.R.

Poestenkill R.

Tide Water

TACONIC RANGE

HORIZONS.

2000 ft. 20° W.
Schist
Schist
Berlin-Stephentown
Hoosic R. Valley
930 ft.
Lebanon Sp.R.R.
62°E.
65°E.
Limestone
Claevage 30°50°E.
Long. 73°20'
Malone Hollow
Probable Anticlinal Axis.
40°45'E.
2500 ft.
N.Y.&Mass. Line
Cleavage 30°50'E.

Srg Sb ₵Ss Sb Sb Sb

₵Ss

Rensselaer Grit.

Greylock Schist.

4 | **General Section, Rensselaer Plateau, Taconic Range & Mt.Greylock**

U. S. Geological Survey, Thirteenth Annual Report, PL. XCVIII, Massachusetts and New York, 1896

:NSSELAER PLATEAU, TACONIC RANGE & Mᵀ GREYLOCK,

t Foot of the Greylock, Mass. to the Hudson Valley at Poestenkill.

Natural Scale, $\frac{1}{62.500}$. 1 inch = 1 mile.

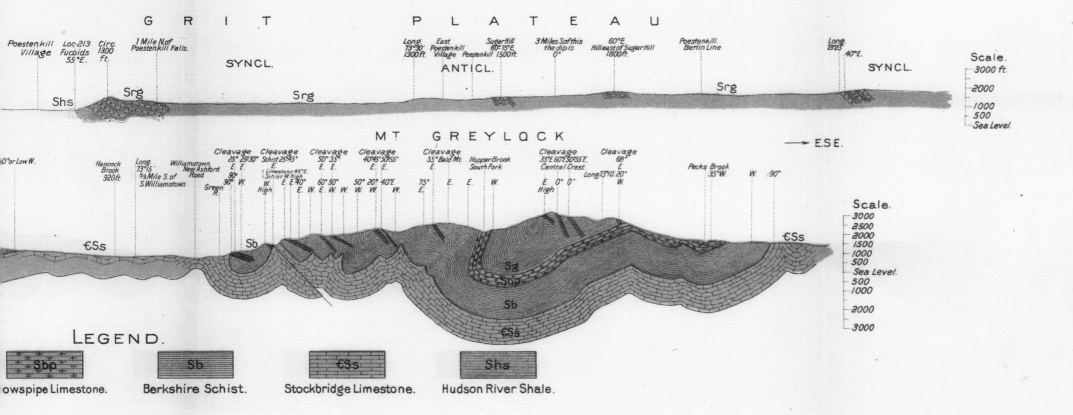

G R I T P L A T E A U

Poestenkill Village — Loc-213 Fucoids 55.°E. — Circ. 1300 ft. — 1 Mile N.of Poestenkill Falls.
Long. 73°30' 1300ft. — East Poestenkill Village — Sugar Hill 60°-75°E. Poestenkill 1500ft. — 3 Miles S.of this the dip is 0° — 60°E. Hill east of Sugar Hill 1800ft. — Poestenkill. Berlin Line — Long. 73.25 40°E.

SYNCL. — ANTICL. — SYNCL.

Shs — Srg — Srg — Srg

Scale.
— 3000 ft.
— 2000
— 1000
— 500
— Sea Level.

→ E.S.E.

Mᵀ G R E Y L O C K

0° or Low W. — Hancock Brook 920ft. — Long. 73°15 ⅗ Mile S.of S.Williamstown — Williamstown New Ashford Road — Green R. — Cleavage 25° 25°30' E. E. 90° W. 90° High — Cleavage Schist 25°45° Limestone 45°E. Schist W.high E. E.40° High W. — Cleavage 50°35° E. 60°50° E. W. — Cleavage 40°45° 50°55° E. E. 50° 20° 40°E. E.W. W. W. — Cleavage 55° Bald Mt. E. 75° E. — Hopper Brook South Fork E. E. W. — Cleavage 35°E 60°E30°55 E. Central Crest E. 0° 0° High — Cleavage 68° Long 73°10.20° W. — Pecks Brook 35°W. W. 90°

€Ss — Sb — Sg — Sbp — Sb — €Ss — €Ss

Scale.
— 3000
— 2500
— 2000
— 1500
— 1000
— 500
— Sea Level.
— 500
— 1000
— 2000
— 3000

LEGEND.

Sbp	Sb	€Ss	Shs
owspipe Limestone.	Berkshire Schist.	Stockbridge Limestone.	Hudson River Shale.

GEO.S.HARRIS & SONS, PHILA.

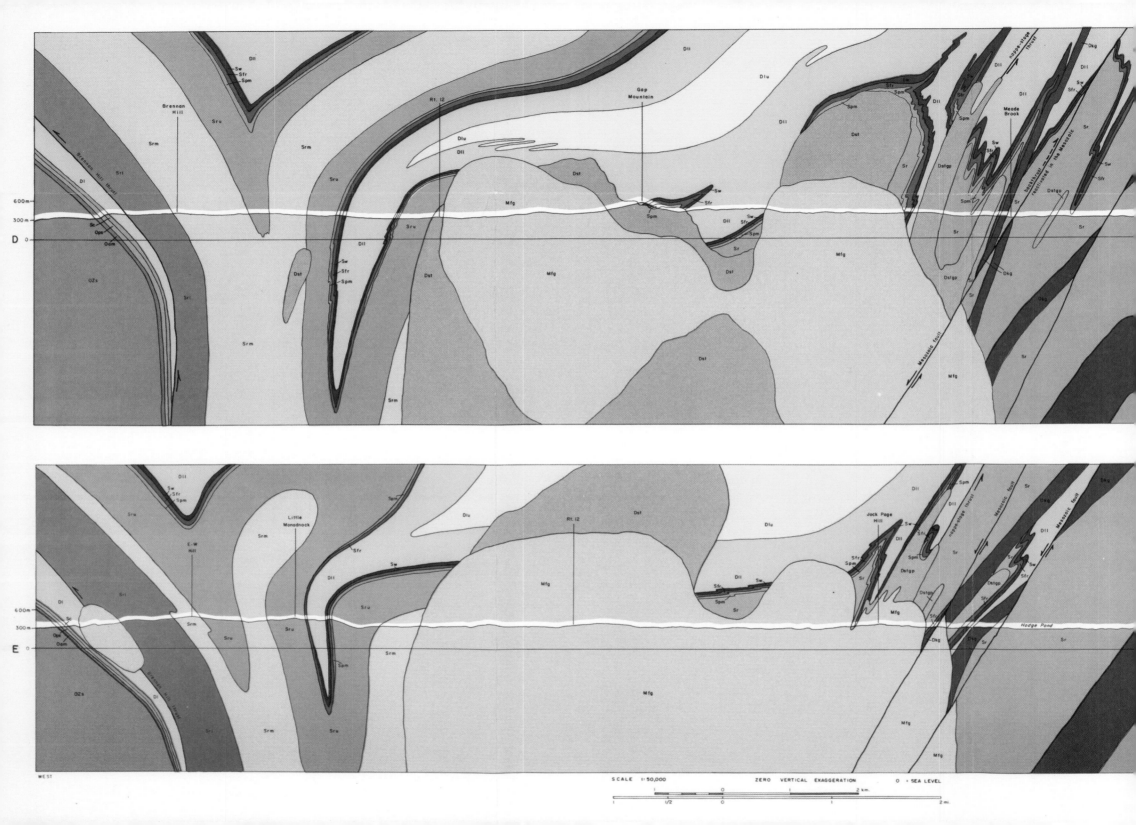

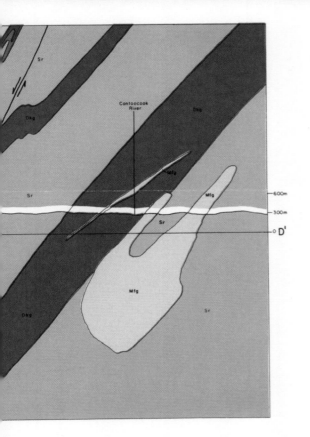

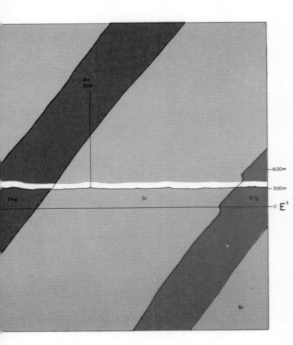

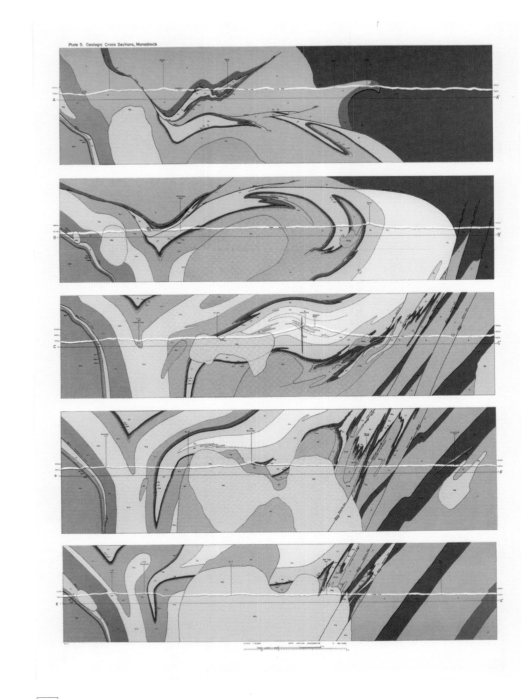

Plate 5. Geologic Cross Sections, Monadnock

5 | **Stratigraphy, Structure, and Metamorphosis in the Monadnock Quadrangle, New Hampshire**

Department of Geology and Geography University of Massachusetts, Amherst, Massachusetts, Plate 5, Geological Cross Section, Monadnock, Peter J. Thompson, New Hampshire, 1985

PLATE III

CONNECTED DETAILED SECTIONS
SHOWING ALL KNOWN COAL BEDS IN
THE BROAD TOP COAL FIELD
By James H. Gardner

Sandstone (Waynesburg?) massive, coarse, cross-bedded, dark-gray with patches of pink and red. Many casts of fossil wood. Caps Round Knob. This sandstone is softer than those below in this section.

Horizon of 16-inch coal bed.

Concealed. Shale and coarse soft sandstone?

Dark clay shales.

Black shale.

Sandstone, massive, coarse-grained, micaceous, dark-gray. Weathers yellowish to brown. Caps Rogers Knob.

Concealed.

Limestone, fine-grained, bluish, hard. No fossils.

Concealed.

Limonite.

Concealed.

Dark shale.

Rogers coal. (Pittsburg bed?)

Concealed.

Sandstone, massive, gray, coarse-grained, pebbly. Pebbles, quartz, and shale inclusions. Weathers in small blocks with lense-shaped cavities. Pebbles pea-size

Concealed

Sandstone, greenish-gray, flaggy.

Concealed

Black, bituminous shale

Horizon of McCue Basin coal.

Sandstone and shale, greenish-gray. Largely concealed.

SECTION	THICKNESS IN FEET			
	90′		Round Knob	DUNKARD?
	150′			
	30′			
	3′			
	40′			
	25′		Rogers Knob	MONONGAHELA? (445′)
	3′			
	55′			
	4′			
	30′			
	15′			
	4′			
	20′			
	50′			
	55′		North side Round Knob	CONEMAUGH (533′)
	15′			
	40′			
	3′			
	235′			

6 Connected Detailed Sections Showing All Known
Coal Beds in the Broad Top Coal Field

Pennsylvania Geological Survey, Plate III, James H. Gardner, Pennsylvania, 1913

Mosquito Hollow coal bed.
Shale, greenish-gray
Phipps coal bed
Shale
Sandstone, greenish-gray, weathers brown
Spear coal bed
Clay
Sandstone, greenish-gray, weathers brown
Shale
Kelly coal bed (Upper Freeport)
Clay and shale
Sandstone, light-gray, white-pebble conglomerate
Pebbles size pea on average
Shale and sandstone
Sandstone, hard, brown
Concealed
Dudley coal . Shale, bone, and coal mixture (Lower Freeport)
Sandstone, brown and shale
Sandstone, hard, gray, fine-grained, irregularly bedded
Shale, dark, sandy, bituminous.
Coal - Barnettstown coal
Shale and hard brown sandstone } (Upper Kittanning?)
Coal
Shale, dark, sandy, bituminous.
Twin coal bed (Middle Kittanning?)
Shale, dark, sandy, bituminous.
Barnett coal bed. (Lower Kittanning)
Shale, dark, sandy, bituminous.
Horizon of Scott shaft coal at Center
Fulton coal bed. (Clarion)
Clay
Shale, dark, sandy, bituminous.
Gordon coal bed. (Brookville)
Shale, dark, sandy, bituminous.

Sandstone, (Homewood), hard, medium-grained, micaceous, gray but weathers reddish-brown. Wood imprints . Stems of Calamites. (Mt. Savage or Mercer horizon?)
Black shale with coal streaks.
Dark, bituminous shale carrying siderite kidney-shaped concretions in upper portion; these concretions concentrated in top 10 feet.
Sandstone (Conoquenessing) hard, medium-grained, micaceous, gray but weathers reddish-brown.
Black shale with coal streaks (Sharon horizon?)
Sandstone, brown, gray, and greenish-gray
Concealed. Probably sandstone.
Sandstone, conglomerate, gray. Quartz-white pebbles, bird-egg size .
Sandstone, gray, with conglomerate lenses; bird-egg size pebbles.
Red shale at top of Mauch Chunk

This interval will average about 90 feet on south and west side of the field. Section from Dudley coal to Kelly coal only on north and east side of the field.
Other sections will show limestone beds locally under Kelly and Dudley coals.
Locally flint-clay under Dudley coal.

Shale in this entire interval only on north side of field, where Gordon coal is found. Usually contains much sandstone and locally a quartz conglomerate lies just over the Fulton coal bed.
Other sections will show flint clays locally under Fulton and Barnett coal beds.

South from Dudley | At Dudley | Gordon Mines

ALLEGHENY (381')

POTTSVILLE (At Hopewell) (192')

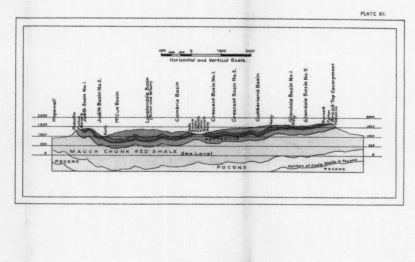

7

8

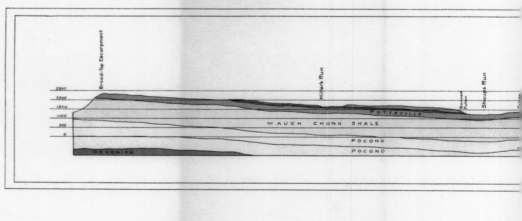

9

10

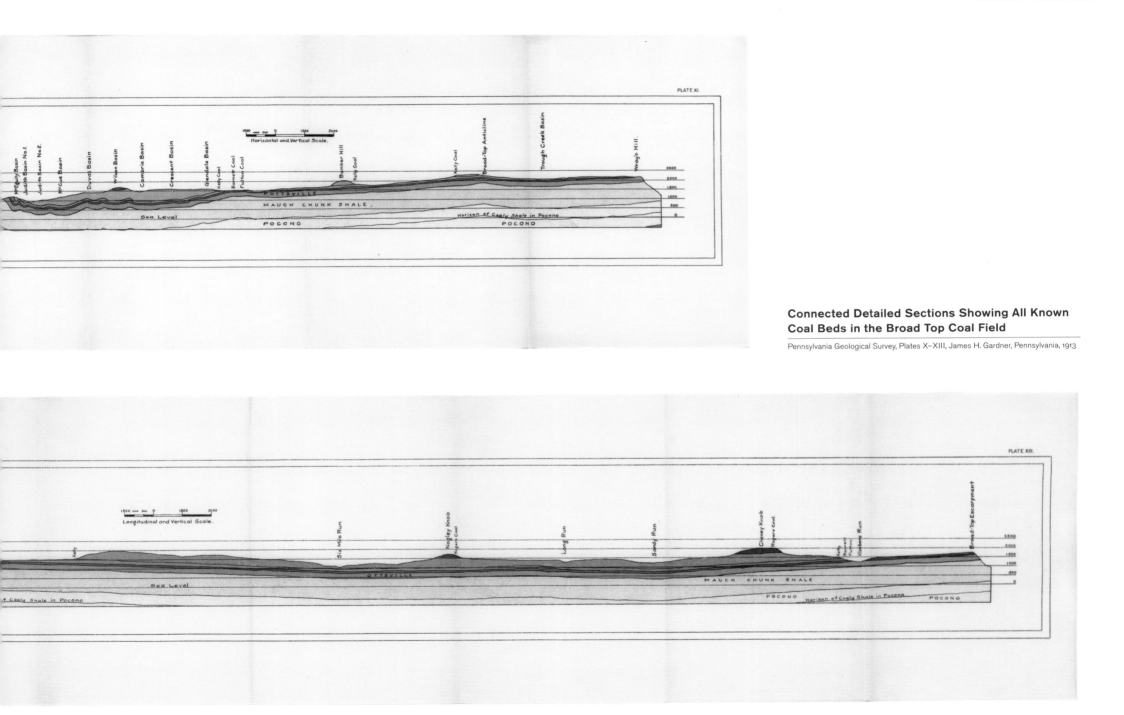

**Connected Detailed Sections Showing All Known
Coal Beds in the Broad Top Coal Field**

Pennsylvania Geological Survey, Plates X–XIII, James H. Gardner, Pennsylvania, 1913

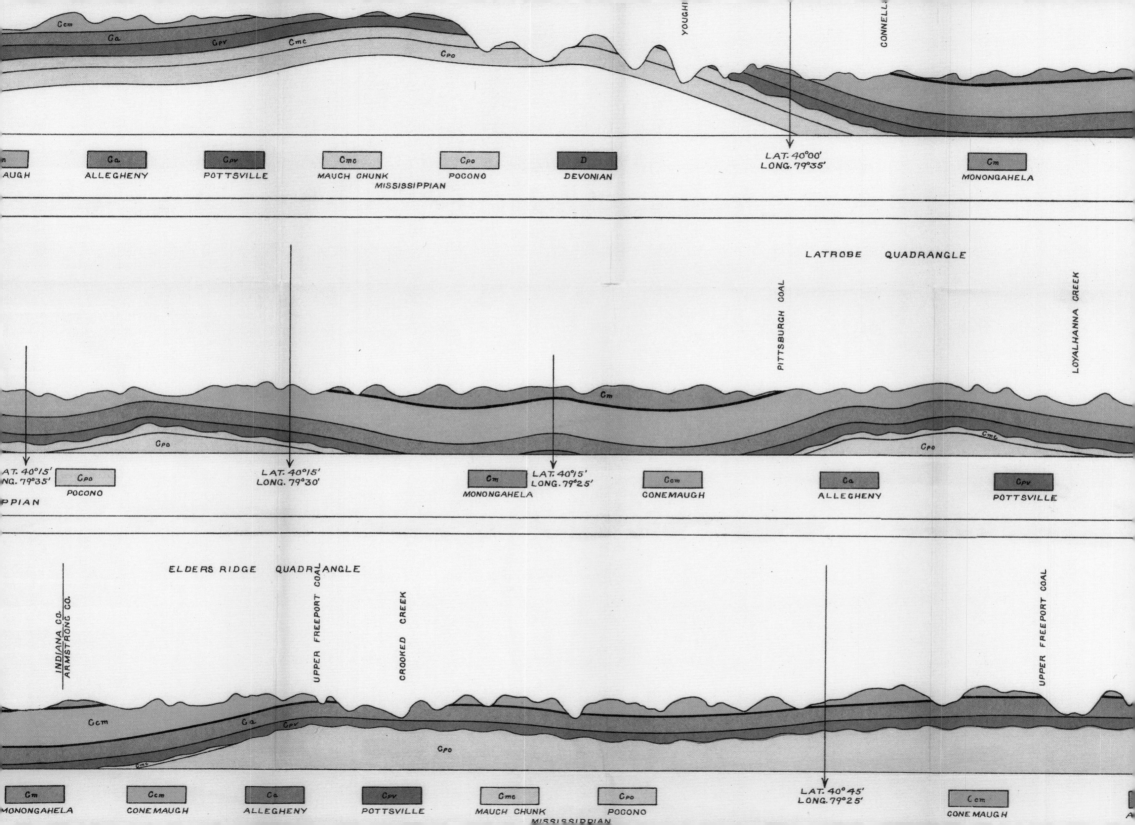

YOUGHI

CONNELL

LAT. 40°00'
LONG. 79°35'

AUGH	Ga	Cpv	Cmc	Cpo	D		Cm
	ALLEGHENY	POTTSVILLE	MAUCH CHUNK	POCONO	DEVONIAN		MONONGAHELA
				MISSISSIPPIAN			

LATROBE QUADRANGLE

PITTSBURGH COAL

LOYALHANNA CREEK

Cm

Cpo

Cme

Cpo

AT. 40°15'	Cpo		LAT. 40°15'	Cm	LAT. 40°15'	Ccm	Ga	Cpv
NG. 79°35'	POCONO		LONG. 79°30'	MONONGAHELA	LONG. 79°25'	CONEMAUGH	ALLEGHENY	POTTSVILLE
PPIAN								

ELDERS RIDGE QUADRANGLE

INDIANA CO.
ARMSTRONG CO.

UPPER FREEPORT COAL

CROOKED CREEK

UPPER FREEPORT COAL

Ccm

Ga

Cpv

Cpo

Cme

LAT. 40°45'
LONG. 79°25'

Cm	Ccm	Ga	Cpv	Cmc	Cpo		Ccm
MONONGAHELA	CONEMAUGH	ALLEGHENY	POTTSVILLE	MAUCH CHUNK	POCONO		CONEMAUGH
				MISSISSIPPIAN			

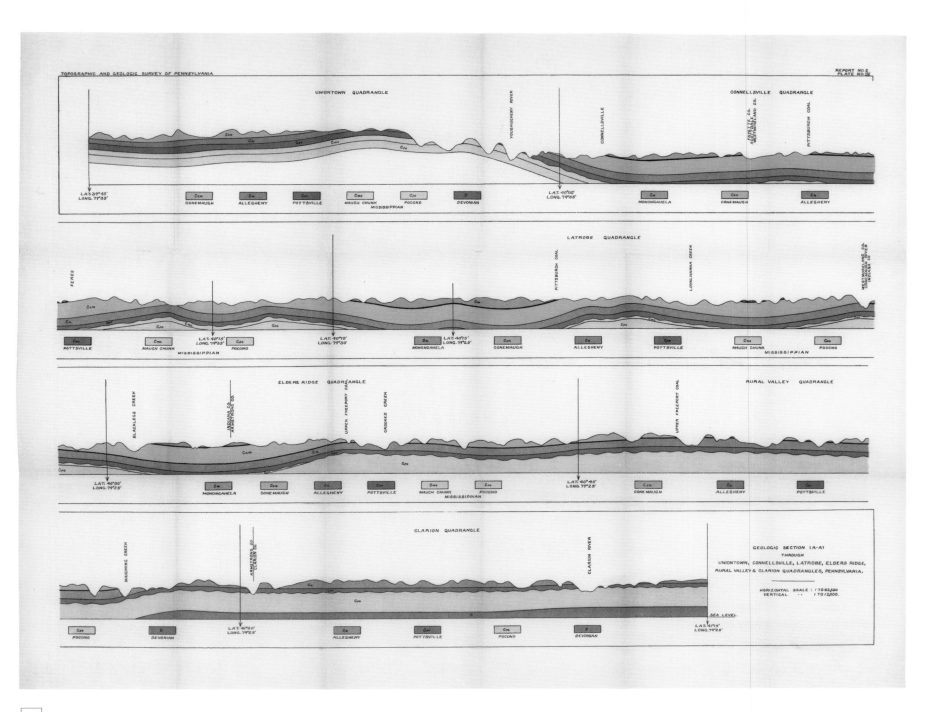

11 **Geologic Section (A-A) Through Uniontown, Connellsville, Latrobe, Elders Ridge, Rural Valley & Clarion Quadrangles, Pennsylvania**

Topographic and Geologic Survey of Pennsylvania, Geologic Map of Southwestern Pennsylvania,
Report No. 2, Plate No. IV, Pennsylvania, 1914

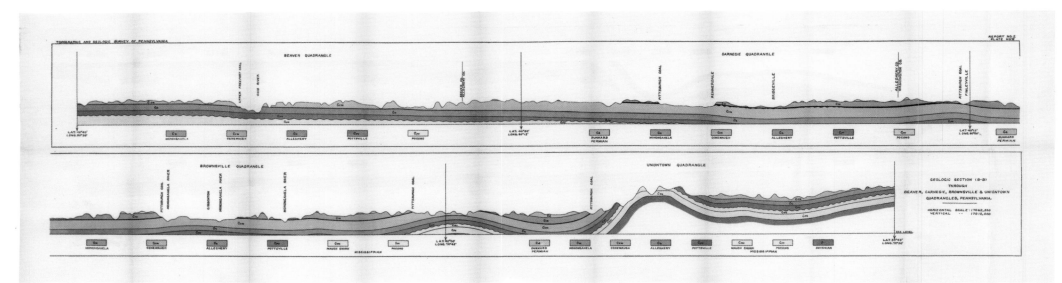

12 Geologic Section (B-B) Through Beaver, Carnegie, Brownsville & Uniontown Quadrangles, Pennsylvania

Topographic and Geologic Survey of Pennsylvania, Geologic Map of Southwestern Pennsylvania, Report No. 2, Plate No. V, Pennsylvania, 1914

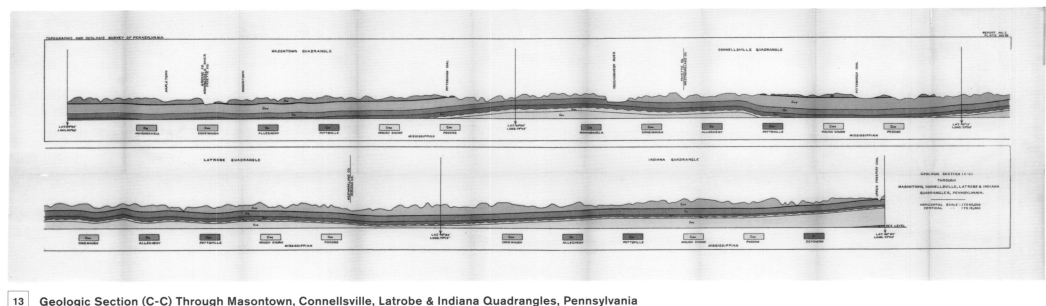

13 Geologic Section (C-C) Through Masontown, Connellsville, Latrobe & Indiana Quadrangles, Pennsylvania

Topographic and Geologic Survey of Pennsylvania, Geologic Map of Southwestern Pennsylvania, Report No. 2, Plate No. VI, Pennsylvania, 1914

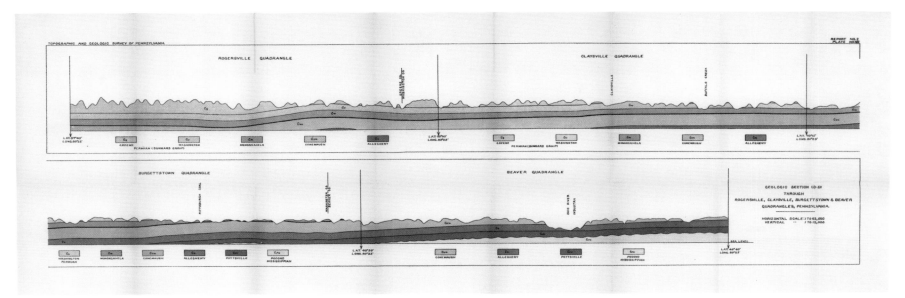

14 **Geologic Section (D-D) Through Rogersville, Claysville, Burgettstown & Beaver Quadrangles, Pennsylvania**

Topographic and Geologic Survey of Pennsylvania, Geologic Map of Southwestern Pennsylvania, Report No. 2, Plate No. VII, Pennsylvania, 1914

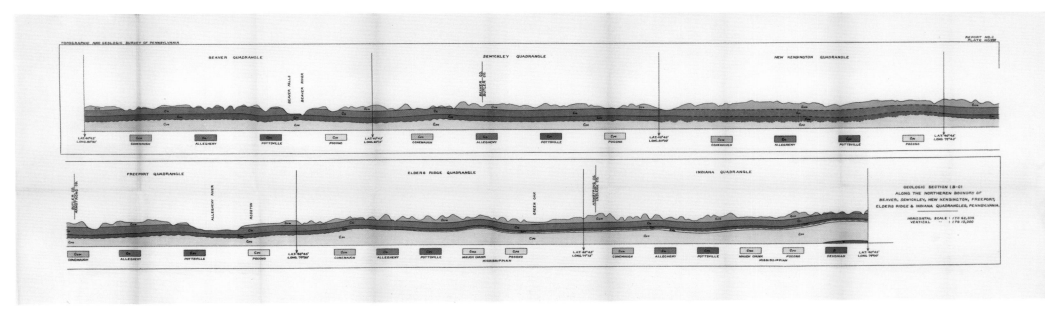

15 **Geologic Section (B-C) Along the Northern Boundary of Beaver, Sewickley, New Kensington, Freeport, Elders Ridge & Indiana Quadrangles, Pennsylvania**

Topographic and Geologic Survey of Pennsylvania, Geologic Map of Southwestern Pennsylvania, Report No. 2, Plate No. VIII, Pennsylvania, 1914

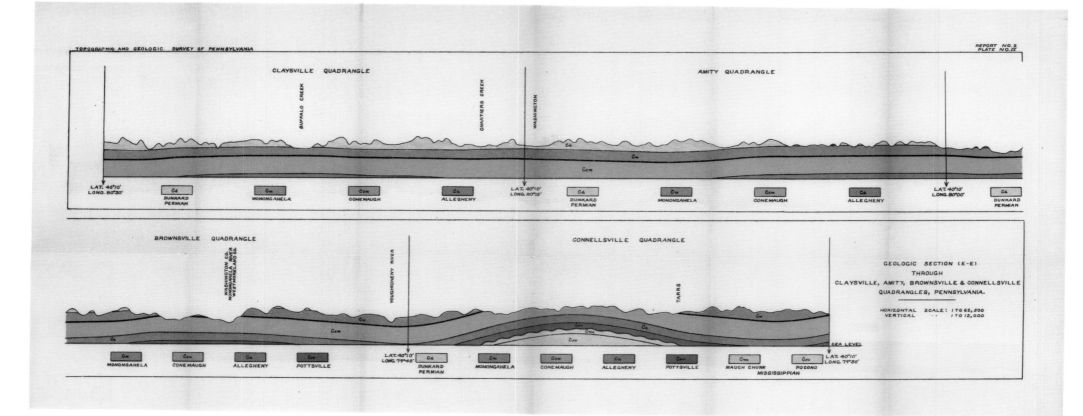

16 Geologic Section (E-E) Through Claysville, Amity,
Brownsville & Connellsville Quadrangles, Pennsylvania

Topographic and Geologic Survey of Pennsylvania, Geologic Map of Southwestern Pennsylvania,
Report No. 2, Plate No. IX, Pennsylvania, 1914

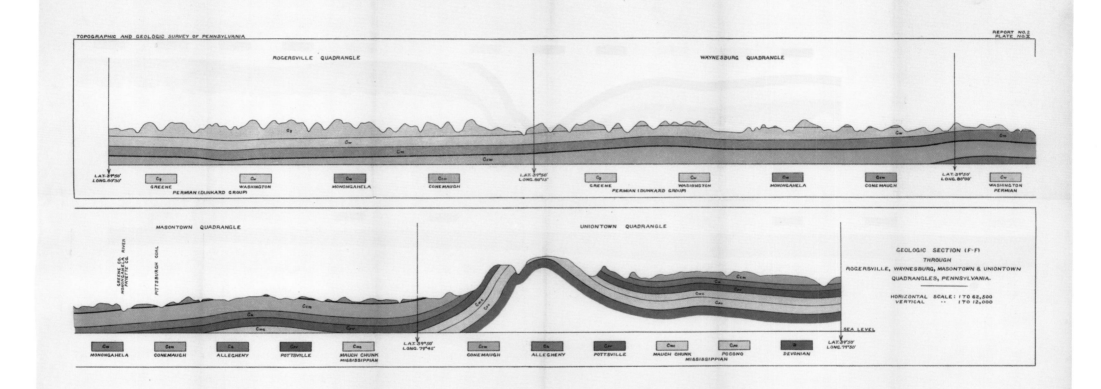

17 **Geologic Section (F-F) Through Rogersville, Waynesburg, Masontown & Uniontown Quadrangles, Pennsylvania**

Topographic and Geologic Survey of Pennsylvania, Geologic Map of Southwestern Pennsylvania, Report No. 2, Plate No. X, Pennsylvania, 1914

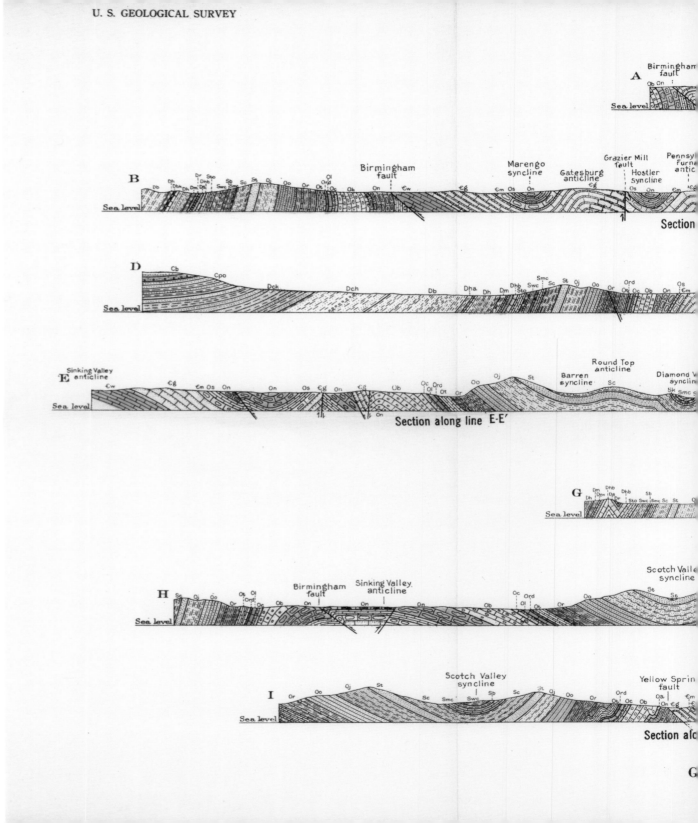

18 **Geologic Structure Sections
of the Tyrone Quadrangle, PA**

U. S. Geological Survey, Pennsylvania Geological Survey,
Atlas 96, Plate 3, Pennsylvania, 1939

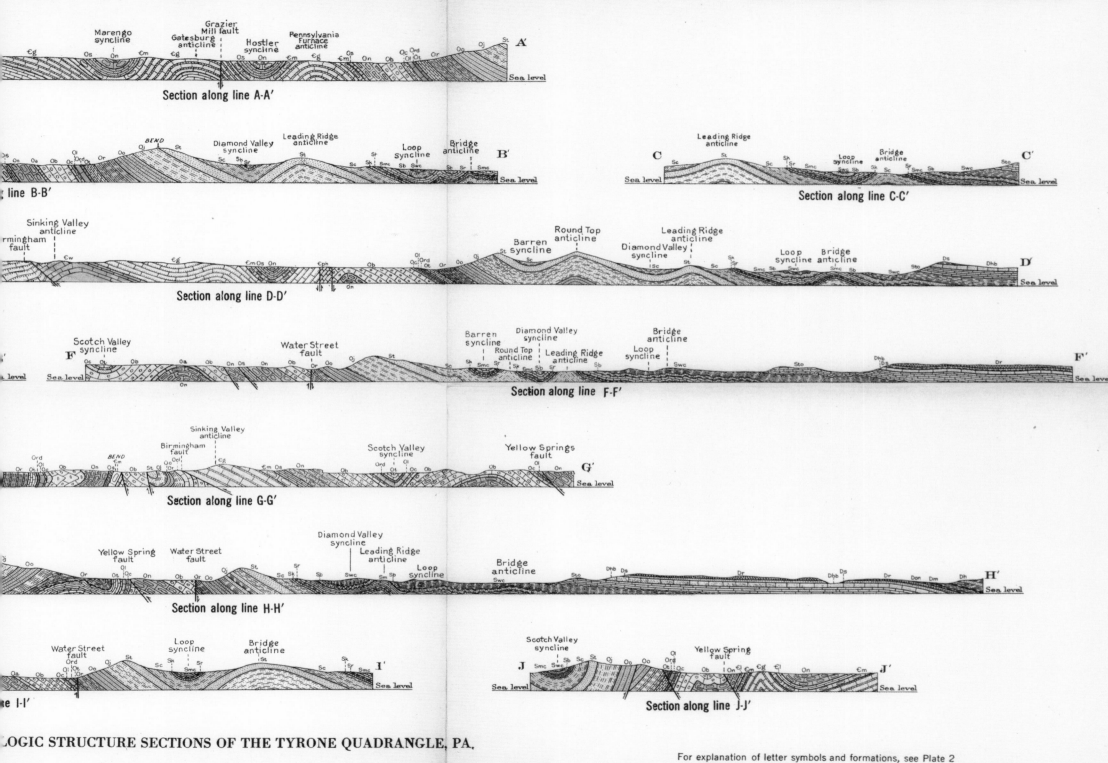

GEOLOGIC STRUCTURE SECTIONS OF THE TYRONE QUADRANGLE, PA.

For explanation of letter symbols and formations, see Plate 2

1939

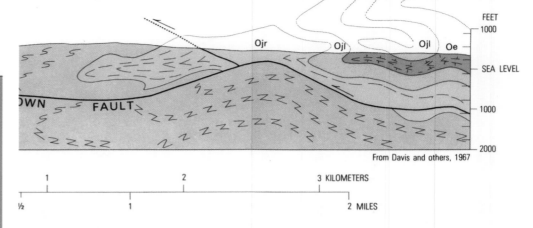

From Davis and others, 1967



1		2	3 KILOMETERS

½ 1 2 MILES

approximate location of the section is shown on plate 1B

CTION THROUGH THE SOUTHWESTERN CORNER
OR QUADRANGLE, PA.–N. J.

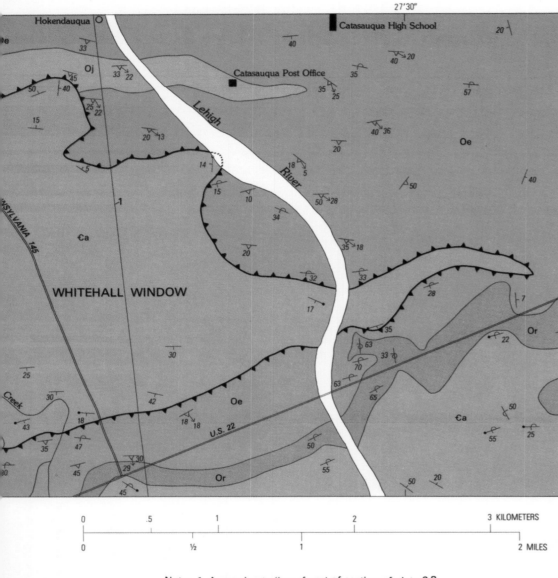

Note: 1, Approximate line of part of section of plate 3,B

A. GEOLOGIC MAP OF THE CATASAUQUA AREA, SHOWING THE WHITEHALL WIN

Based in part on Sherwood (1964, sec. D–D')

1000 2000 3000 METERS

1000 2000 3000 4000 5000 6000 7000 8000 9000 10,000 MILES

IATIC GEOLOGIC SECTION, SHOWING RELATION
TOCKERTOWN FAULT TO THE PORTLAND FAULT

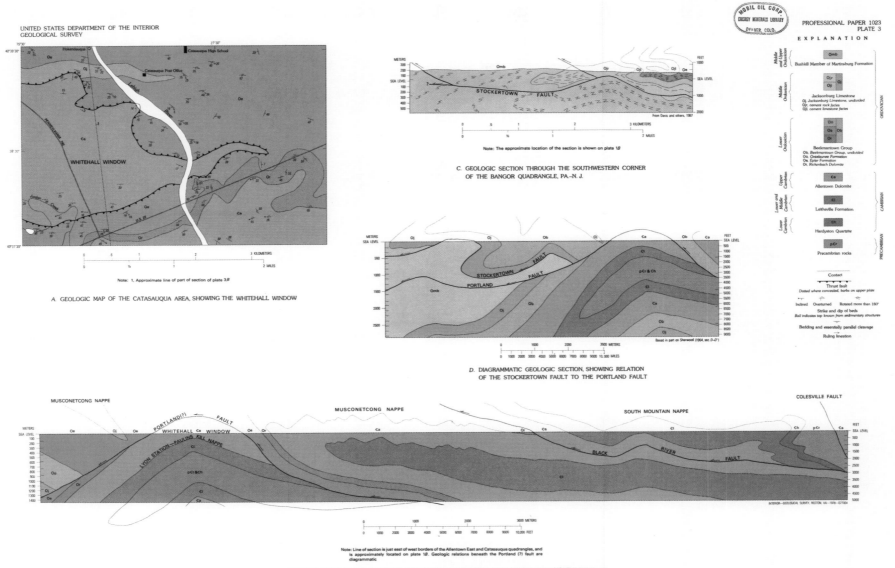

GEOLOGIC MAP AND SECTIONS OF AREAS IN THE LEHIGH VALLEY, PENNSYLVANIA

19 Geological Map and Sections of Areas in the Lehigh Valley, Pennsylvania

United States Department of the Interior Geological Survey, Professional Paper 1023, Plates 1–3, Pennsylvania, 1964, 1967, 1978

39

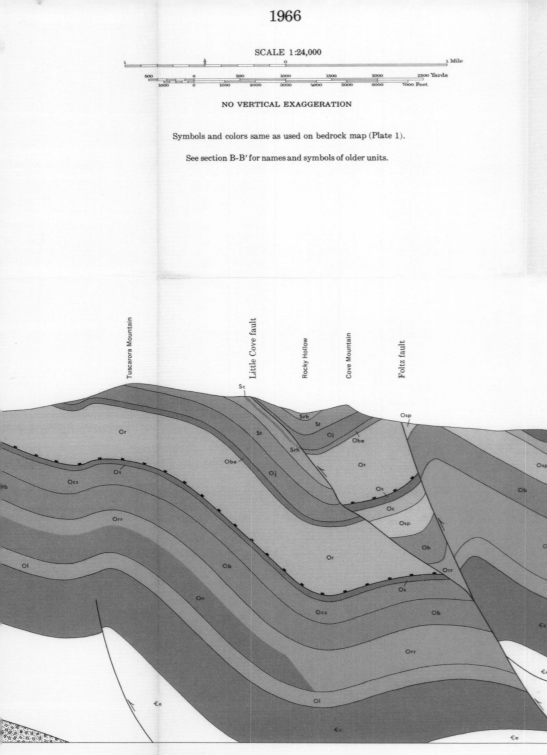

1966

SCALE 1:24,000

NO VERTICAL EXAGGERATION

Symbols and colors same as used on bedrock map (Plate 1).

See section B-B' for names and symbols of older units.

CROSS SECTION ALONG LINE C-C'

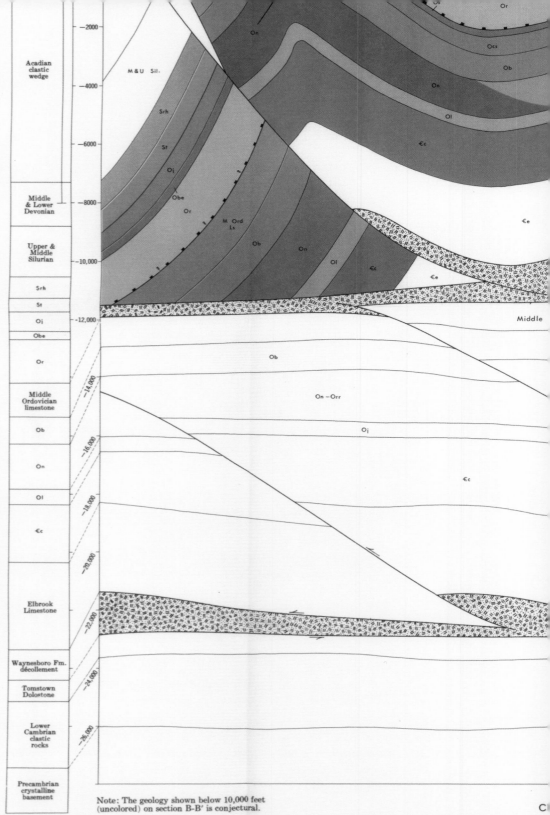

Note: The geology shown below 10,000 feet (uncolored) on section B-B' is conjectural.

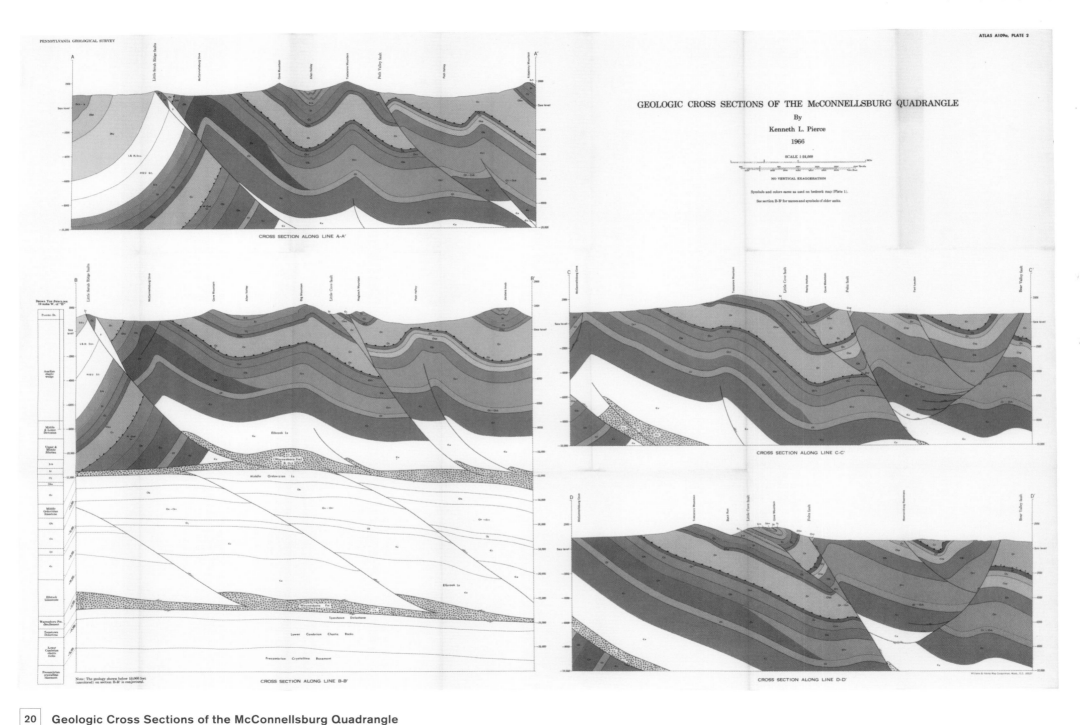

GEOLOGIC CROSS SECTIONS OF THE McCONNELLSBURG QUADRANGLE

By

Kenneth L. Pierce

1966

SCALE 1:24,000

NO VERTICAL EXAGGERATION

Symbols and colors same as used on bedrock map (Plate 1).

See section B-B' for names and symbols of older units.

CROSS SECTION ALONG LINE A-A'

CROSS SECTION ALONG LINE B-B'

CROSS SECTION ALONG LINE C-C'

CROSS SECTION ALONG LINE D-D'

20 Geologic Cross Sections of the McConnellsburg Quadrangle

Pennsylvania Geological Survey, Atlas A109a, Plate 2, Kenneth L. Pierce, Pennsylvania, 1966

BODIES,

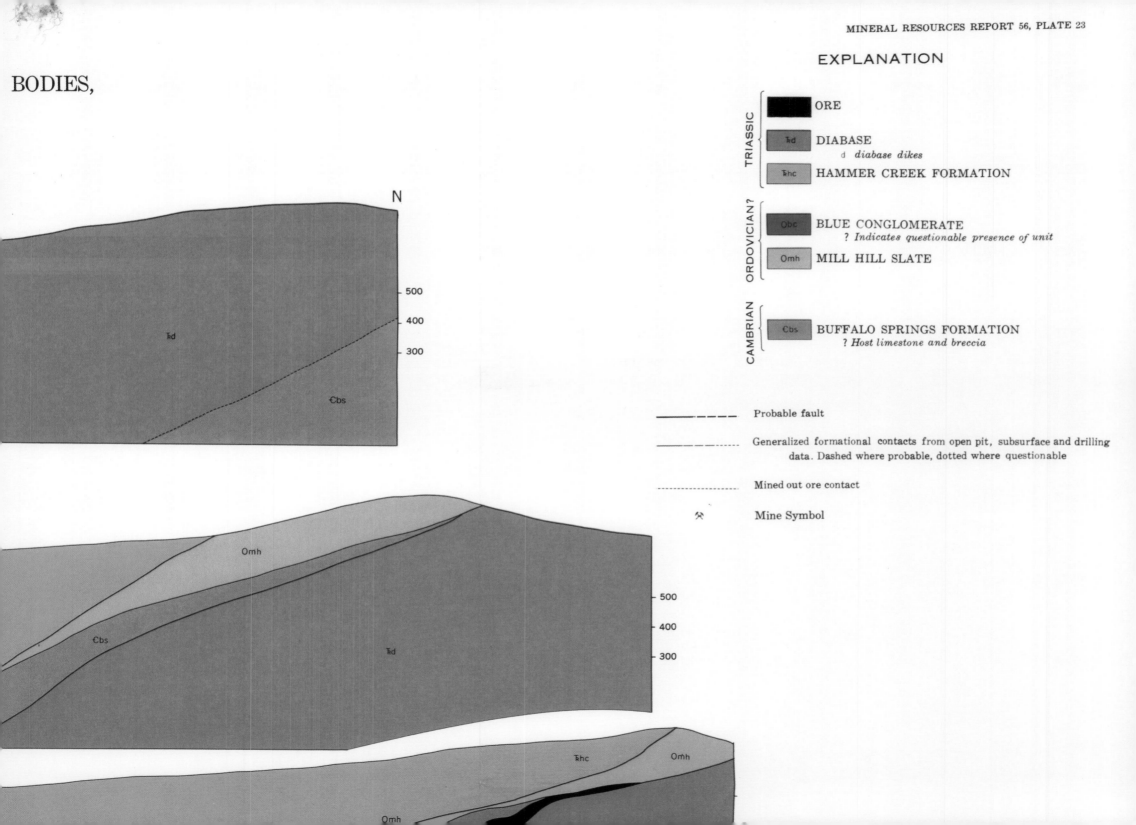

EXPLANATION

TRIASSIC

ORE

$\overline{\text{T}}\text{d}$ DIABASE
d *diabase dikes*

$\overline{\text{T}}\text{hc}$ HAMMER CREEK FORMATION

ORDOVICIAN?

Obc BLUE CONGLOMERATE
? *Indicates questionable presence of unit*

Omh MILL HILL SLATE

CAMBRIAN

€bs BUFFALO SPRINGS FORMATION
? *Host limestone and breccia*

———————— Probable fault

———————— Generalized formational contacts from open pit, subsurface and drilling
data. Dashed where probable, dotted where questionable

················ Mined out ore contact

⚒ Mine Symbol

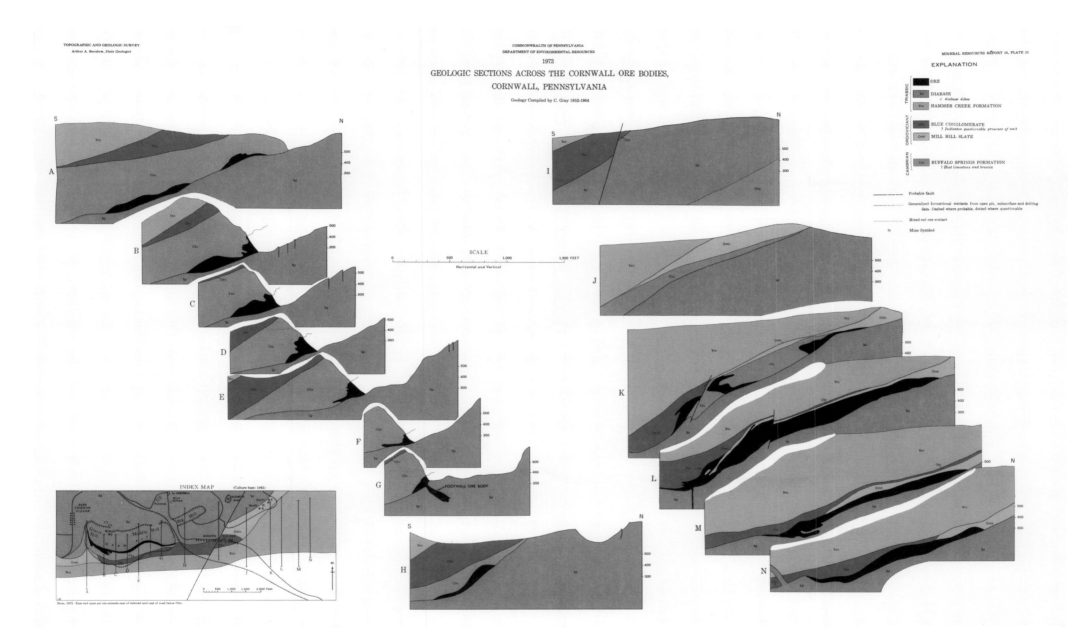

TOPOGRAPHIC AND GEOLOGIC SURVEY
Arthur A. Socolow, *State Geologist*

COMMONWEALTH OF PENNSYLVANIA
DEPARTMENT OF ENVIRONMENTAL RESOURCES
1973

MINERAL RESOURCES REPORT 56, PLATE 23

GEOLOGIC SECTIONS ACROSS THE CORNWALL ORE BODIES,
CORNWALL, PENNSYLVANIA

Geology Compiled by C. Gray 1952–1964

EXPLANATION

	ORE
	DIABASE *± diabase dikes*
	HAMMER CREEK FORMATION
	BLUE CONGLOMERATE *? indicates questionable presence of unit*
	MILL HILL SLATE
	BUFFALO SPRINGS FORMATION *? Host limestone and breccia*

Probable fault

Generalized formational contacts from open pit, subsurface and drilling data. Dashed where probable, dotted where questionable

Mined out ore contact

Mine Symbol

SCALE

0 500 1,000 1,500 FEET

Horizontal and Vertical

INDEX MAP (Culture base: 1965)

21 **Geologic Sections Across the Cornwall Ore Bodies, Cornwall, Pennsylvania**

Commonwealth of Pennsylvania Department of Environmental Resources, Topographic and Geological Survey,
Mineral Resources Report 56, Plate 23, C. Gray 1952–1964, Pennsylvania, 1973

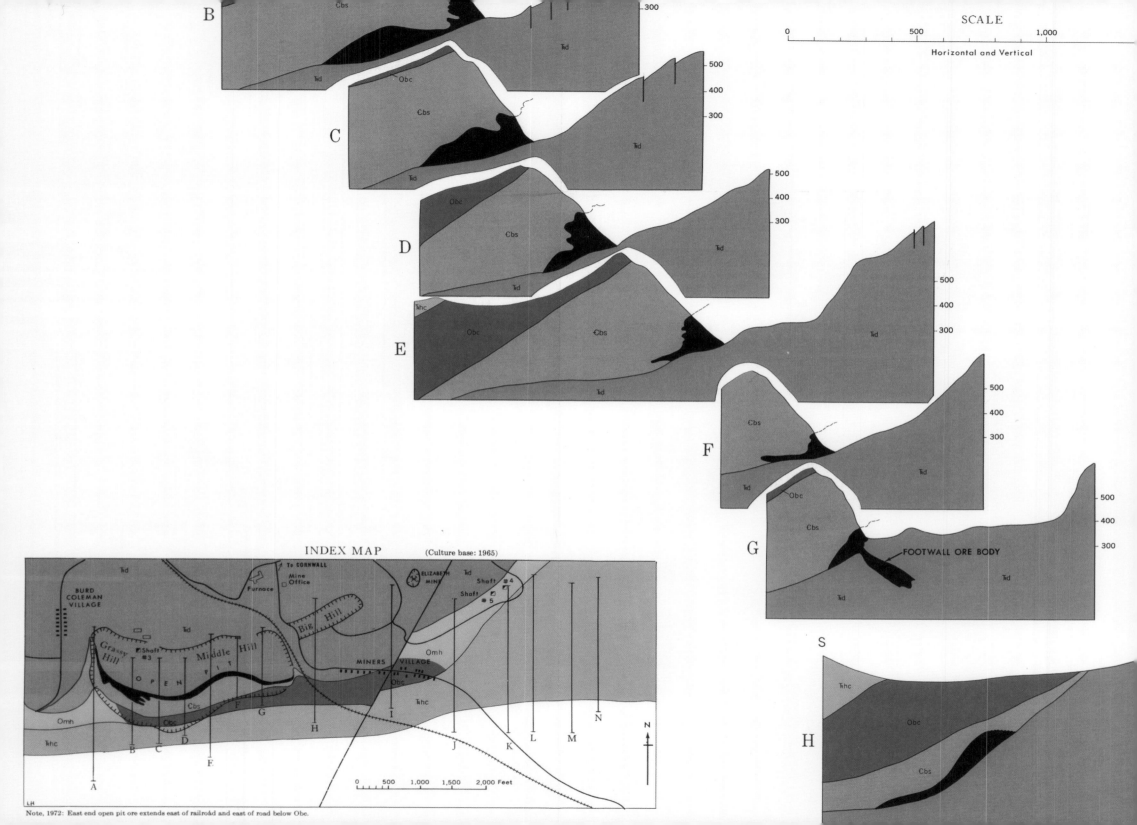

B

C

D

E

F

G

S

H

300

500
400
300

500
400
300

500
400
300

500
400
300

500
400
300

Cbs

Obc

Ṫd

Ṫd

Cbs

Ṫd

Obc

Obc

Cbs

Ṫd

Ṫhc

Obc

Cbs

Ṫd

Ṫd

Ṫd

Cbs

Ṫd

Obc

Cbs

Ṫd

FOOTWALL ORE BODY

Ṫd

Ṫhc

Obc

Cbs

SCALE

0 500 1,000

Horizontal and Vertical

INDEX MAP (Culture base: 1965)

To CORNWALL
Mine Office
Furnace
ELIZABETH MINE
Shaft #4
Shaft #5
BURD COLEMAN VILLAGE
Ṫd
Big Hill
Grassy Hill
Shaft #3
Middle Hill
OPEN PIT
MINERS VILLAGE
Omh
Obc
Ṫhc
Cbs
Omh
Ṫhc
Ṫd

A B C D E F G H I J K L M N

N

0 500 1,000 1,500 2,000 Feet

L.H.

Note, 1972: East end open pit ore extends east of railroad and east of road below Obc.

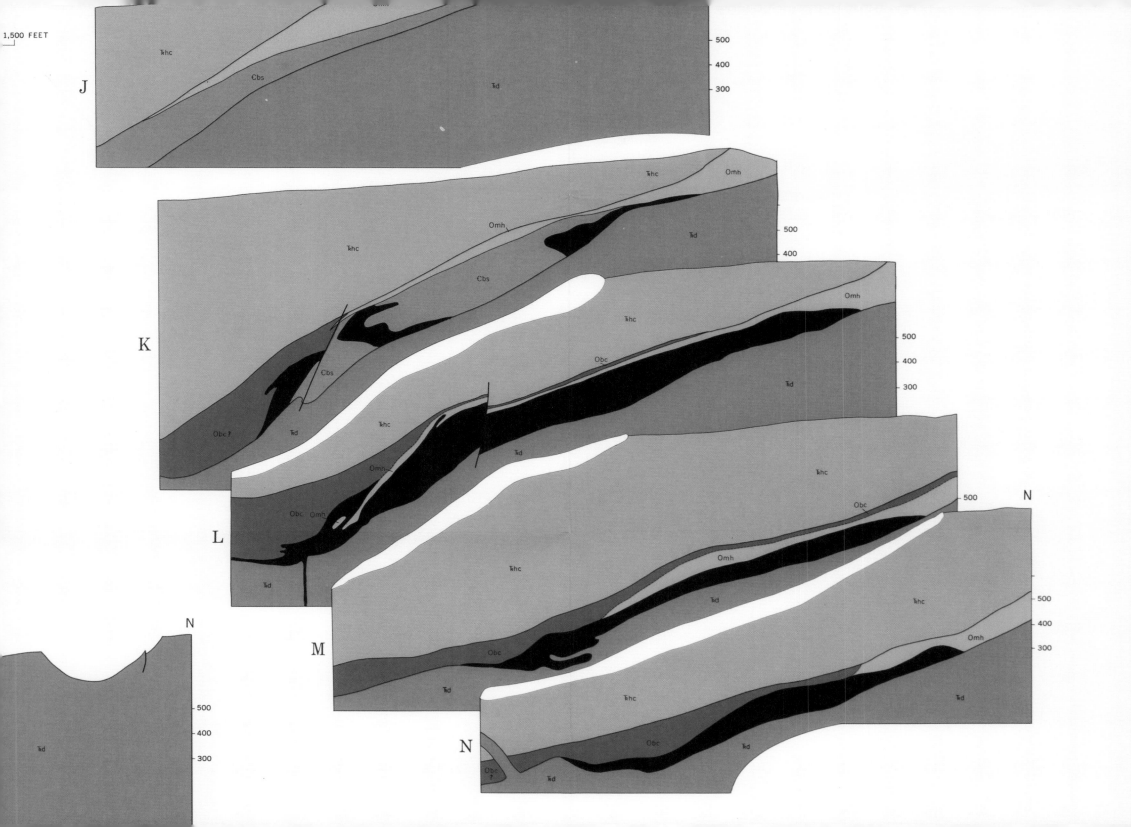

1,500 FEET

J

Cbs

Thc

Td

500
400
300

K

Thc

Omh

Omh

Td

Cbs

Thc

500
400

Cbs

Obc

500
400
300

Obc?

Td

Thc

Td

L

Thc

Omh

Obc Omh

Td

Td

Thc

Obc

Omh

Thc

500

N

N

Td

500
400
300

M

Thc

Td

Obc

Td

Obc

Omh

Td

Thc

Omh

500
400
300

N

Thc

Td

Obc

Obc
?

Td

Td

EXP

Section trends N20W and passes
line A-A' on Plates 1 and 5. Strati
used on the geologic map (Plate 1

Dm	Montebello, Fisher Ridge, Da Mahantango Formation
Omro	Marcellus and Onondaga Form
SD	Old Port, Keyser, and Tonolo
Skr	Keefer and Rose Hill Format
Oj	Juniata Formation
Or	Reedsville Formation
Osn	Salona and Nealmont Format

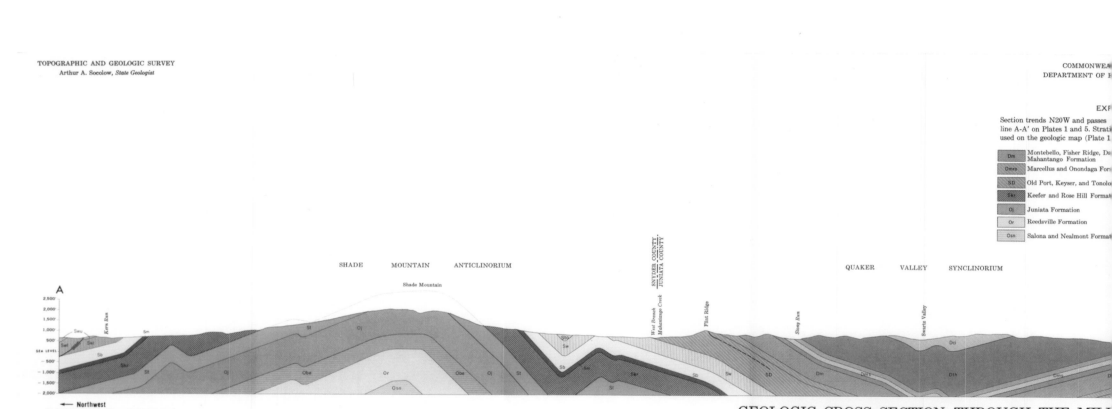

SHADE MOUNTAIN ANTICLINORIUM

QUAKER VALLEY SYNCLINORIUM

Shade Mountain

A

2,500'
2,000'
1,500'
1,000'
500'
SEA LEVEL
-500'
-1,000'
-1,500'
-2,000'

⟵ Northwest
Scale 1:24,000 No vertical exaggeration

GEOLOGIC CROSS SECTION THROUGH THE MILL

22

**Geologic Cross Section Through the Millerstown
15-Minute Quadrangle, Pennsylvania**

Commonwealth of Pennsylvania Department of Environmental Resources, Topographic and Geological Survey,
Atlas 136. Plate 2, Arthur A. Socolow, State Geologist, Pennsylvania, 1974

PENNSYLVANIA
MENTAL RESOURCES

Atlas 136, Plate 2

ION

the center of the quadrangle. See
bbreviations are the same as those
or the following units:

d Turkey Ridge Members,

ations

TUSCARORA MOUNTAIN ANTICLINORIUM BUFFALO - BERRY SYNCLINORIUM

JUNIATA COUNTY
PERRY COUNTY

Turkey Valley Cabela Run Cranst Run Turkey Ridge Pfoutz Valley Wildcat Ridge Wildcat Run Perry Valley Buffalo Mountain Hunters Run Berry Mountain A′

STOWN 15-MINUTE QUADRANGLE, PENNSYLVANIA South →

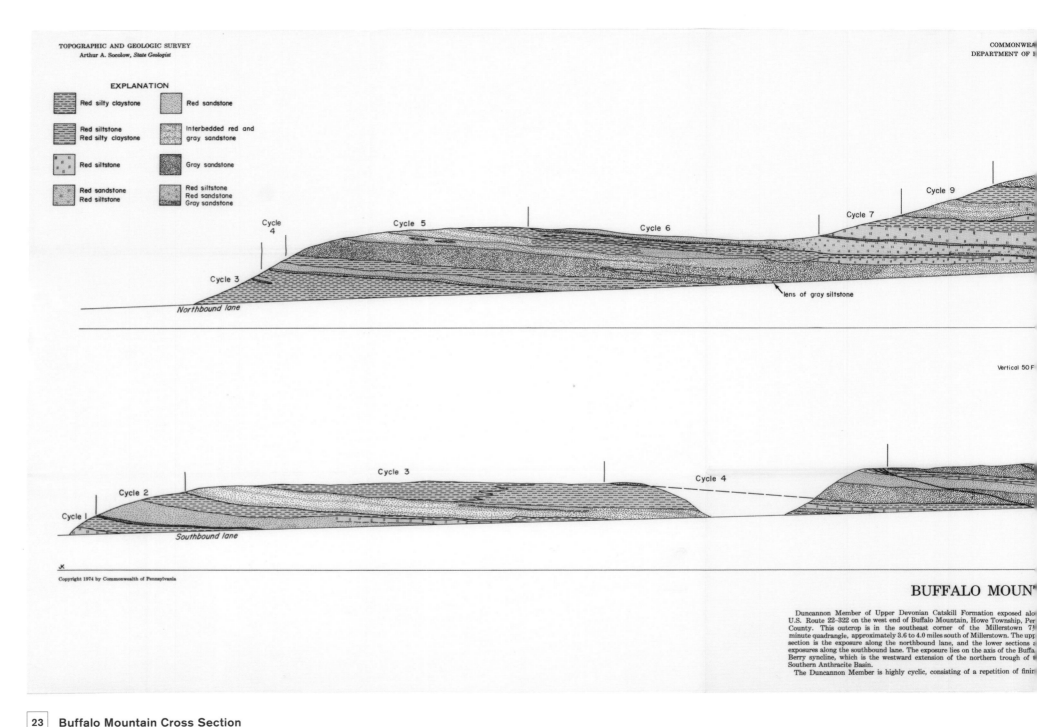

EXPLANATION

Red silty claystone

Red sandstone

Red siltstone
Red silty claystone

Interbedded red and
gray sandstone

Red siltstone

Gray sandstone

Red sandstone
Red siltstone

Red siltstone
Red sandstone
Gray sandstone

Cycle 9

Cycle 7

Cycle 6

Cycle 5

Cycle 4

Cycle 3

Northbound lane

lens of gray siltstone

Vertical 50 F

Cycle 3

Cycle 2

Cycle 4

Cycle I

Southbound lane

BUFFALO MOUN

Duncannon Member of Upper Devonian Catskill Formation exposed alo
U.S. Route 22–322 on the west end of Buffalo Mountain, Howe Township, Per
County. This outcrop is in the southeast corner of the Millerstown 7½-
minute quadrangle, approximately 3.6 to 4.0 miles south of Millerstown. The upp
section is the exposure along the northbound lane, and the lower sections
exposures along the southbound lane. The exposure lies on the axis of the Buffa
Berry syncline, which is the westward extension of the northern trough of
Southern Anthracite Basin.

The Duncannon Member is highly cyclic, consisting of a repetition of finir

23 | Buffalo Mountain Cross Section

Commonwealth of Pennsylvania Department of Environmental Resources, Topographic and Geological Survey,
Atlas 136, Plate 6, Arthur A. Socolow, State Geologist, Pennsylvania, 1974

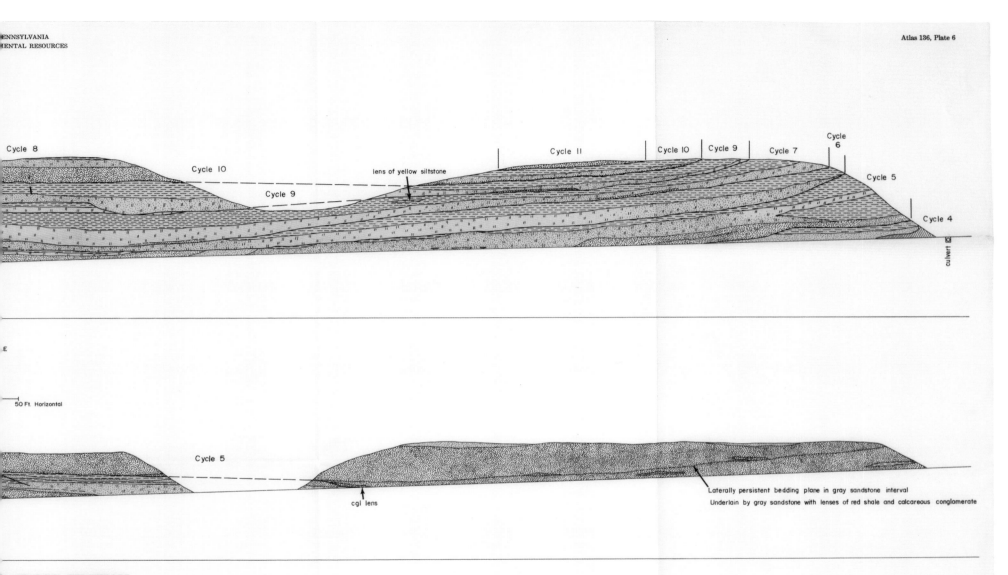

Cycle 8

Cycle 10

Cycle 9

lens of yellow siltstone

Cycle 11

Cycle 10

Cycle 9

Cycle 7

Cycle 6

Cycle 5

Cycle 4

culvert

E

50 Ft. Horizontal

Cycle 5

cgl lens

Laterally persistent bedding plane in gray sandstone interval

Underlain by gray sandstone with lenses of red shale and calcareous conglomerate

CROSS SECTION

upward cycles. A typical cycle, illustrated in Figure 41, begins with gray, fine-grained sandstone overlying an erosion surface, overlain by reddish-gray, very fine grained sandstone, grayish-red siltstone, and red silty claystone. Locally, conglomerate lenses occur at the base of cycles, which consist of subangular clay chips, nodular or concretionary carbonate fragments, small (generally less than cm in diameter) quartz pebbles, and wood fragments.

Parts of 11 major cycles are exposed here, ranging in thickness from 0 to 70 feet. Many of the cycles contain nested subcycles, which represent local inter-ruptions of the general fining-upward pattern.

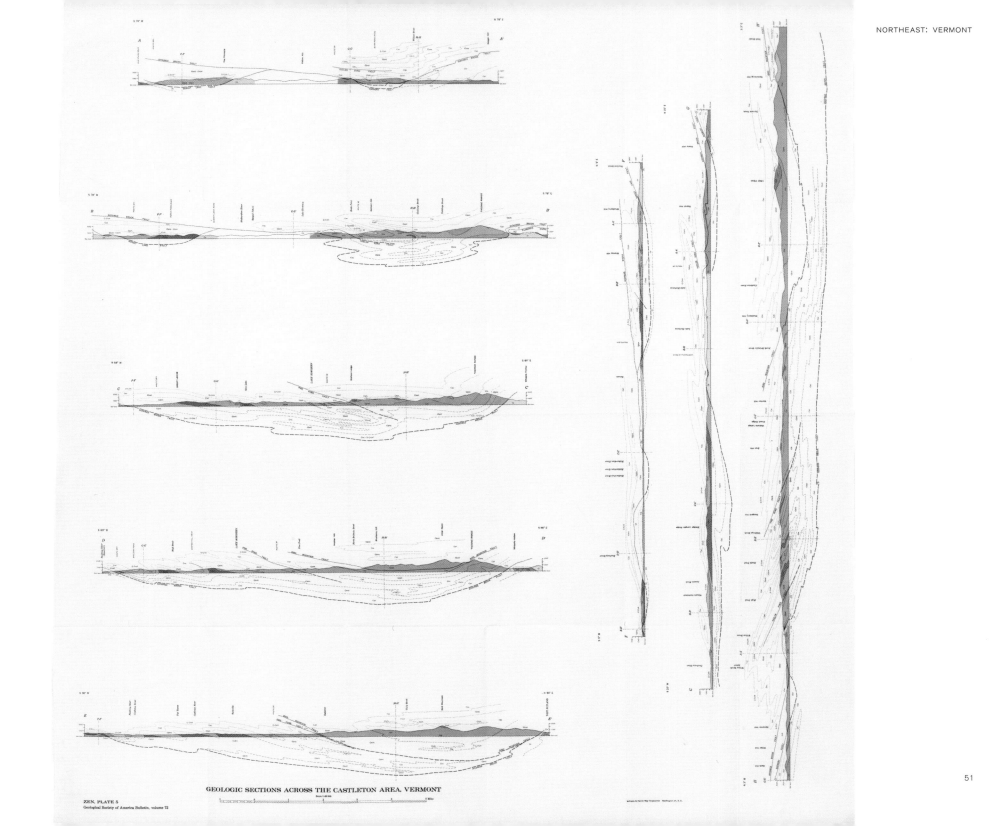

GEOLOGIC SECTIONS ACROSS THE CASTLETON AREA, VERMONT

51

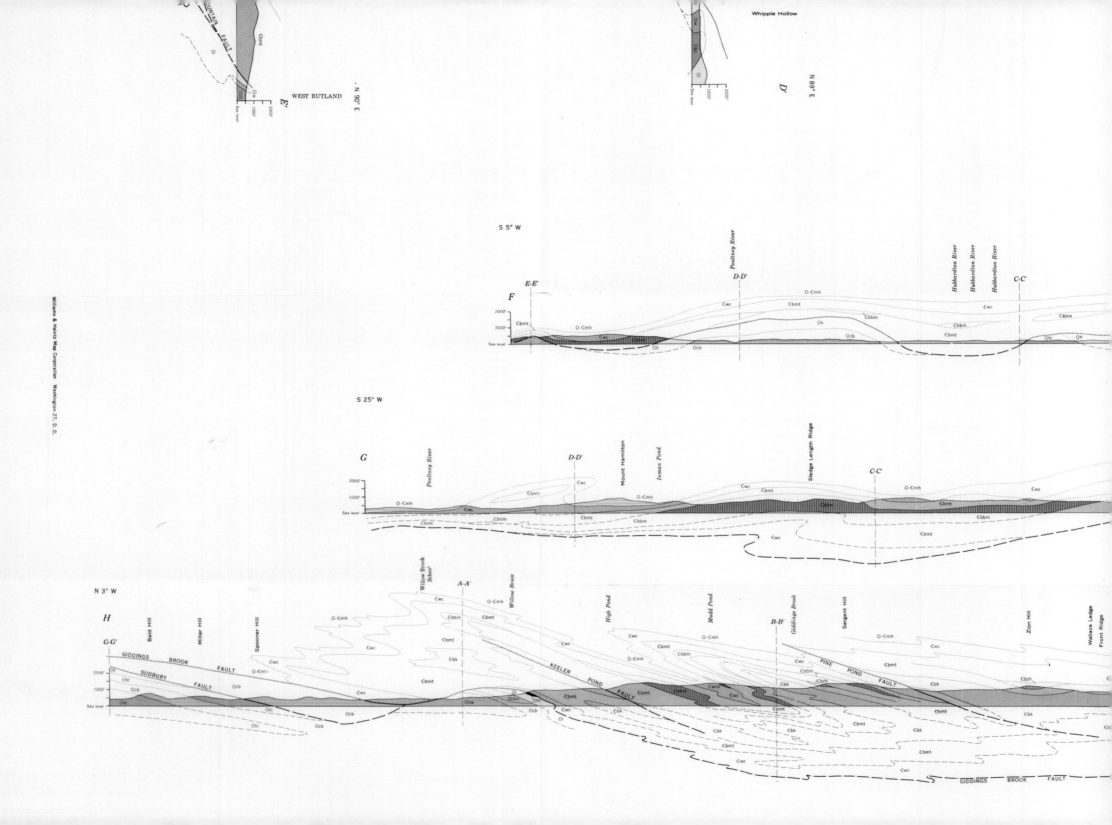

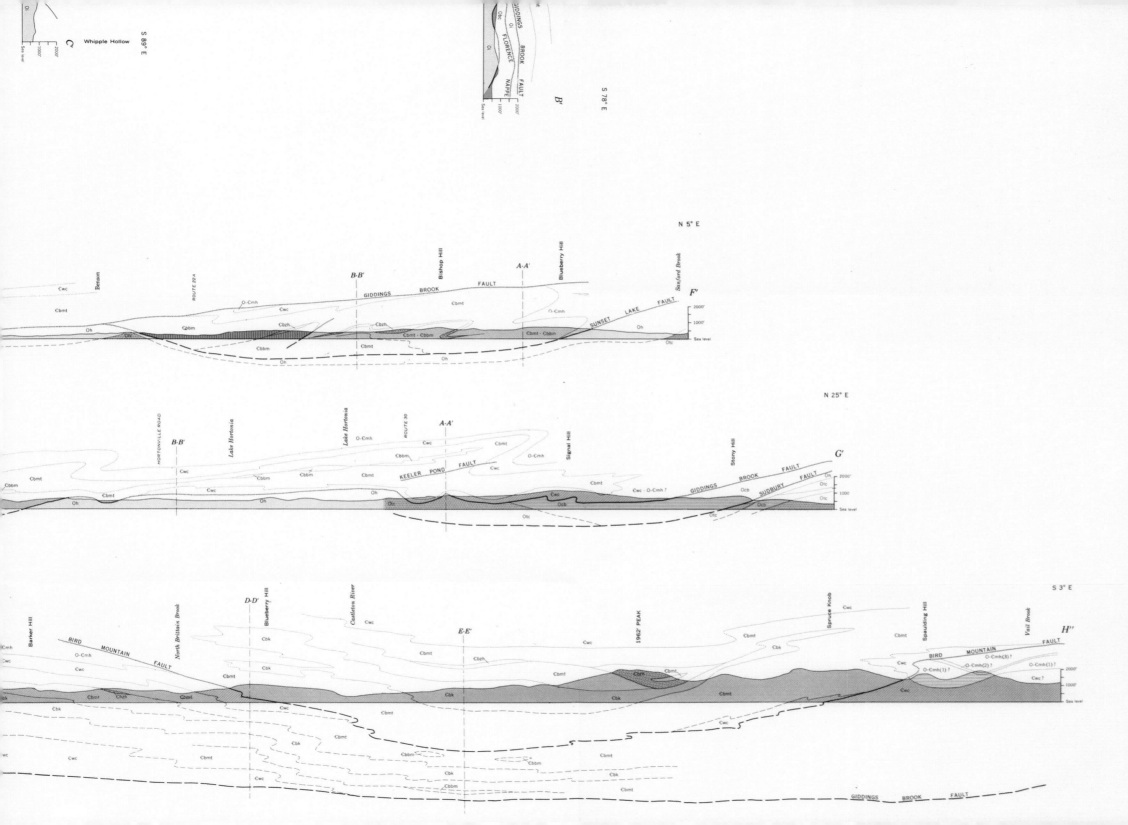

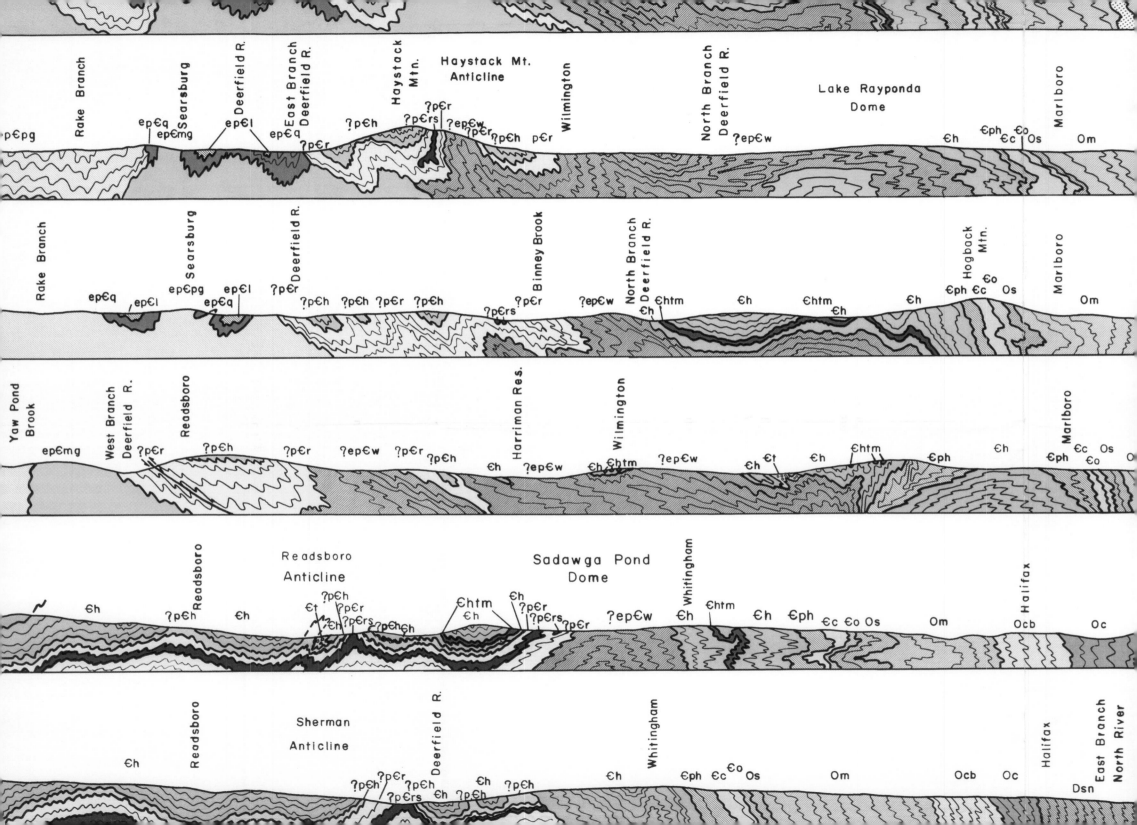

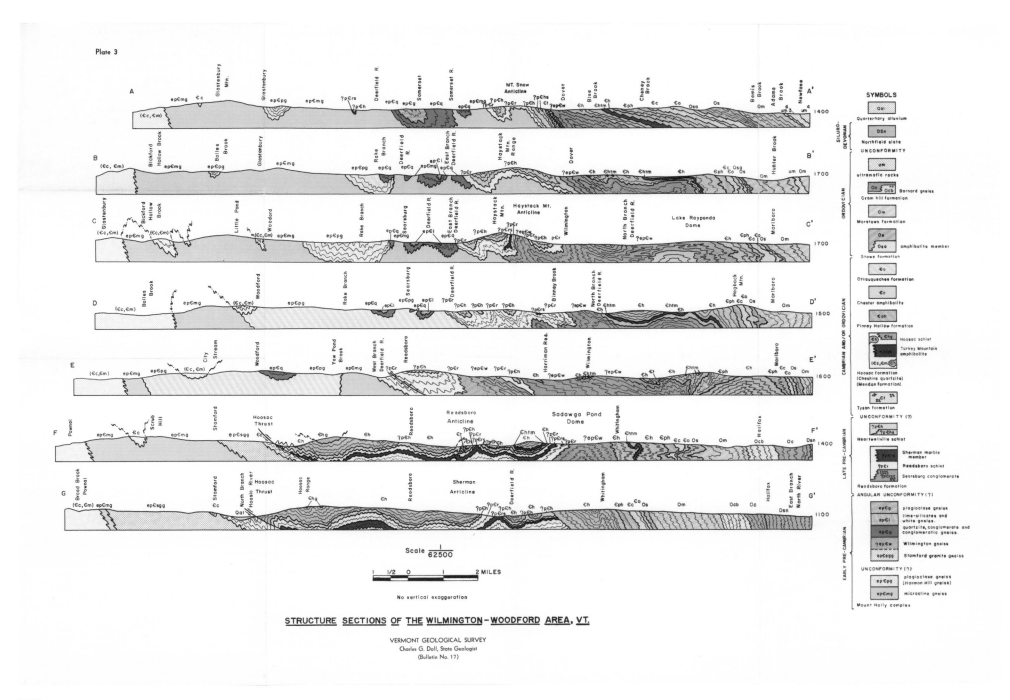

Plate 3

STRUCTURE SECTIONS OF THE WILMINGTON—WOODFORD AREA, VT.

VERMONT GEOLOGICAL SURVEY
Charles G. Doll, State Geologist
(Bulletin No. 17)

Scale $\frac{1}{62500}$

No vertical exaggeration

25 **Structure Sections of the Wilmington-Woodford Area, VT**

Vermont Geological Survey, Bulletin No. 17, Plate 3, Charles G. Doll, State Geologist;
James William Skehan, S.J., Vermont, 1961

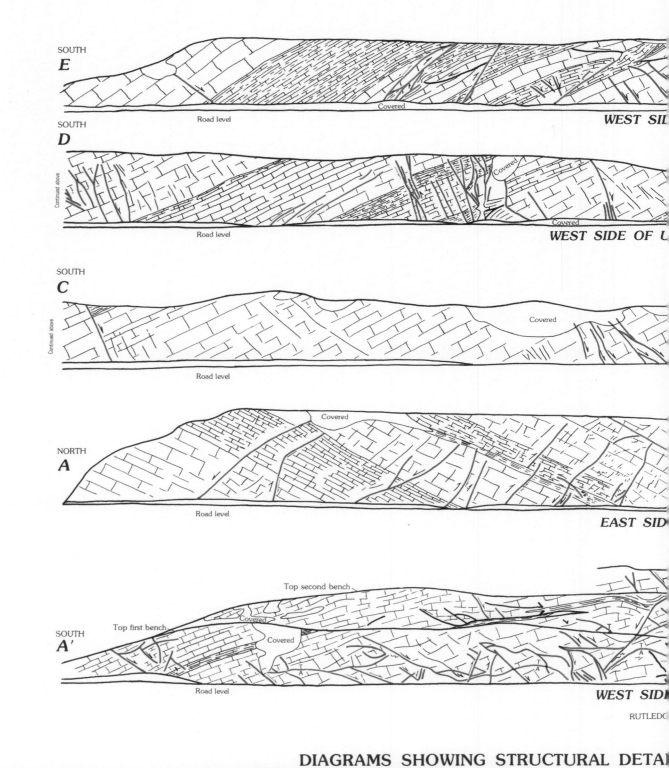

26 Diagrams Showing Structural Details
in Carbonate Rock in the Hunter Valley
Décollement Zone Near Duffield, Virginia

United States Department of the Interior Geological Survey,
Professional Paper 1018, Plate 9, Leonard D. Harris, Robert C. Milici,
Virginia, 1977

DIAGRAMS SHOWING STRUCTURAL DETAI

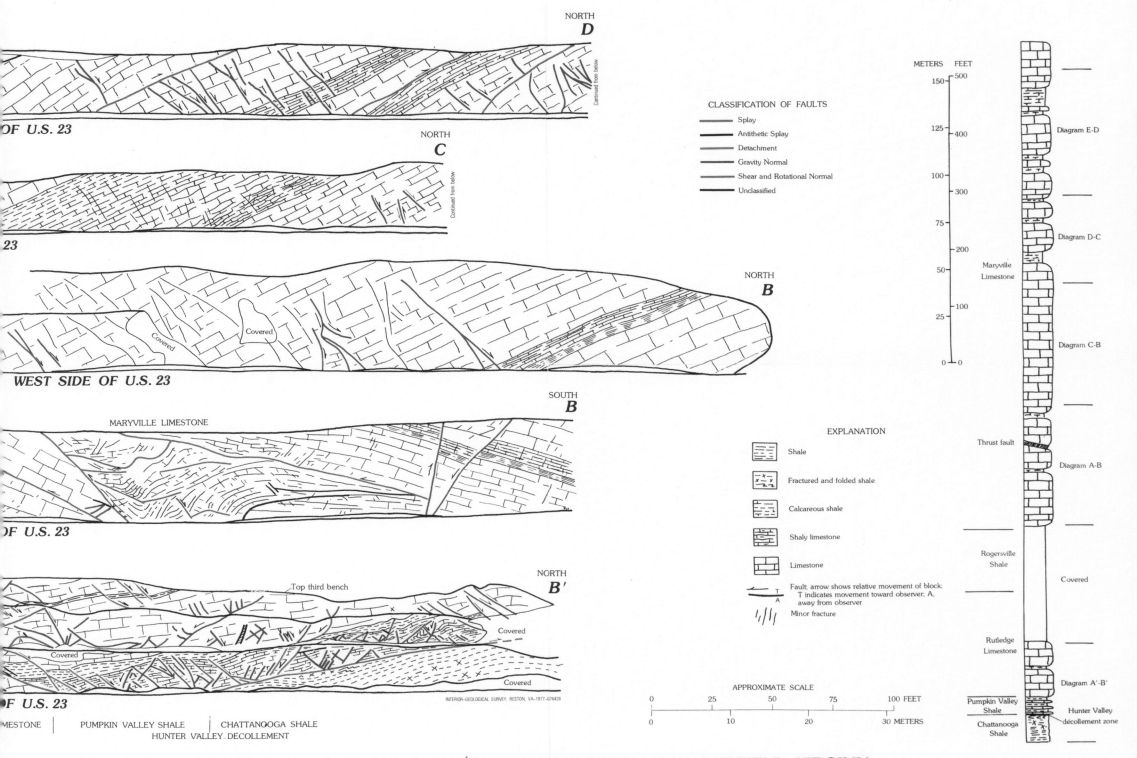

NORTH
D

Continued from below

OF U.S. 23

NORTH
C

Continued from below

23

NORTH
B

Covered

Covered

WEST SIDE OF U.S. 23

SOUTH
B

MARYVILLE LIMESTONE

OF U.S. 23

NORTH
B'

Top third bench

Covered

Covered

OF U.S. 23

MESTONE | PUMPKIN VALLEY SHALE | CHATTANOOGA SHALE
HUNTER VALLEY DÉCOLLEMENT

INTERIOR—GEOLOGICAL SURVEY, RESTON, VA—1977—G76428

CLASSIFICATION OF FAULTS

Splay
Antithetic Splay
Detachment
Gravity Normal
Shear and Rotational Normal
Unclassified

EXPLANATION

Shale

Fractured and folded shale

Calcareous shale

Shaly limestone

Limestone

Fault; arrow shows relative movement of block; T indicates movement toward observer; A, away from observer

Minor fracture

APPROXIMATE SCALE

0 25 50 75 100 FEET

0 10 20 30 METERS

METERS FEET

150 — 500

125 — 400

100 — 300

75

50 — 200

25 — 100

0 — 0

Diagram E-D

Diagram D-C

Maryville
Limestone

Diagram C-B

Thrust fault

Diagram A-B

Rogersville
Shale Covered

Rutledge
Limestone

Diagram A'-B'

Pumpkin Valley
Shale Hunter Valley
 décollement zone
Chattanooga
Shale

IN CARBONATE ROCK IN THE HUNTER VALLEY DÉCOLLEMENT ZONE NEAR DUFFIELD, VIRGINIA

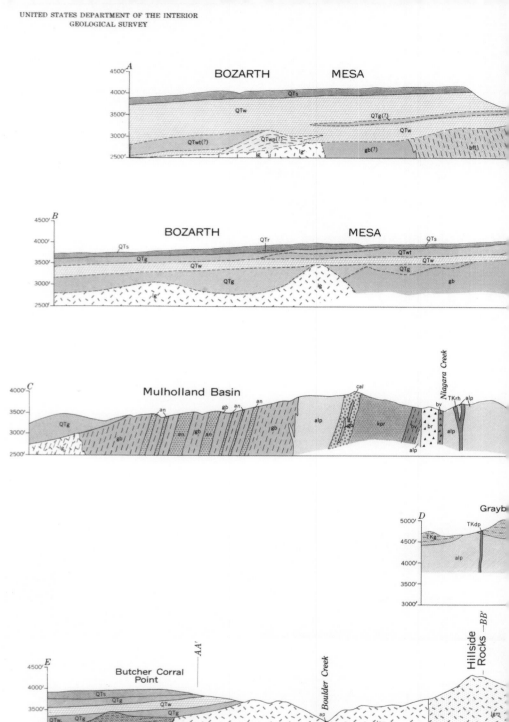

27 **Geologic Sections of the Bagdad Area, Yavapai County, Arizona**

United States Department of the Interior Geological Survey, Professional Paper 278, Plate 4,
Geology by C. A. Anderson, E. A. Scholz, and J. D. Strobell, Arizona, 1955

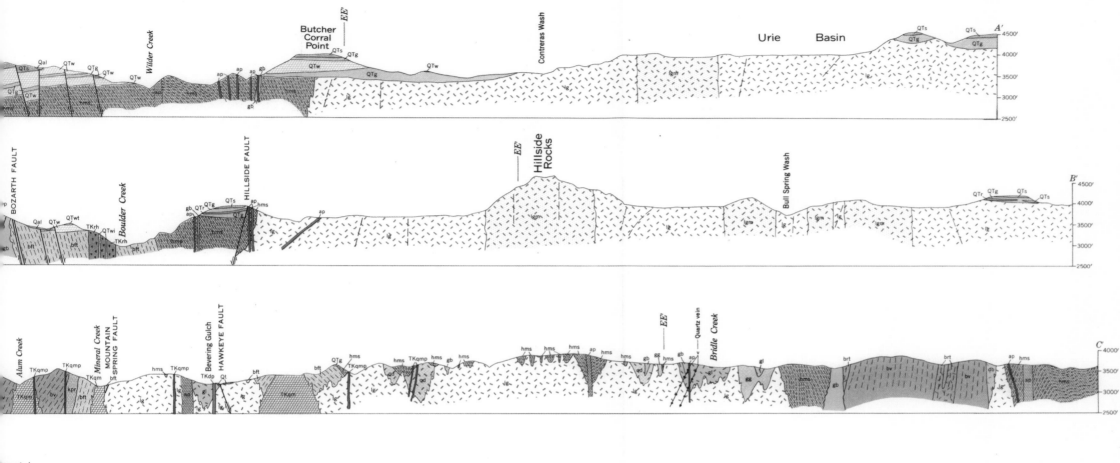

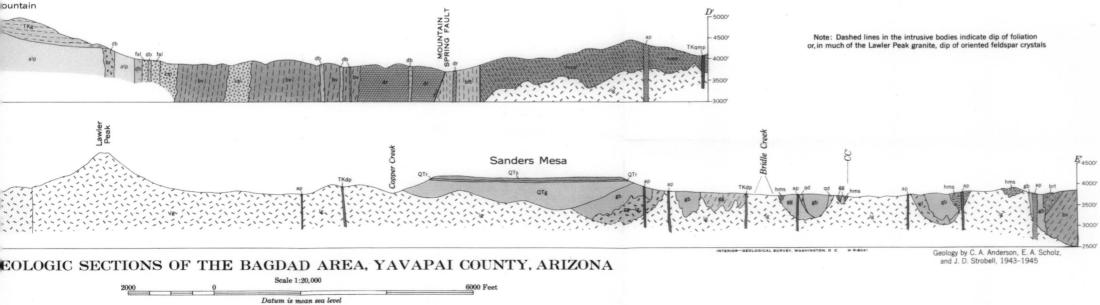

Note: Dashed lines in the intrusive bodies indicate dip of foliation or, in much of the Lawler Peak granite, dip of oriented feldspar crystals

EOLOGIC SECTIONS OF THE BAGDAD AREA, YAVAPAI COUNTY, ARIZONA

INTERIOR—GEOLOGICAL SURVEY, WASHINGTON, D. C. H R-8041

Geology by C. A. Anderson, E. A. Scholz, and J. D. Strobell, 1943-1945

Scale 1:20,000

2000 0 6000 Feet

Datum is mean sea level

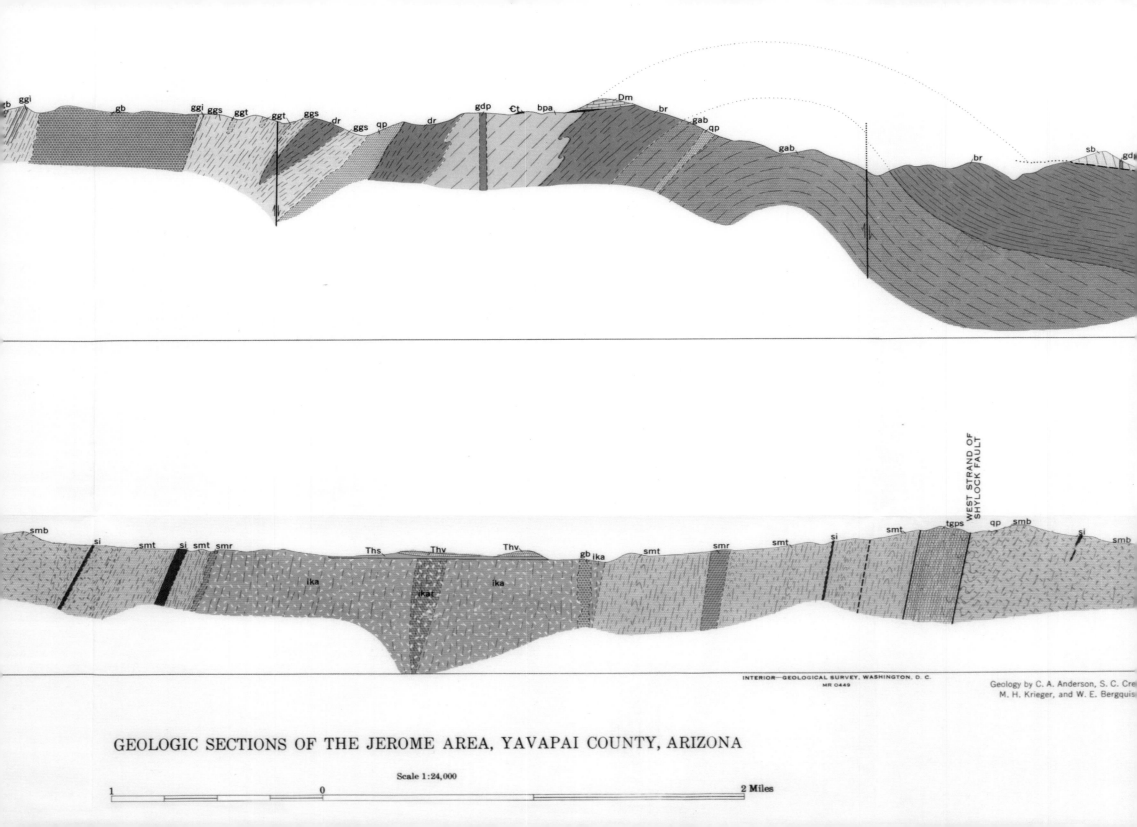

GEOLOGIC SECTIONS OF THE JEROME AREA, YAVAPAI COUNTY, ARIZONA

Scale 1:24,000

1 0 2 Miles

INTERIOR—GEOLOGICAL SURVEY, WASHINGTON, D. C.
MR 0449

Geology by C. A. Anderson, S. C. Cre
M. H. Krieger, and W. E. Bergquist

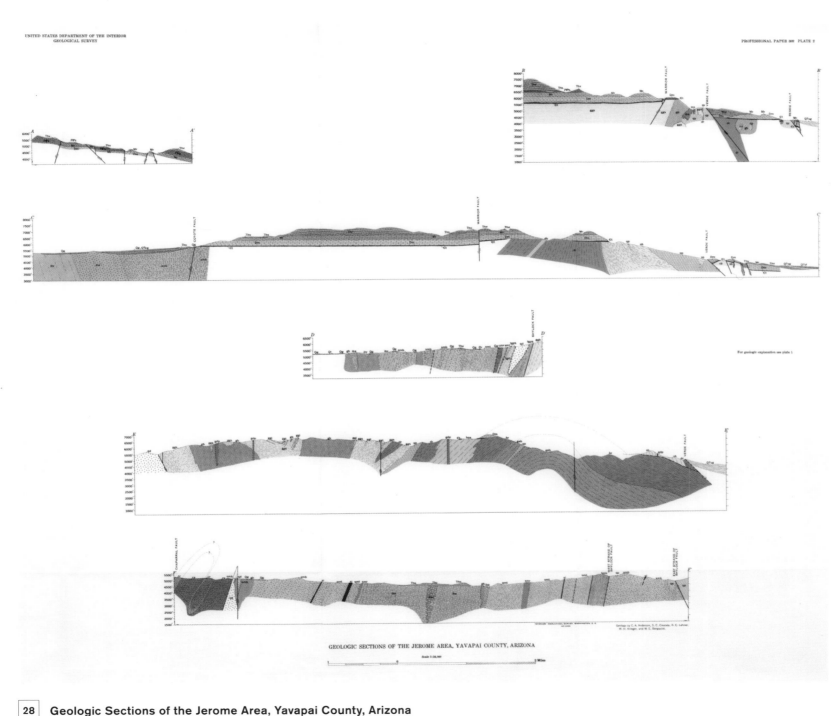

UNITED STATES DEPARTMENT OF THE INTERIOR
GEOLOGICAL SURVEY

PROFESSIONAL PAPER 308 PLATE 2

For geologic explanation see plate 1

GEOLOGIC SECTIONS OF THE JEROME AREA, YAVAPAI COUNTY, ARIZONA

Scale 1:24,000

2 Miles

Geology by C. A. Anderson, S. C. Creasey, R. E. Lehner,
M. H. Krieger, and W. E. Bergquist.

28 **Geologic Sections of the Jerome Area, Yavapai County, Arizona**

United States Department of the Interior Geological Survey, Professional Paper 308, Plate 2, Interior—Geological Survey, Washington D. C.
MR 0449, Geology by C. A. Anderson, S. C. Creasey, R. E. Lehner, M. H. Krieger, and W. E. Bergquist, Arizona, 1958

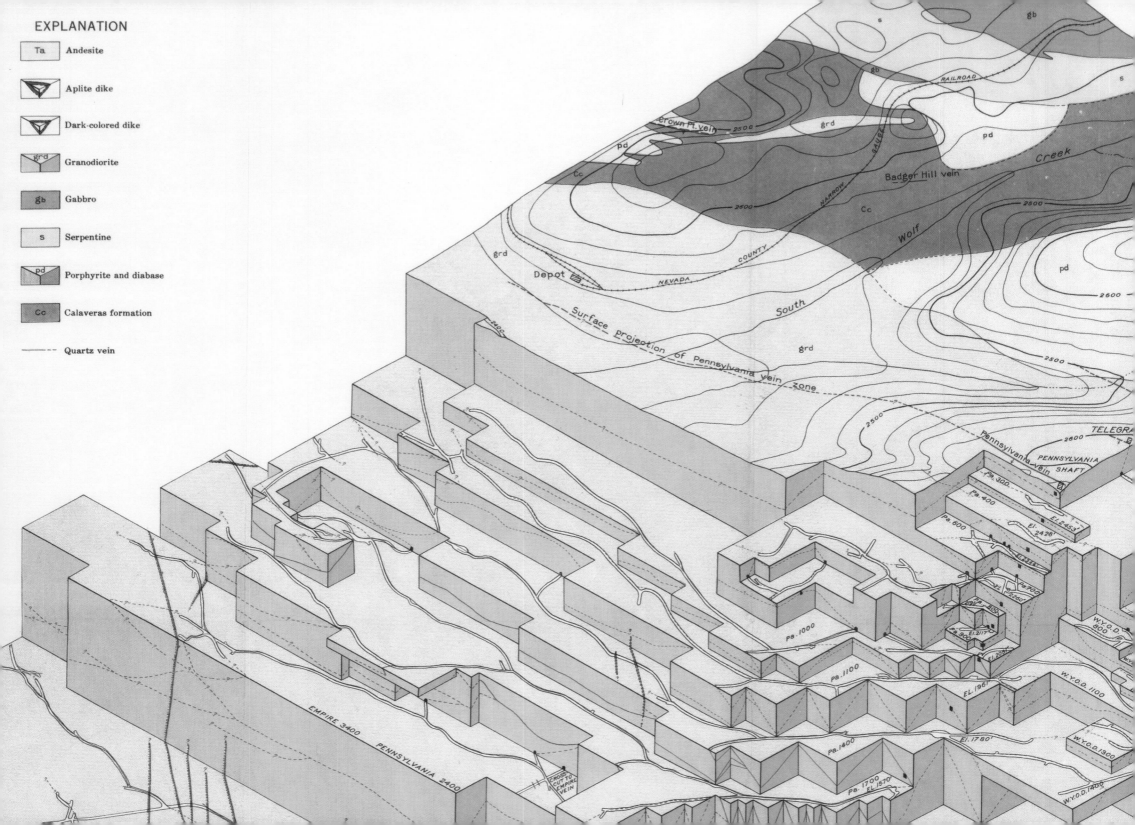

EXPLANATION

Ta	Andesite
	Aplite dike
	Dark-colored dike
grd	Granodiorite
gb	Gabbro
s	Serpentine
pd	Porphyrite and diabase
Cc	Calaveras formation
— — —	Quartz vein

Crown Pt. vein

RAILROAD

gb

s

2500

grd

pd

pd

Cc

Badger Hill vein

Creek

HARROW GAUGE

Cc

2500

Wolf

2500

grd

Depot

NEVADA

COUNTY

South

pd

2600

Surface projection of Pennsylvania vein zone

grd

2500

2400

2500

TELEGRA

2600

Pennsylvania vein

PENNSYLVANIA SHAFT

Pa. 300

Pa. 400

El. 2453'

Pa. 600

El. 2426'

Pa. 700

El. 2367

Pa. 800

El. 2260

Pa. 900 El. 2117'

Pa. 1000

W.Y.O.D. 800

El. 2021'

Pa. 1100

El. 1961'

W.Y.O.D. 1100

Pa. 1400

El. 1780'

W.Y.O.D. 1300

EMPIRE 3400

PENNSYLVANIA 2400

CROSS CUT TO EMPIRE VEIN

Pa. 1700 El. 1570'

W.Y.O.D. 1400

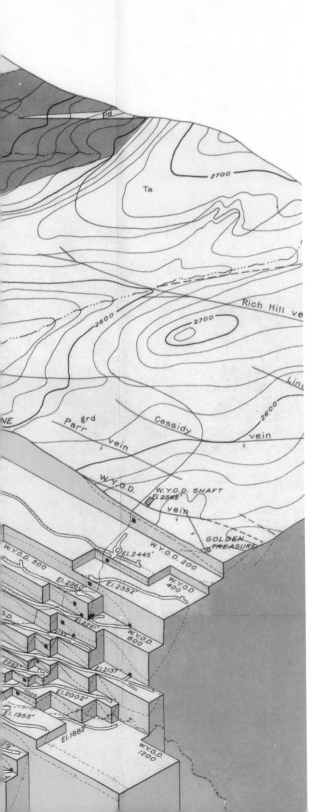

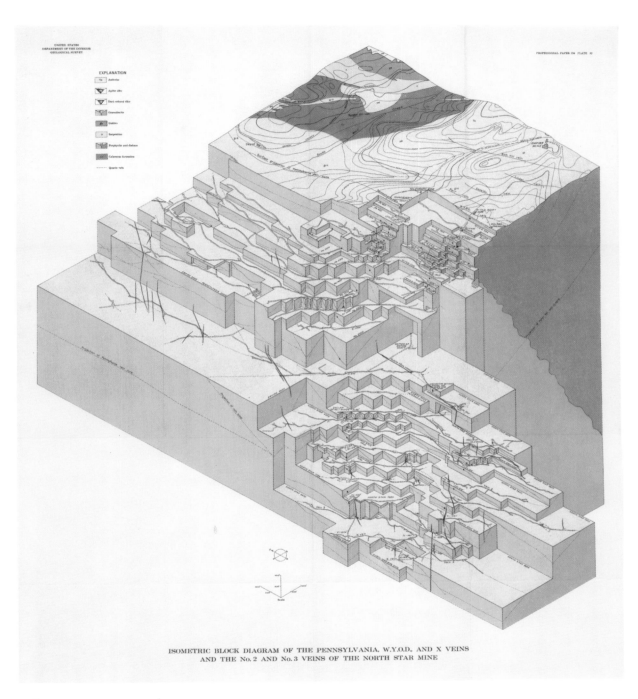

ISOMETRIC BLOCK DIAGRAM OF THE PENNSYLVANIA, W.Y.O.D., AND X VEINS
AND THE No. 2 AND No. 3 VEINS OF THE NORTH STAR MINE

29 | **Isometric Block Diagram of the Pennsylvania, W.Y.O.D., and X Veins
and the No. 2 and No. 3 Veins of the North Star Mine**

United States Department of the Interior Geological Survey, Professional Paper 194, Plate 32, California, 1938

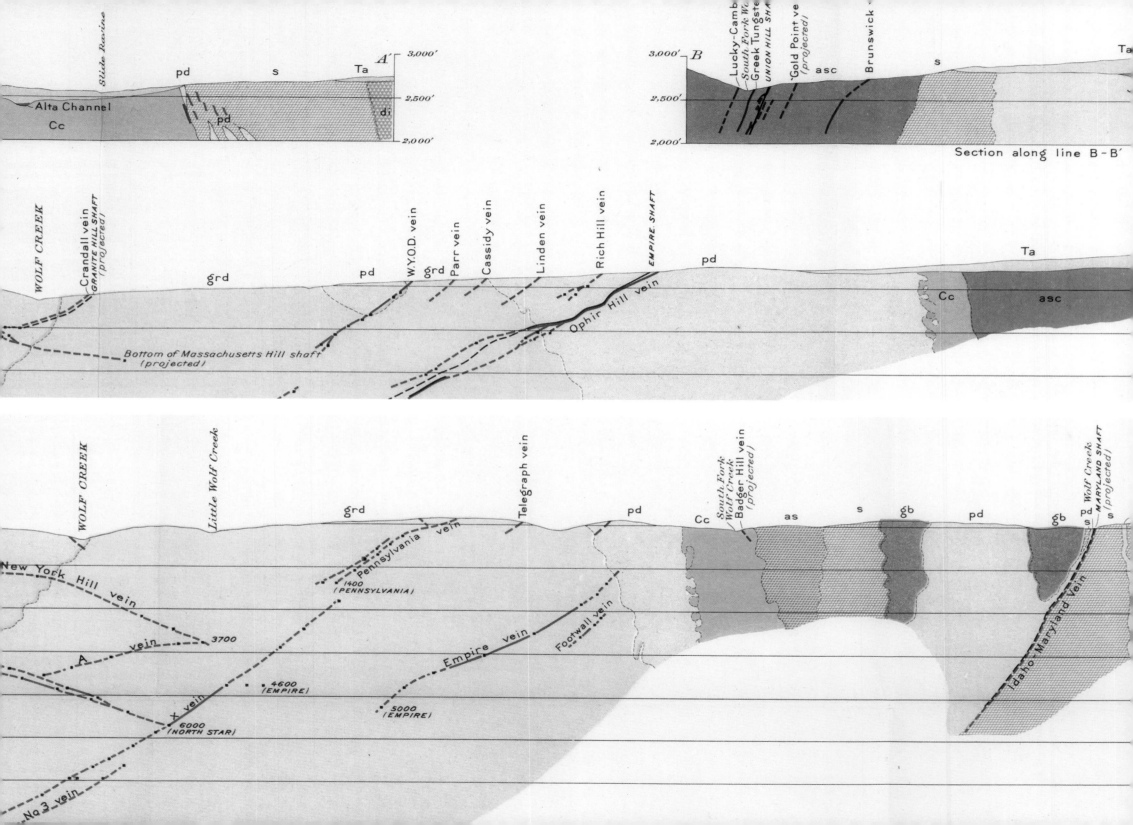

Section along line B–B'

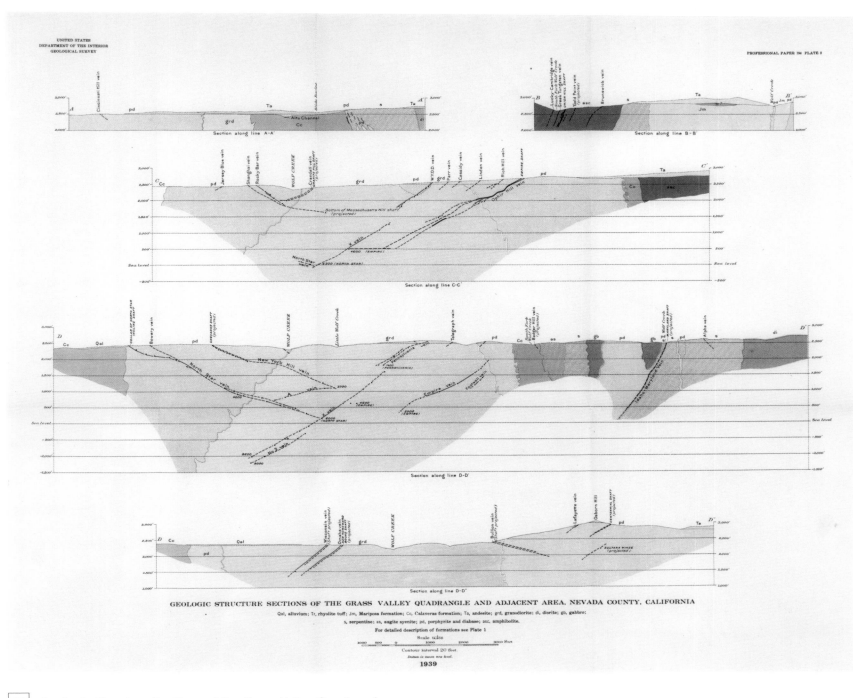

UNITED STATES
DEPARTMENT OF THE INTERIOR
GEOLOGICAL SURVEY

PROFESSIONAL PAPER 194 PLATE 2

GEOLOGIC STRUCTURE SECTIONS OF THE GRASS VALLEY QUADRANGLE AND ADJACENT AREA, NEVADA COUNTY, CALIFORNIA

Qal, alluvium; Tr, rhyolite tuff; Jm, Mariposa formation; Cc, Calaveras formation; Ta, andesite; grd, granodiorite; di, diorite; gb, gabbro;

s, serpentine; xs, augite syenite; pd, porphyrite and diabase; asc, amphibolite.

For detailed description of formations see Plate 1

Scale 16,800

1000 500 0 1000 2000 3000 Feet

Contour interval 20 feet.

Datum is mean sea level.

1939

30 **Geologic Structure Sections of the Grass Valley Quadrangle and Adjacent Area, Nevada County, California**

United States Department of the Interior Geological Survey, Professional Paper 194, Plate 2, California, 1939

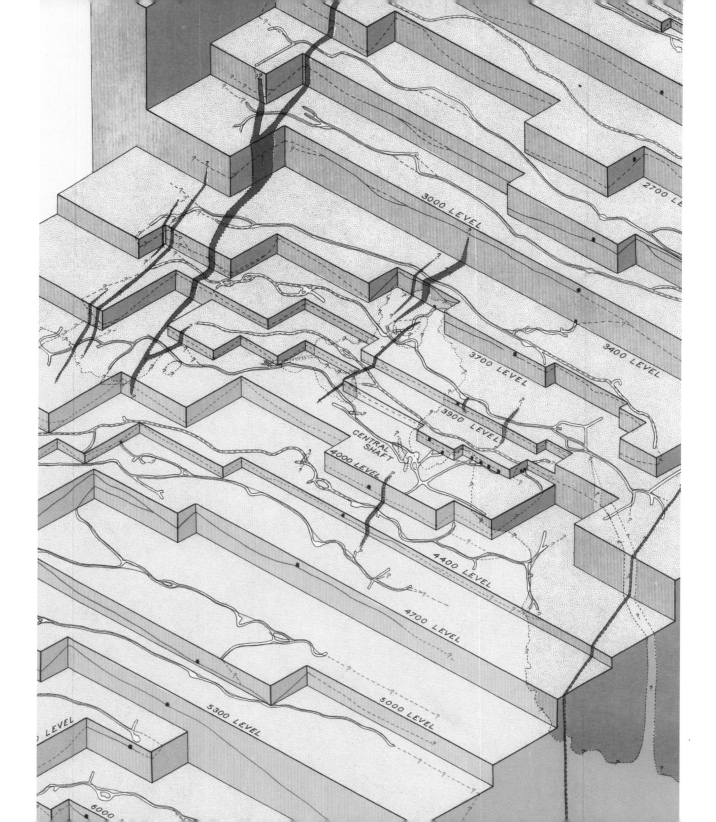

2700 LE

3000 LEVEL

3400 LEVEL

3700 LEVEL

3900 LEVEL

CENTRAL SHAFT

4000 LEVEL

4400 LEVEL

4700 LEVEL

5000 LEVEL

5300 LEVEL

LEVEL

6000

31 **Isometric Block Diagram of the North Star Vein of the North Star Mine in 1931**

United States Department of the Interior Geological Survey, Professional Paper 194, Plate 27, California, 1940

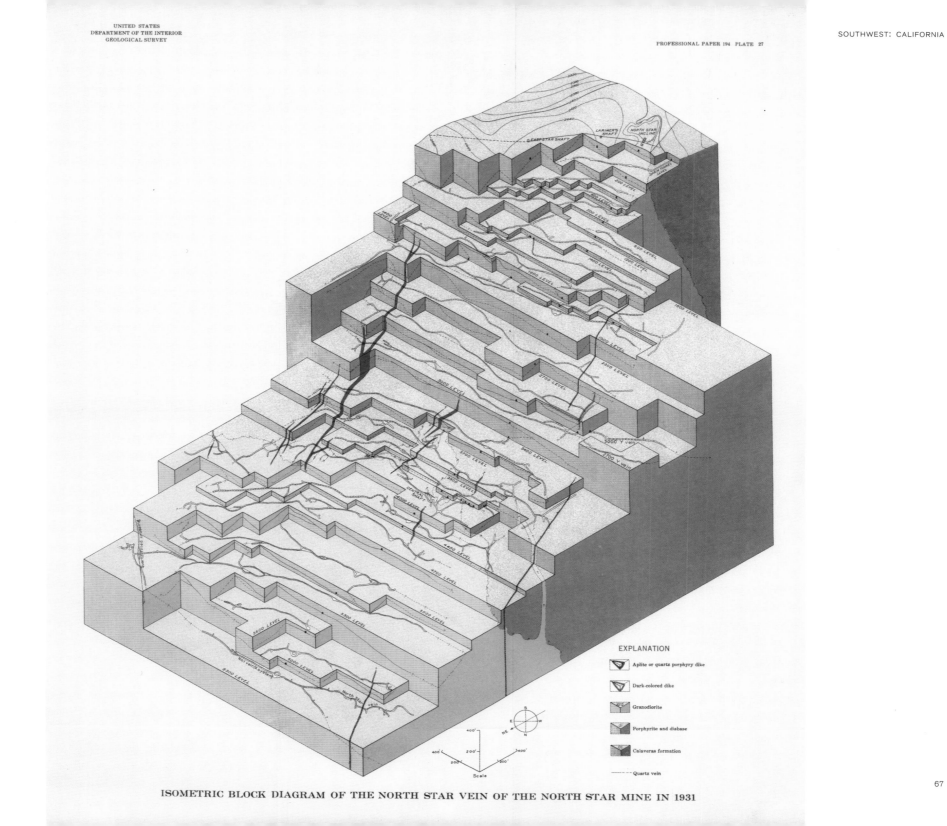

EXPLANATION

Aplite or quartz porphyry dike

Dark-colored dike

Granodiorite

Porphyrite and diabase

Calaveras formation

— — — Quartz vein

Scale

ISOMETRIC BLOCK DIAGRAM OF THE NORTH STAR VEIN OF THE NORTH STAR MINE IN 1931

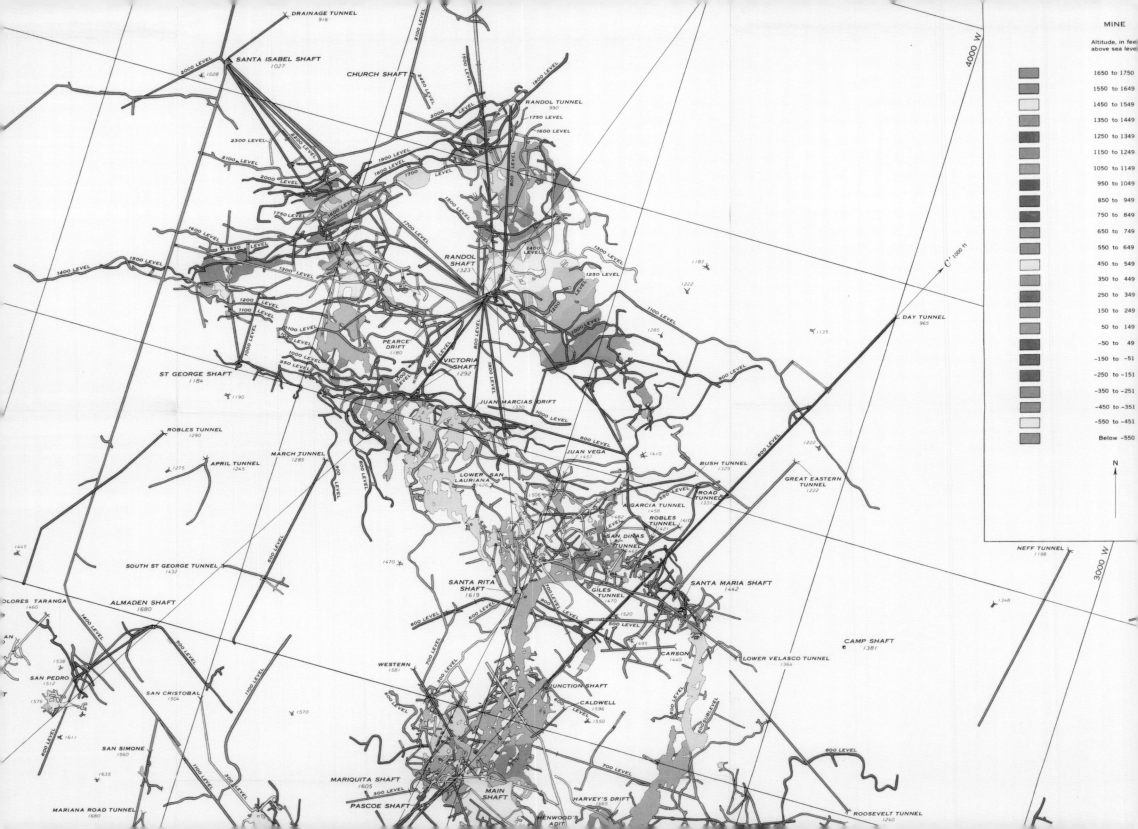

MINE

DRAINAGE TUNNEL
916

SANTA ISABEL SHAFT
1027

2000 LEVEL 1028

CHURCH SHAFT

RANDOL TUNNEL
990

1750 LEVEL

1600 LEVEL

2300 LEVEL

2300 LEVEL

2100 LEVEL

1900 LEVEL

2000 LEVEL

1800 LEVEL 1700 LEVEL

1600 LEVEL

1500 LEVEL 1550 LEVEL

1400 LEVEL 1500 LEVEL

1500 LEVEL

1900 LEVEL

1700 LEVEL

RANDOL
SHAFT
1323

1400
LEVEL

1300 LEVEL

1250 LEVEL

1183

1222

1300 LEVEL

1200 LEVEL

1100 LEVEL

1100 LEVEL

1100 LEVEL

1000 LEVEL

1000 LEVEL

1000 LEVEL

950 LEVEL

1000 LEVEL

PEARCE
DRIFT
1180

1200 LEVEL

1100 LEVEL

1000 LEVEL

C' 1000 ft

DAY TUNNEL
965

1285

1135

VICTORIA
SHAFT
1292

900 LEVEL

ST GEORGE SHAFT
1184

1190

JUAN MARCIAS DRIFT
1330

1000 LEVEL

800 LEVEL

900 LEVEL

ROBLES TUNNEL
1290

MARCH TUNNEL
1285

JUAN VEGA
1457

1410

BUSH TUNNEL
1329

1222

1275

APRIL TUNNEL
1245

LOWER SAN
LAURIANA
1426

550 LEVEL

GREAT EASTERN
TUNNEL
1222

ROAD
TUNNEL
1331

1506

GARCIA TUNNEL
1458

ROBLES
TUNNEL
1421

1410

1445

1482
LEVEL

500

SAN DINAS
TUNNEL

N

SOUTH ST GEORGE TUNNEL
1432

500 LEVEL

1470

NEFF TUNNEL
1198

SANTA RITA
SHAFT
1619

800 LEVEL

700 LEVEL

GILES
TUNNEL
1470

SANTA MARIA SHAFT
1442

DOLORES TARANGA
1460

ALMADEN SHAFT
1680

1348

600 LEVEL

1520

CAMP SHAFT
1381

1400 LEVEL

800 LEVEL

1495

CARSON
1440

LOWER VELASCO TUNNEL
1364

1538

WESTERN
1581

500 LEVEL

SAN PEDRO
1512

300 LEVEL

SAN CRISTOBAL
1504

700 LEVEL

JUNCTION SHAFT

CALDWELL
1596

1576

1570

600 LEVEL

1550

600 LEVEL

SUBLEVEL

600 LEVEL

1611

600 LEVEL

SAN SIMONE
1560

1100 LEVEL

300 LEVEL

1635

800 LEVEL

MARIQUITA SHAFT
1605

300 LEVEL

700 LEVEL

MARIANA ROAD TUNNEL
1680

PASCOE SHAFT

MAIN
SHAFT

HARVEY'S DRIFT
1465

ROOSEVELT TUNNEL

HENWOOD'S
ADIT
1240

3000 W

4000 W

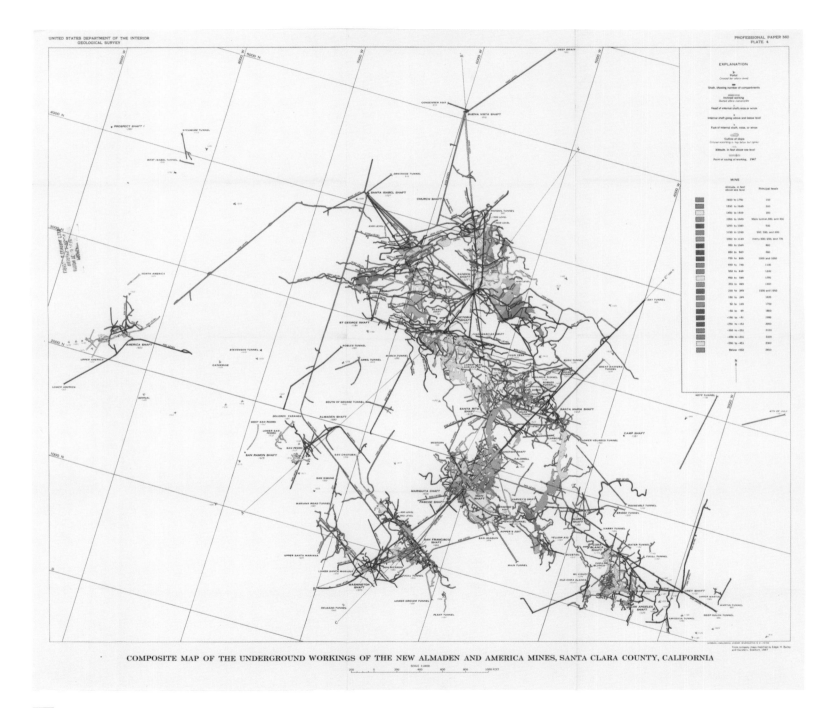

COMPOSITE MAP OF THE UNDERGROUND WORKINGS OF THE NEW ALMADEN AND AMERICA MINES, SANTA CLARA COUNTY, CALIFORNIA

32 **Composite Map of the Underground Workings of the New Almaden and America Mines, Santa Clara County, California**

United States Department of the Interior Geological Survey, *Geology and Quicksilver Deposits of the New Almaden District, Santa Clara County California*, Professional Paper 360, Plate 4, Edgar H. Bailey and Donald L. Everhart, California, 1964

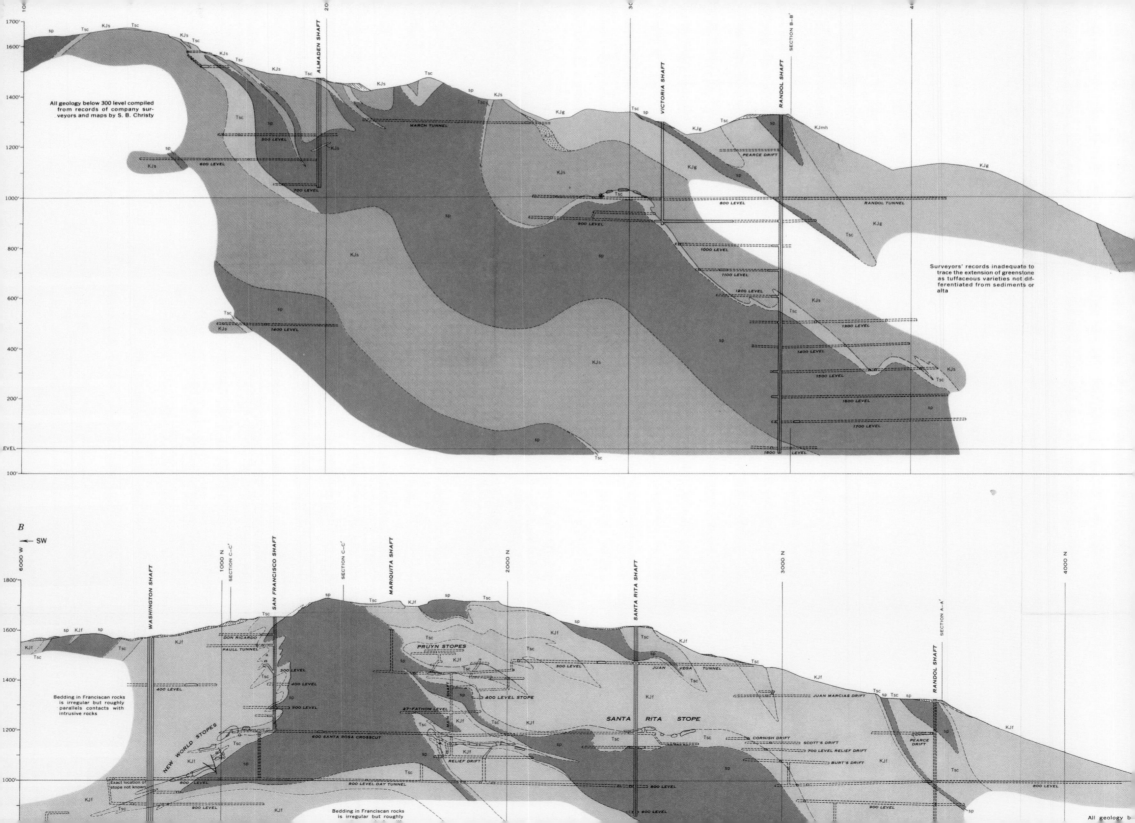

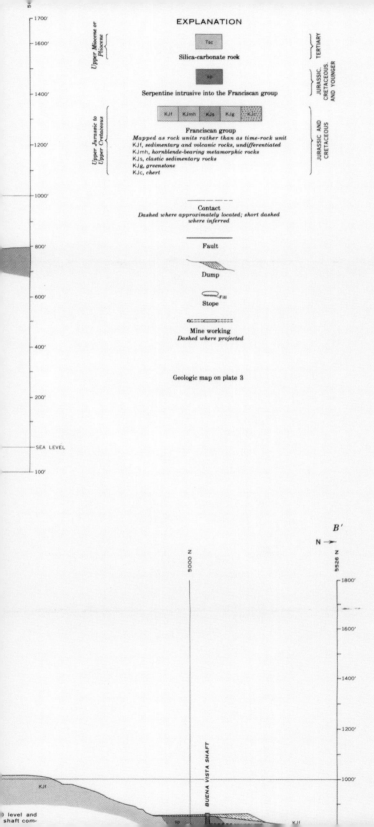

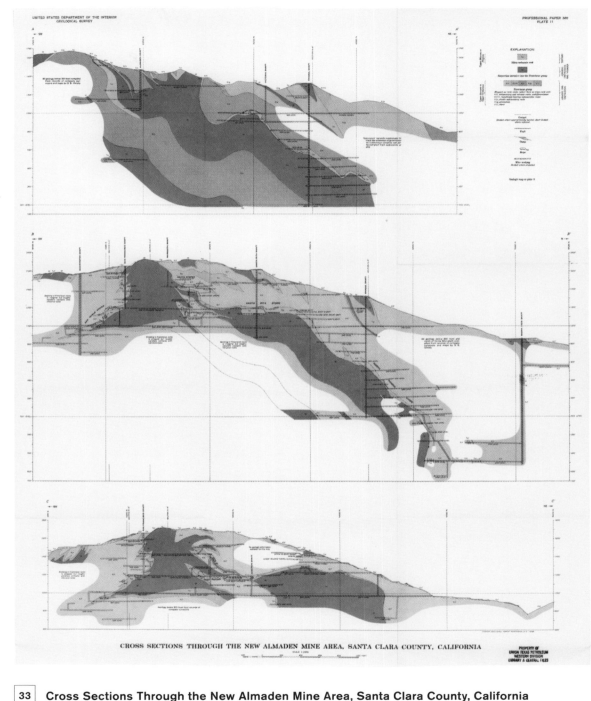

CROSS SECTIONS THROUGH THE NEW ALMADEN MINE AREA, SANTA CLARA COUNTY, CALIFORNIA

33 | **Cross Sections Through the New Almaden Mine Area, Santa Clara County, California**

United States Department of the Interior Geological Survey, *Geology and Quicksilver Deposits of the New Almaden District,*
Santa Clara County California, Professional Paper 360, Plate 11, California, 1964

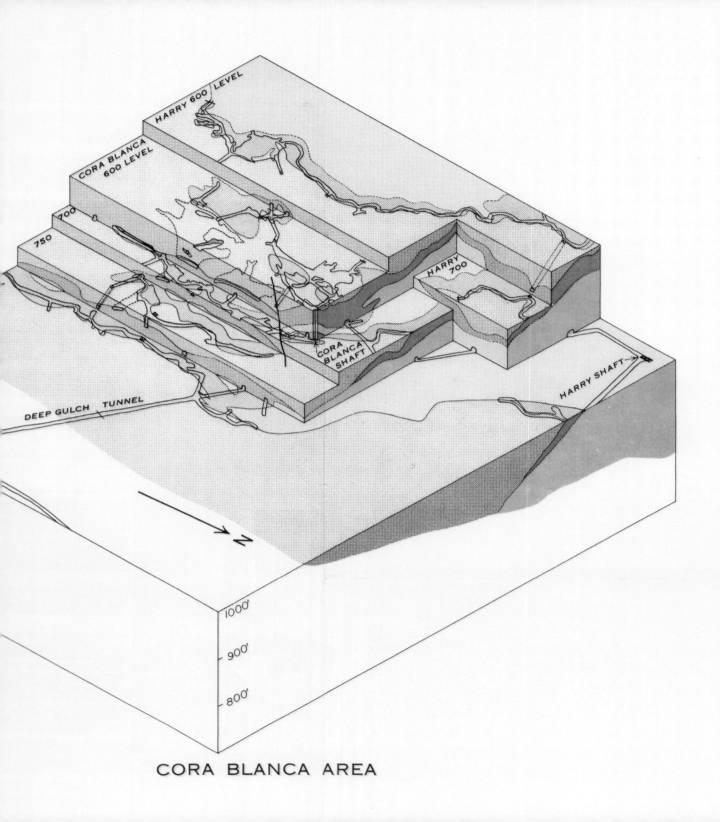

CORA BLANCA AREA

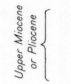

EXPLANATION

Silica-carbonate rock

Serpentine

Rocks of the Franciscan group

Contact
*Dashed where approximately
located; dotted where pro-
jected*

Fault

Shaft, showing number of
compartments

Mine working
Dotted where concealed

Point of inaccessibility
of working

CORA BLANCA AREA

HARRY AREA

SAN FRANCISCO AREA

GEOLOGIC SECTION THROUGH THE HARRY AREA AND BLOCK DIAGRAMS OF CORA BLANCA AND SAN FRANCISCO AREAS
OF THE NEW ALMADEN MINE, SANTA CLARA COUNTY, CALIFORNIA

Geology and workings by U. S. Geological Survey.
Geology and workings below 800 level are inaccessible
and are from records of company surveyors

34 Geological Section Through the Harry Area and Block Diagrams of Cora Blanca
and San Francisco Areas of the New Almaden Mine, Santa Clara County, California

United States Department of the Interior Geological Survey, *Geology and Quicksilver Deposits of the New Almaden District,
Santa Clara County California*, Professional Paper 360, Plate 12, California, 1964

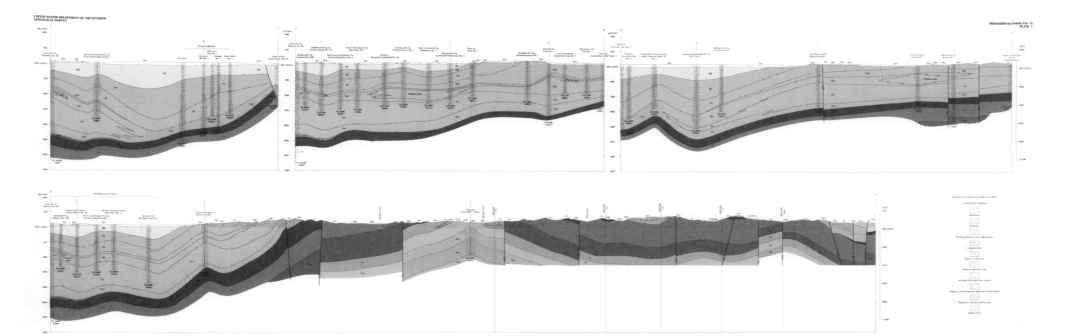

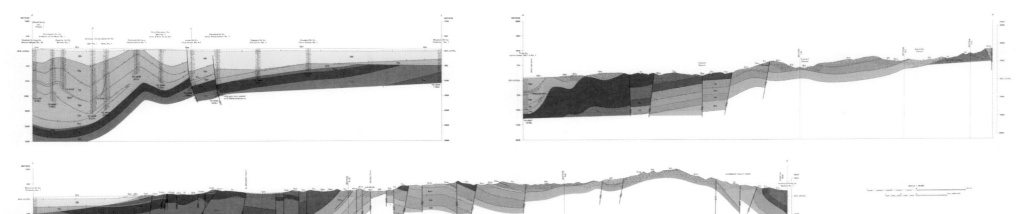

STRUCTURE SECTIONS *A–C, A–H, B–N, A–K, E–L, H–O, L–Q,*
NORTHERN SANTA ANA MOUNTAINS, CALIFORNIA

35 **Structure Sections *A-C, A-H, B-N, A-K, E-L, H-O, L-Q,***
Northern Santa Ana Mountains, California

United States Department of the Interior Geological Survey, *Geology of the Northern Santa Ana Mountains,*
Professional Paper 420-D, Plate 2, Interior-Geological Survey, Reston, VA, G79378, California, 1981

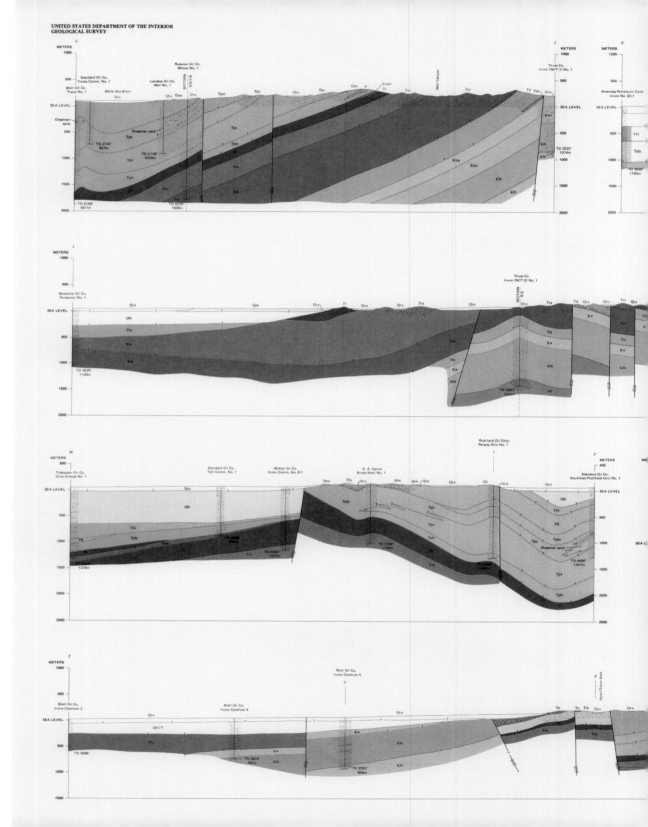

36 Structure Sections *G-J*, *R-S*, *L-P*, *U-W*, *M-F*, *U-V*, *T-X*, Northern Santa Ana Mountains, California

United States Department of the Interior Geological Survey, *Geology of the Northern Santa Ana Mountains*, Professional Paper 420-D, Plate 3, Interior-Geological Survey, Reston, VA, G79378, California, 1981

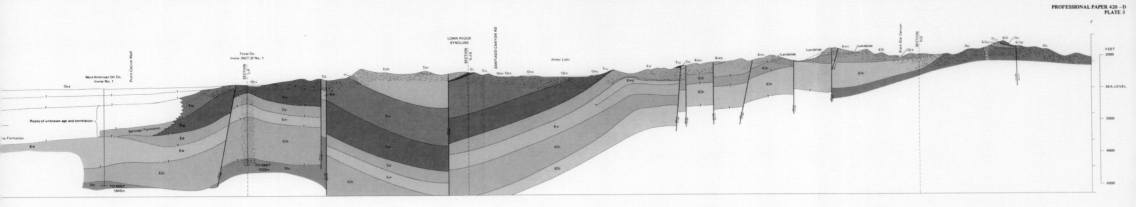

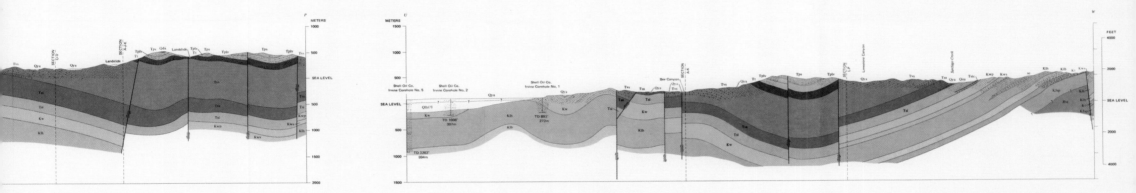

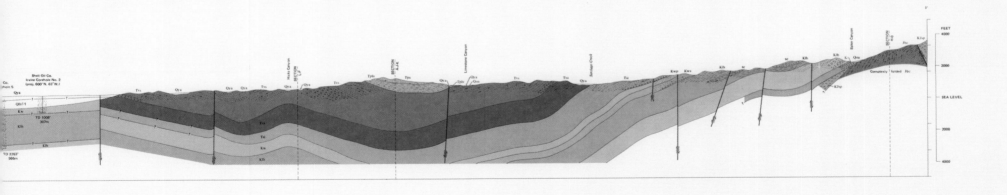

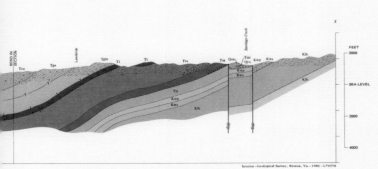

SCALE 1:24,000

STRUCTURE SECTIONS *G–J*, *R–S*, *L–P*, *U–W*, *M–F*, *U–V*, *T–X*,
NORTHERN SANTA ANA MOUNTAINS, CALIFORNIA

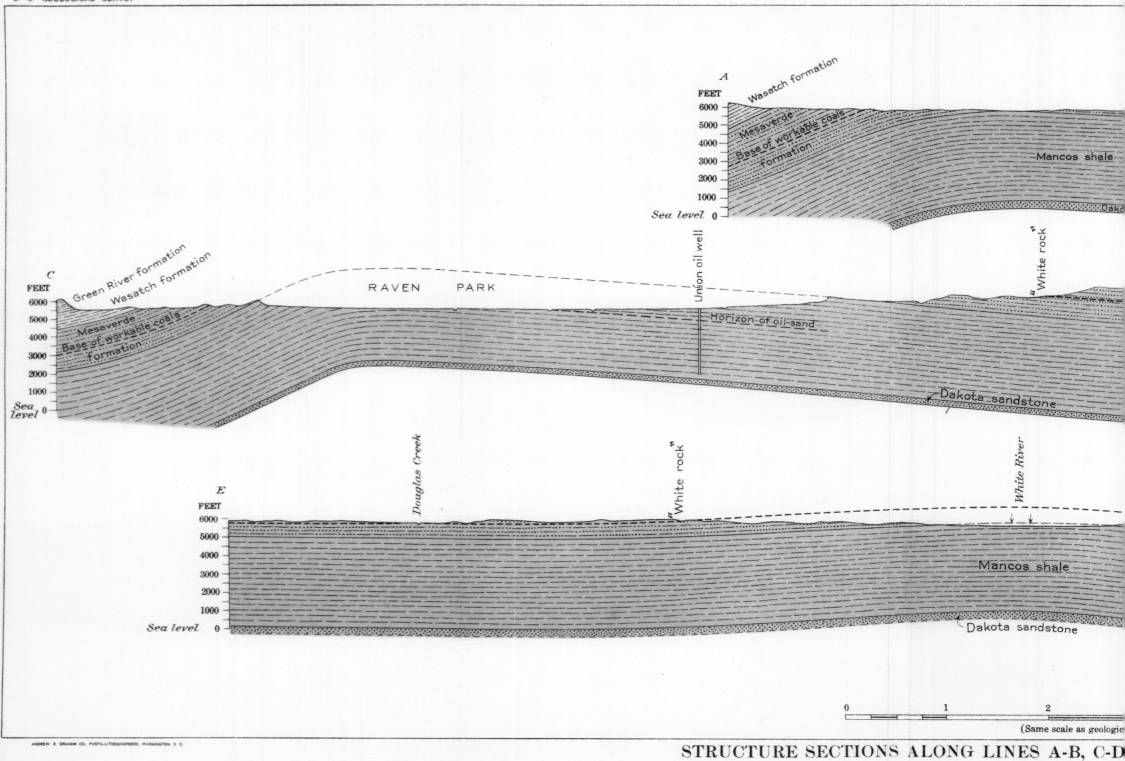

STRUCTURE SECTIONS ALONG LINES A-B, C-D

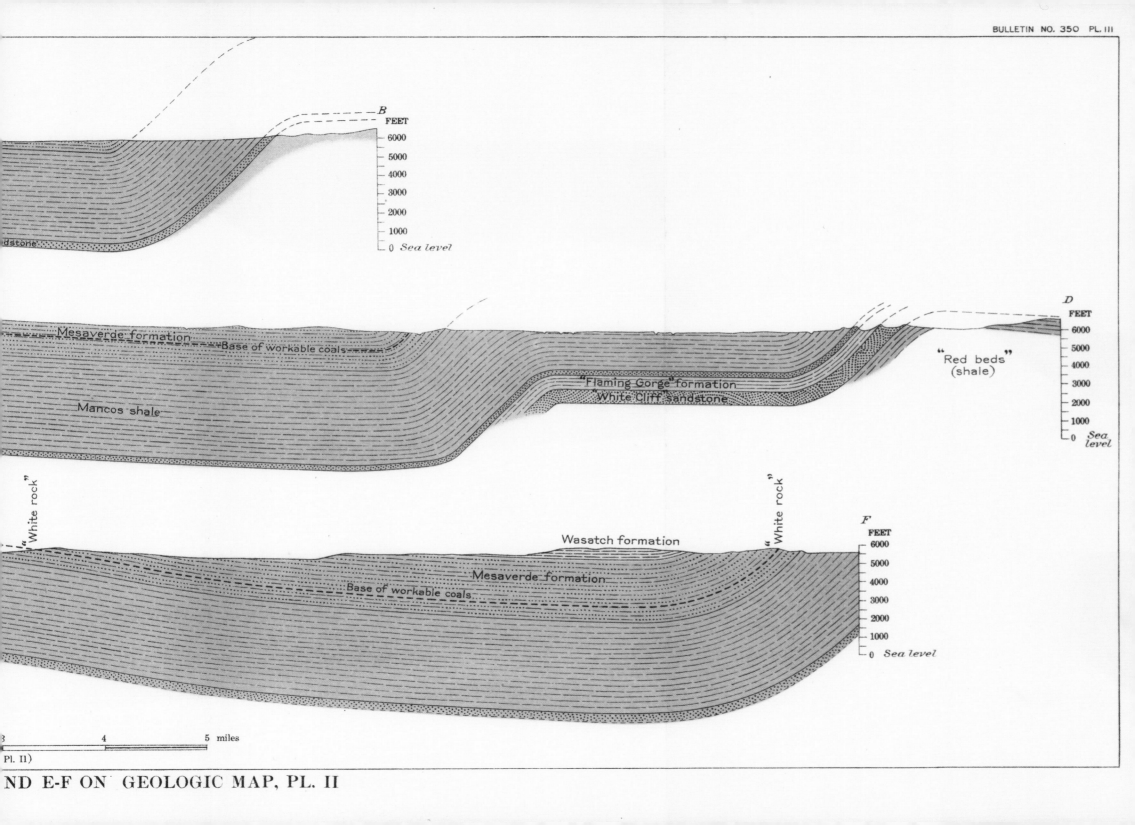

B

FEET

6000
5000
4000
3000
2000
1000
0 *Sea level*

dstone

Mesaverde formation
Base of workable coals

D

FEET

6000
5000
4000
3000
2000
1000
0 *Sea level*

"Red beds"
(shale)

"Flaming Gorge" formation
White Cliff sandstone

Mancos shale

"White rock"

"White rock"

F

FEET

Wasatch formation

6000
5000

Mesaverde formation

4000

Base of workable coals

3000
2000
1000
0 *Sea level*

3 4 5 miles

PL. II)

ND E-F ON GEOLOGIC MAP, PL. II

U. S. Geological Survey, Bulletin No. 350, PL. III, California, publication date unknown

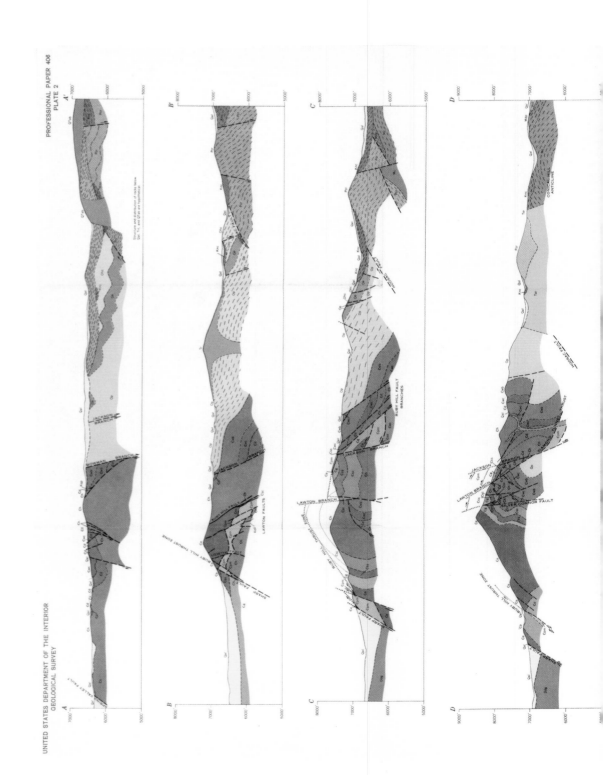

PROFESSIONAL PAPER 406
PLATE 2

UNITED STATES DEPARTMENT OF THE INTERIOR
GEOLOGICAL SURVEY

38 Geologic Sections of the Eureka Mining District, Nevada

United States Department of the Interior Geological Survey, Professional Paper 406 Plate 2, Geology T. B. Nolan, Alan Broderick, J. V. Dorr 2d, D. T. Griggs, and J. S. Shelton, 1932–46, Nevada, publication date unknown

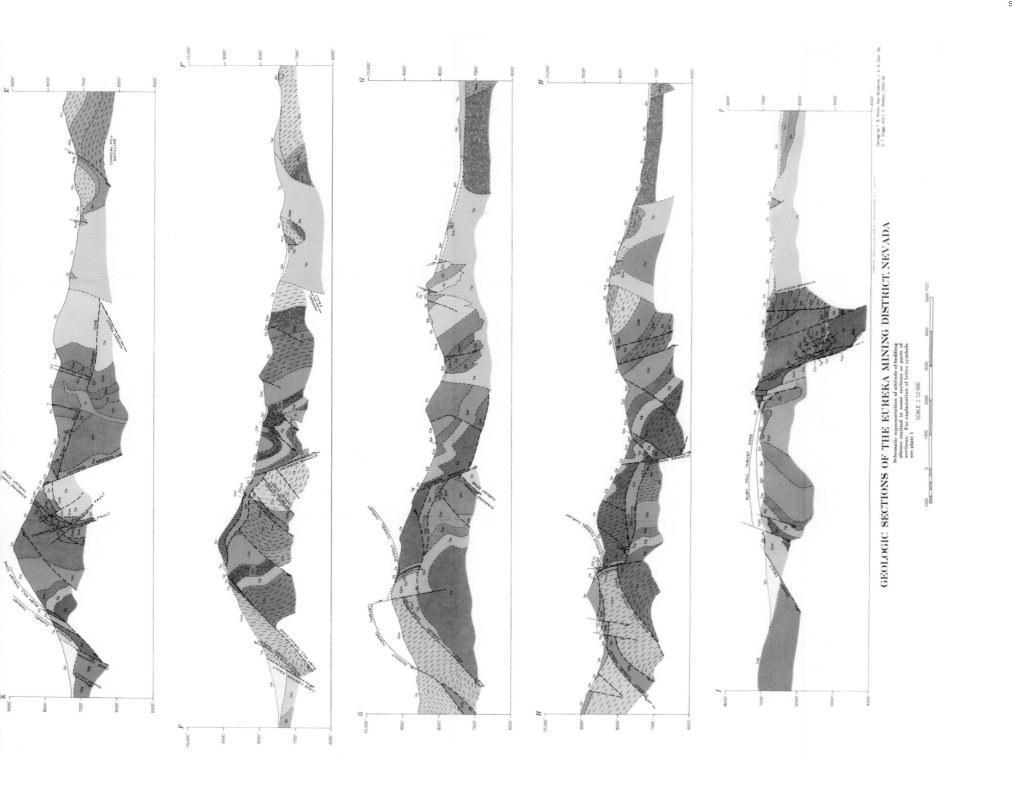

GEOLOGIC SECTIONS OF THE EUREKA MINING DISTRICT, NEVADA

Schematic representation of attitude of bedding
planes omitted in some sections or parts of
sections. For explanation of letter symbols
see plate 1

SCALE 1:12,000

Geology by T. B. Nolan, Alan Brothers, J. V. N. Dorr 2d,
O. T. Griggs, and J. S. Shelton, 1932-46

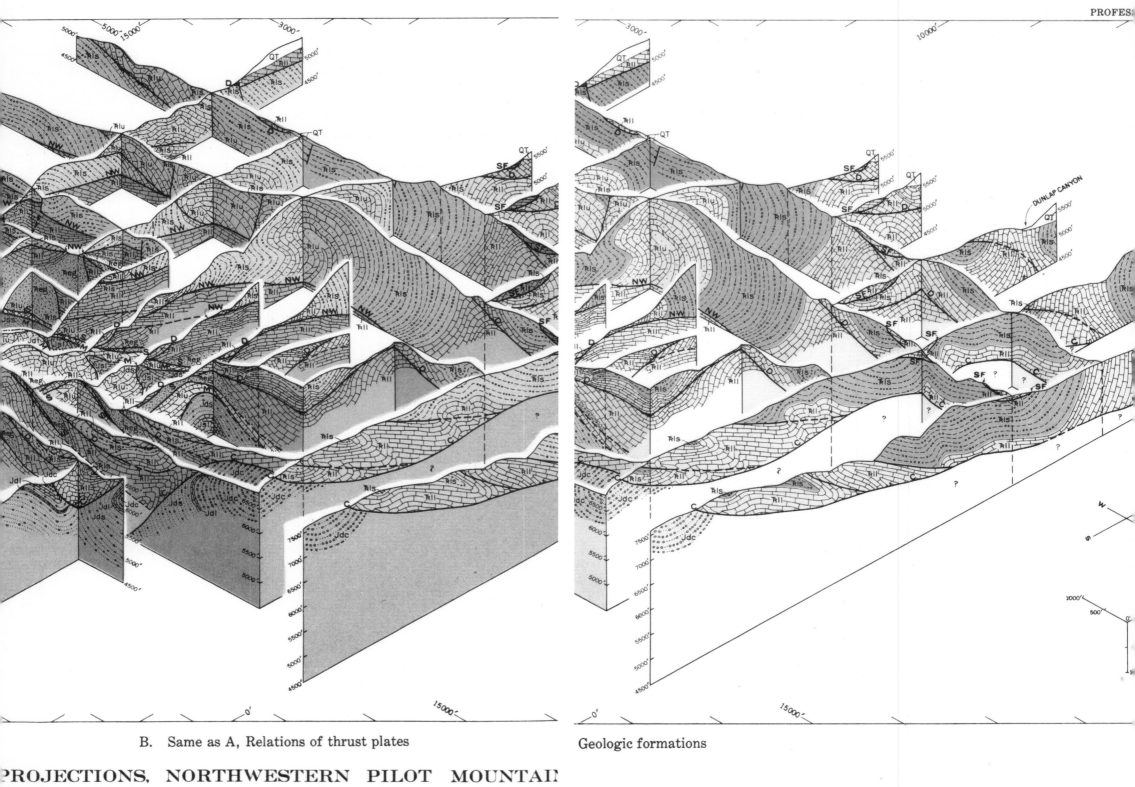

B. Same as A, Relations of thrust plates

Geologic formations

EXPLANATION

QT

Undivided Quaternary and Tertiary deposits

gd

Granodiorite

Jd1

Thrust conglomerate

Jdc

Conglomerate and fanglomerate
(*Limestone and dolomite pebbles derived from Luning formation*)

Jdl

Limestone and dolomite

Jds

Sandstone and conglomerate
(*Chert pebbles derived from Luning formation*)

Jsl

Limestone

Jss

Slate

Rlu

Upper limestone and dolomite

Rls

Slate and conglomerate

Rll

Lower limestone

Rec

Greenstone

Rec

Chert and tuff

Lower Jurassic — Dunlap formation — Sunrise formation (JURASSIC (?) / JURASSIC)

Upper Triassic — Luning formation — *Middle Triassic* — Excelsior formation (TRIASSIC)

PRINCIPAL THRUSTS

C. Cinnabar Canyon

WR. West Ridge

SF. South Fork

D. Dunlap Canyon

NW. Northwest

S. Spearmint

M. Mac

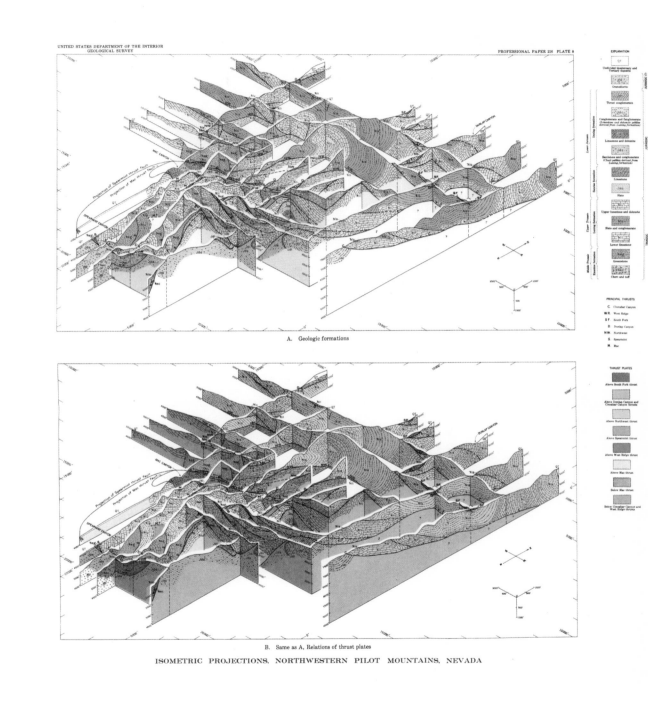

A. Geologic formations

B. Same as A, Relations of thrust plates

ISOMETRIC PROJECTIONS, NORTHWESTERN PILOT MOUNTAINS, NEVADA

39 **Isometric Projections, Northwestern Pilot Mountains, Nevada**

United States Department of the Interior Geological Survey, Professional Paper 216, Plate 8,
Structural Geology of the Hawthorne and Tonopah Quadrangles, Nevada, 1949

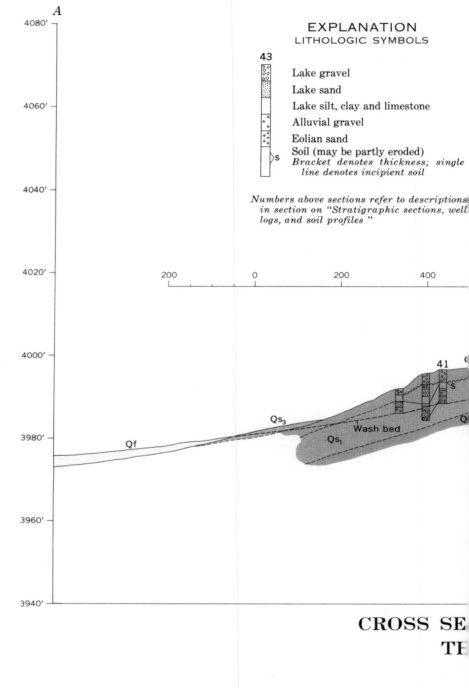

EXPLANATION
LITHOLOGIC SYMBOLS

43

Lake gravel

Lake sand

Lake silt, clay and limestone

Alluvial gravel

Eolian sand

Soil (may be partly eroded)
*Bracket denotes thickness; single
line denotes incipient soil*

*Numbers above sections refer to descriptions
in section on "Stratigraphic sections, well
logs, and soil profiles "*

CROSS SE

TI

40 | **Cross Section Through Saddle at Western End of Wyemaha
Valley the Type Area of the Wyemaha and Sehoo Formations**

United States Department of the Interior Geological Survey, Professional Paper 401, Plate 8,
Structural Geology of the Hawthorne and Tonopah Quadrangles, Nevada, 1964

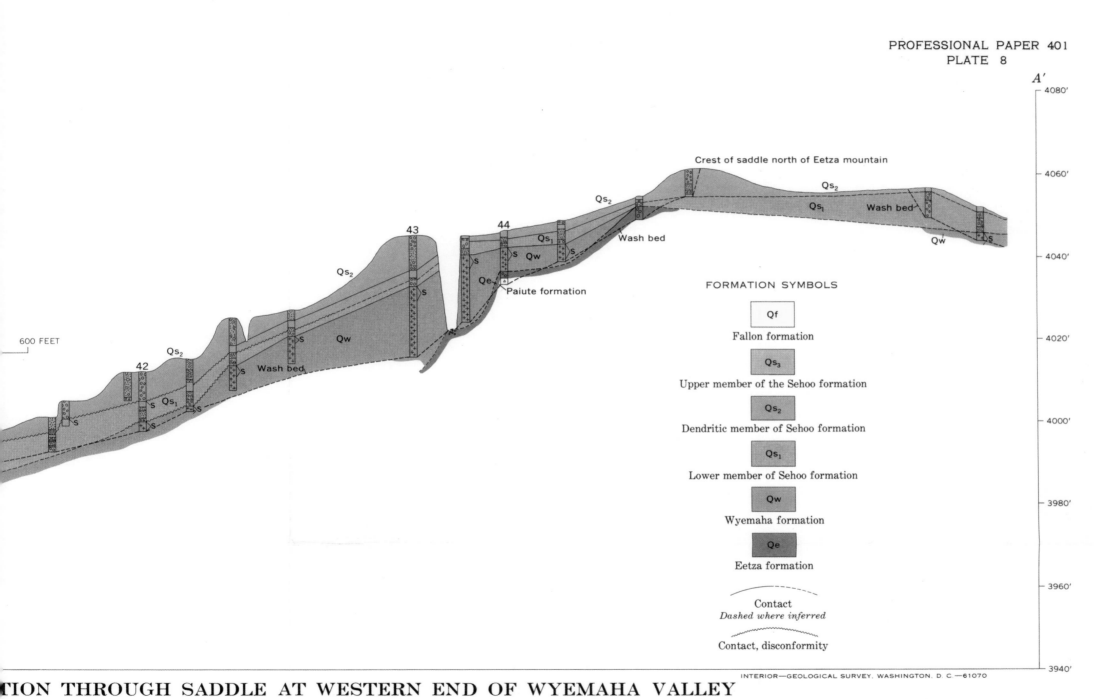

Crest of saddle north of Eetza mountain

Qs_2

Qs_1 Wash bed

Qw

S

Qs_2

Qs_1 Wash bed

Qs_2

44

Qs_1 S Qw S

Qe

Paiute formation

43

Qs_2

S

Qw

FORMATION SYMBOLS

Qf	Fallon formation
Qs_3	Upper member of the Sehoo formation
Qs_2	Dendritic member of Sehoo formation
Qs_1	Lower member of Sehoo formation
Qw	Wyemaha formation
Qe	Eetza formation

Contact
Dashed where inferred

Contact, disconformity

600 FEET

42 Qs_2

Qs_2 S

S Wash bed

S Qs_1 S

S

S

INTERIOR—GEOLOGICAL SURVEY, WASHINGTON, D. C.—61070

TION THROUGH SADDLE AT WESTERN END OF WYEMAHA VALLEY
TYPE AREA OF THE WYEMAHA AND SEHOO FORMATIONS

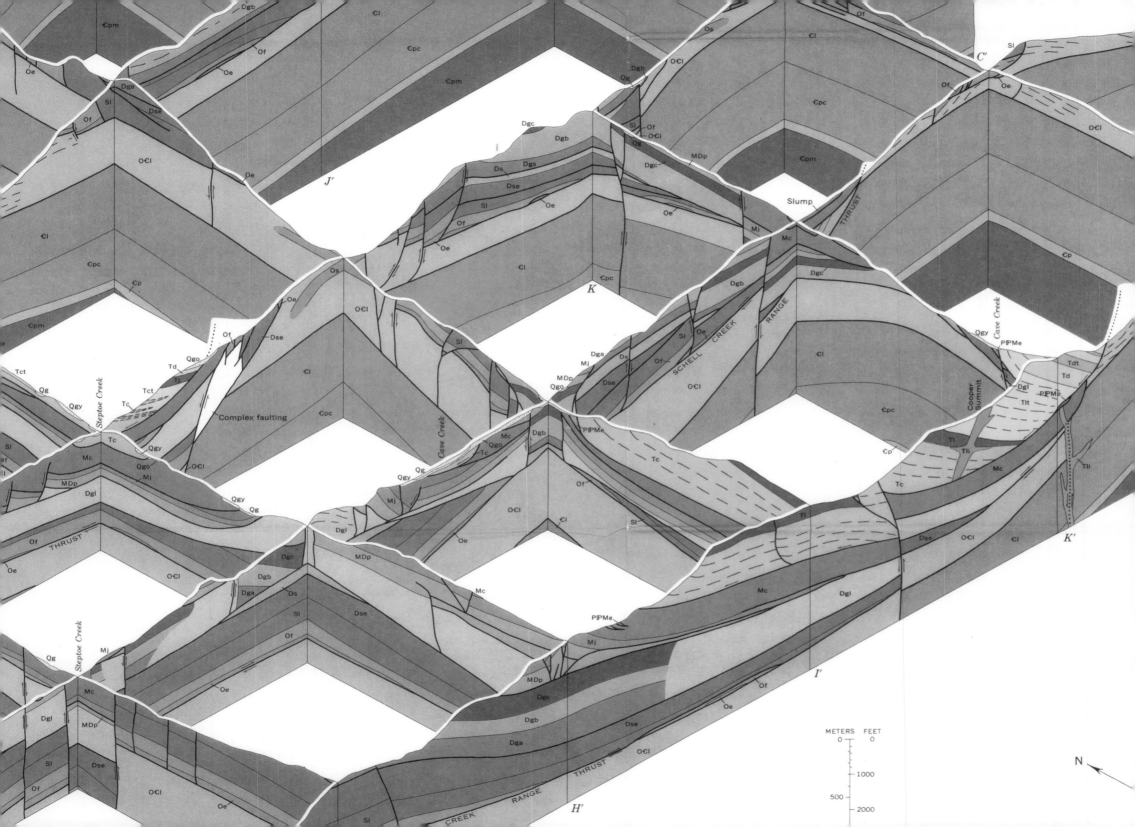

UNITED STATES DEPARTMENT OF THE INTERIOR
GEOLOGICAL SURVEY

PROFESSIONAL PAPER 557
PLATE 3

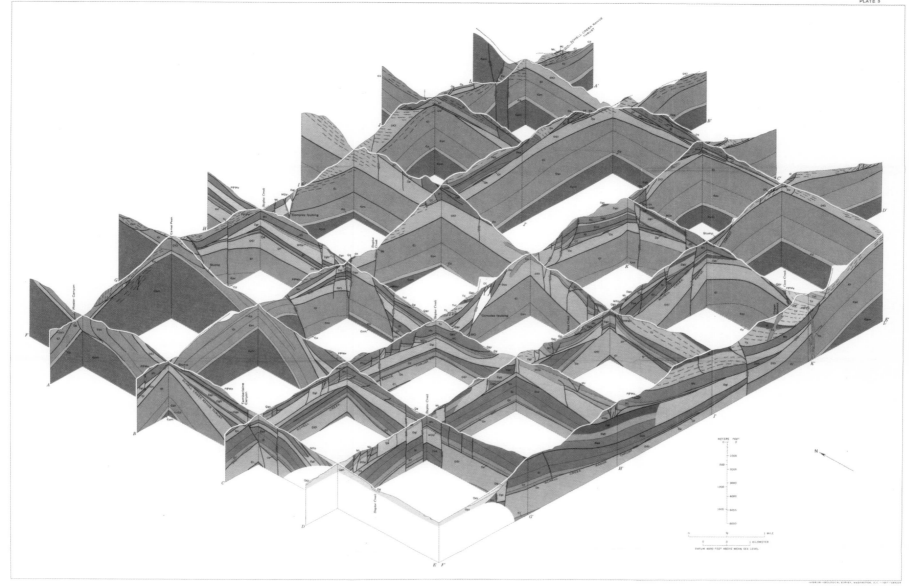

ISOMETRIC DIAGRAM OF THE STEPTOE CREEK-CAVE CREEK AREA, NORTHWESTERN PART
OF THE CONNORS PASS QUADRANGLE, WHITE PINE COUNTY, NEVADA

See geologic map for traces of sections and explanation

41 **Isometric Diagram of the Steptoe Creek-Cave Creek Area, Northwestern Part
of the Connors Pass Quadrangle, White Pine County, Nevada**

United States Department of the Interior Geological Survey, Professional Paper 557, Plate 3,
Interior-Geological Survey Washington D. C., G66245, Nevada, 1967

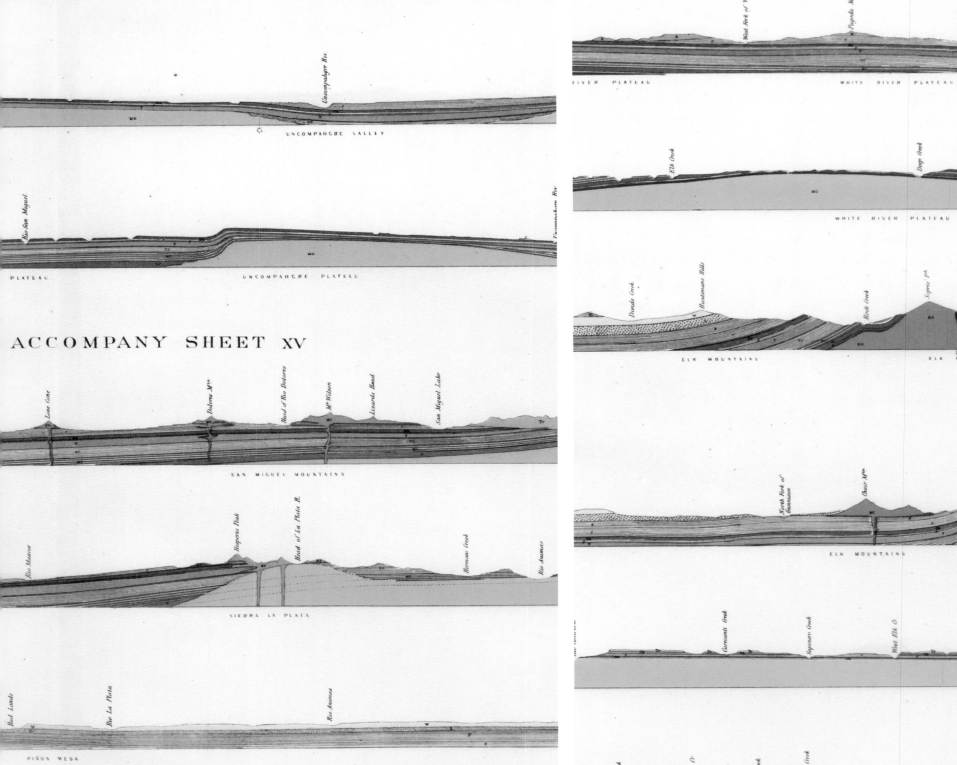

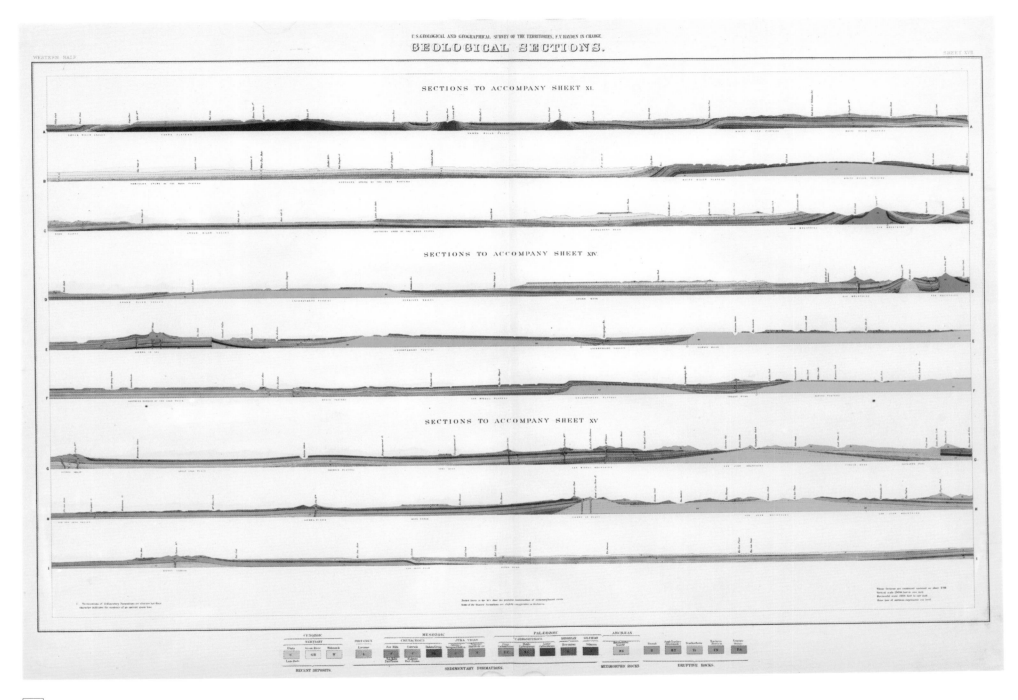

**U. S. Geological and Geographical Survey of the Territories,
F. V. Hayden in Charge. Geological Sections.**

Western Half, Sheet XVII, Colorado, 1874 and 1875–82

GEOLOGICAL SECTIONS.

SECTIONS TO ACCOMPANY SHEET XII.

SECTIONS TO ACCOMPANY SHEET XIII.

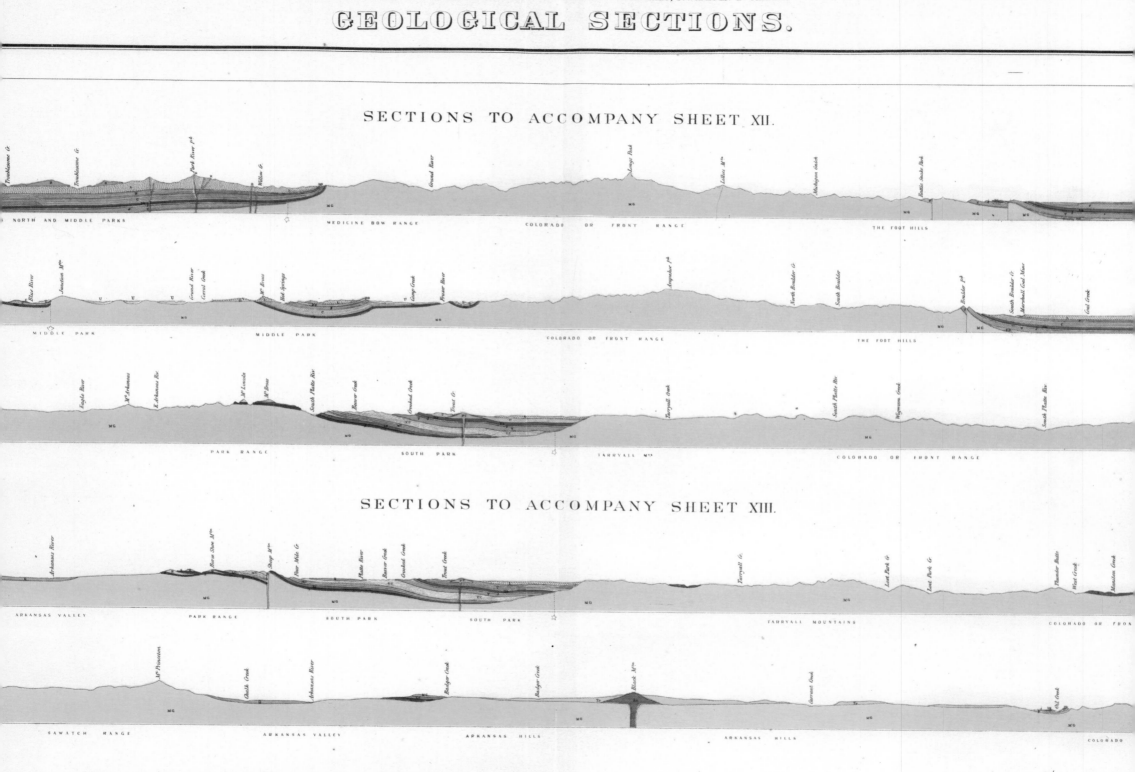

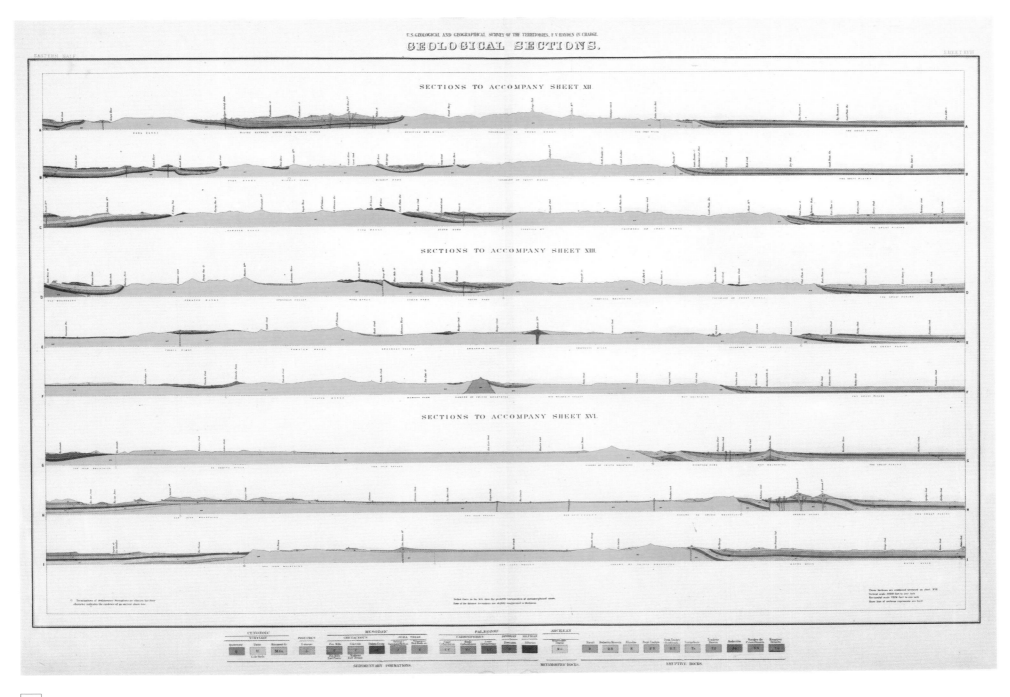

43 **U. S. Geological and Geographical Survey of the Territories, F. V. Hayden in Charge. Geological Sections.**

Eastern Half, Sheet XVIII, Colorado, 1874 and 1875–82

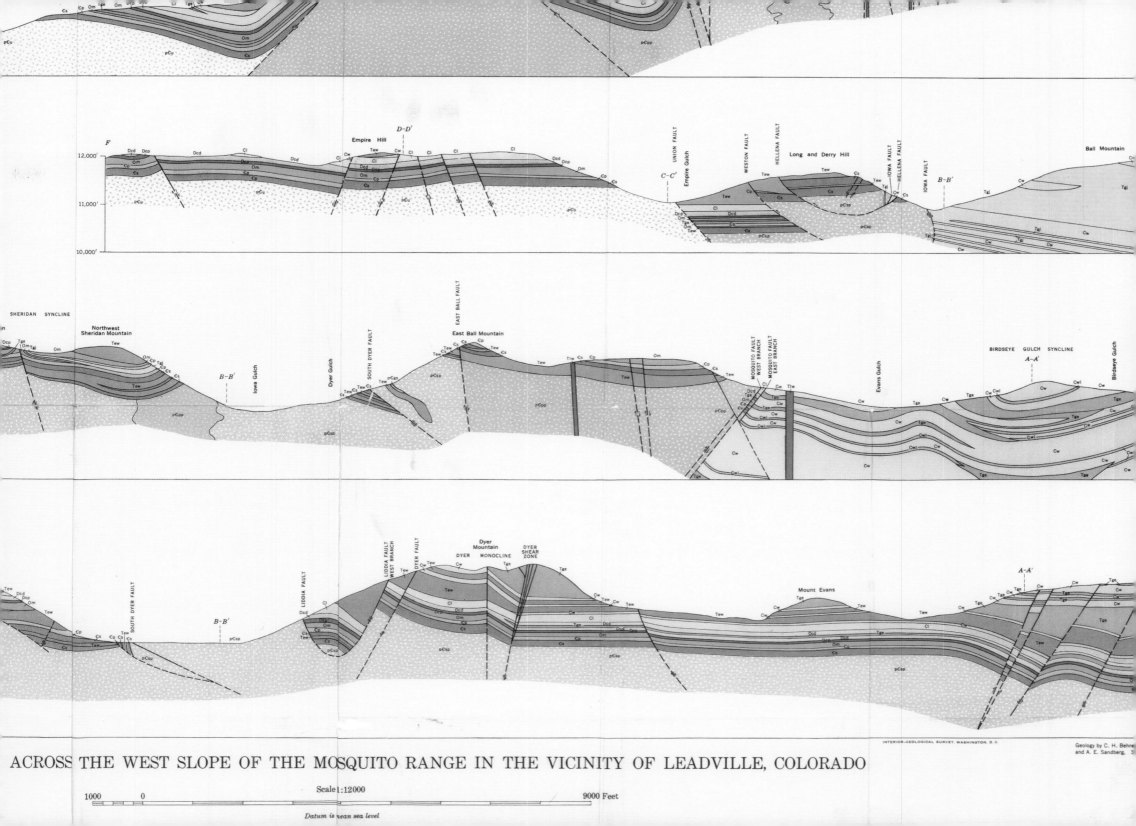

ACROSS THE WEST SLOPE OF THE MOSQUITO RANGE IN THE VICINITY OF LEADVILLE, COLORADO

Scale 1:12000

1000 0 9000 Feet

Datum is mean sea level

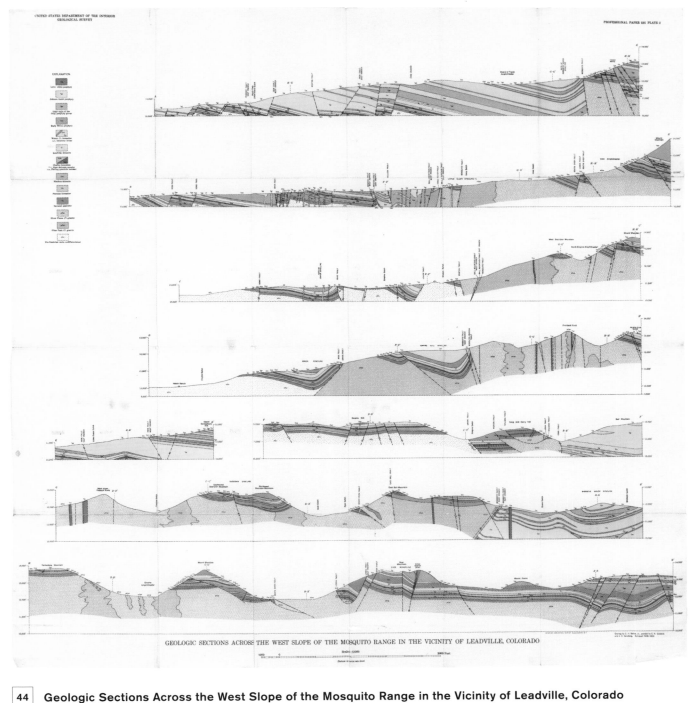

GEOLOGIC SECTIONS ACROSS THE WEST SLOPE OF THE MOSQUITO RANGE IN THE VICINITY OF LEADVILLE, COLORADO

44 | **Geologic Sections Across the West Slope of the Mosquito Range in the Vicinity of Leadville, Colorado**

Department of the Interior United States Geological Survey, Professional Paper 235, Plate 2, Geology by C. H. Benre, Jr.,
Assisted by E. N. Goddard, and A. E. Sandberg. Surveyed 1928–1930, Colorado, publication date unknown

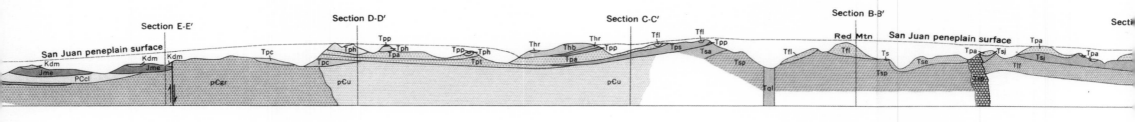

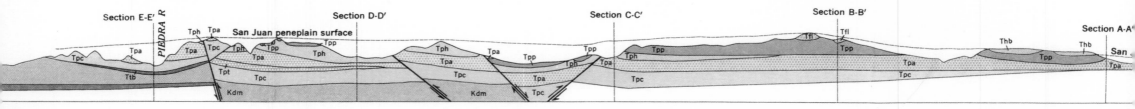

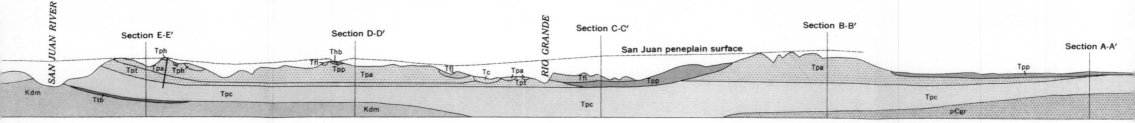

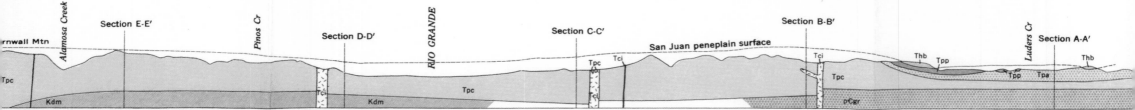

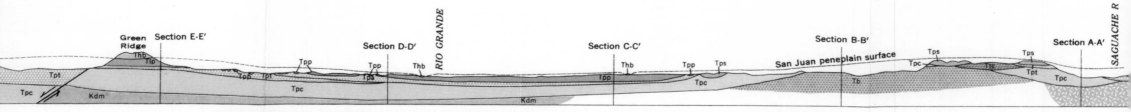

GEOLOGIC SECTIONS OF THE SAN JUAN REGION, COLORADO

Scale 1:250,000

5 0 25 Miles

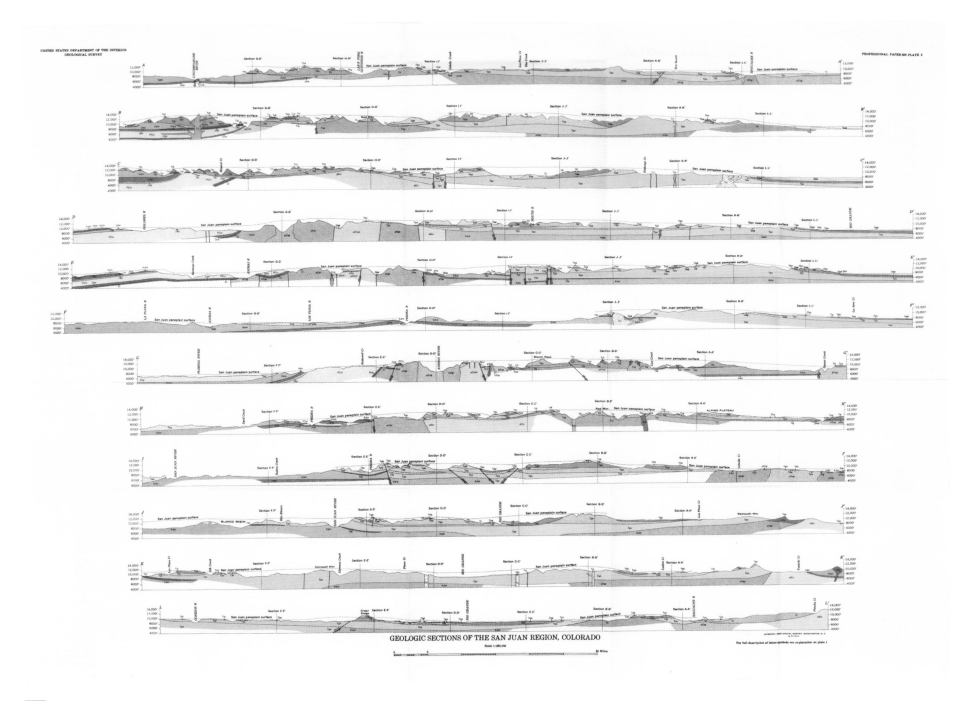

GEOLOGIC SECTIONS OF THE SAN JUAN REGION, COLORADO

45 | **Geologic Sections of the San Juan Region, Colorado**

United States Department of the Interior Geological Survey, Professional Paper 258,
Plate 2, Interior—Geological Survey, Washington D. C., M R-7313, Colorado, 1956

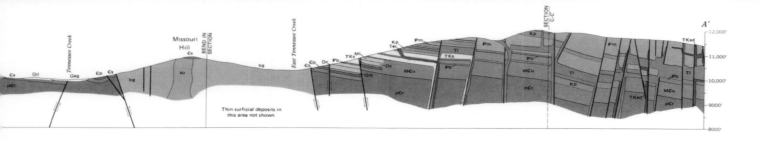
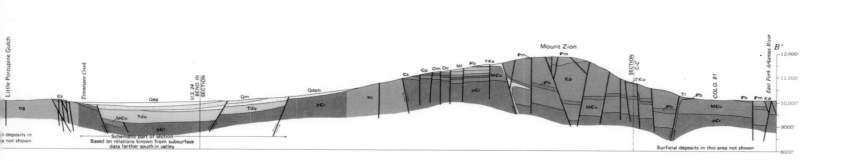
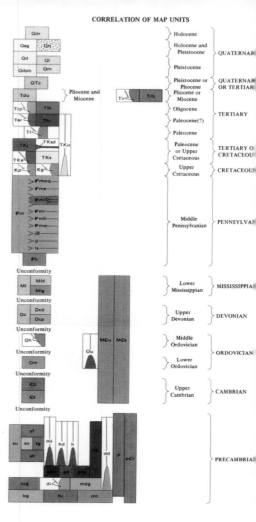
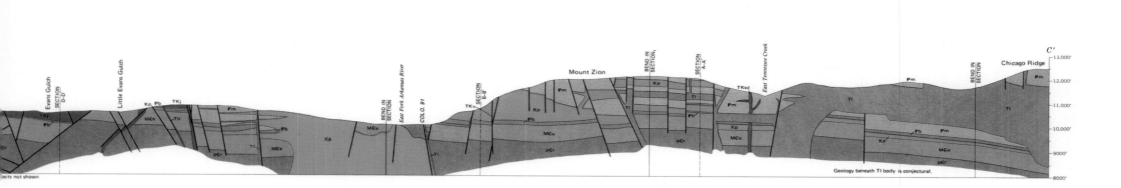

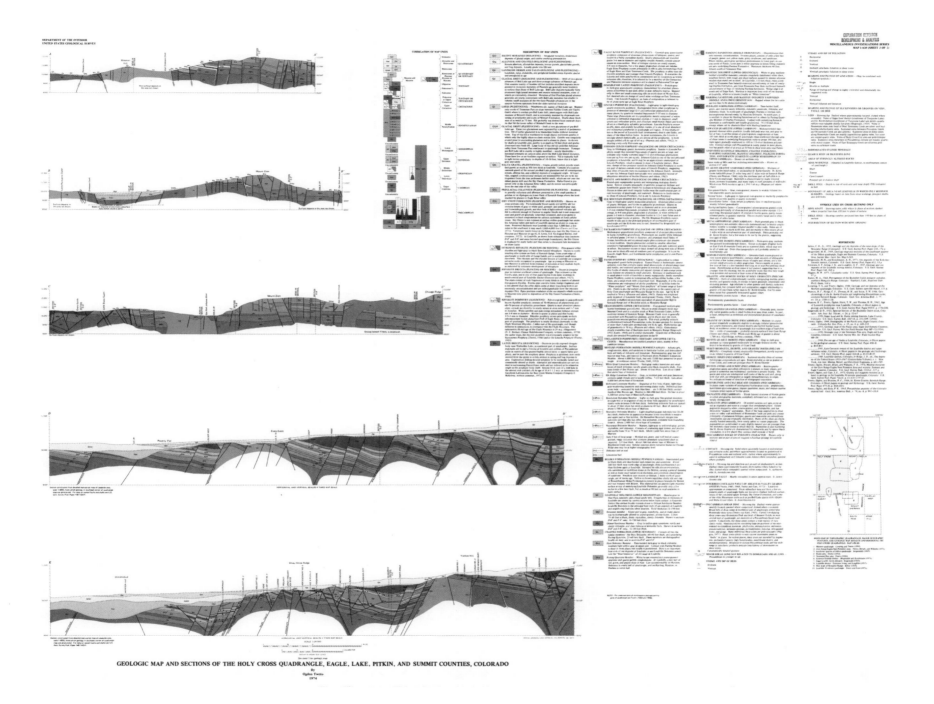

GEOLOGIC MAP AND SECTIONS OF THE HOLY CROSS QUADRANGLE, EAGLE, LAKE, PITKIN, AND SUMMIT COUNTIES, COLORADO
By
Ogden Tweto
1974

46 Geological Map and Sections of the Holy Cross Quadrangle, Eagle, Lake, Pitkin, and Summit Counties, Colorado

Department of the Interior, United States Geological Survey, Miscellaneous Investigation Series, Map I-380 (sheet 2 of 2), Ogden Tweto, Colorado, 1974

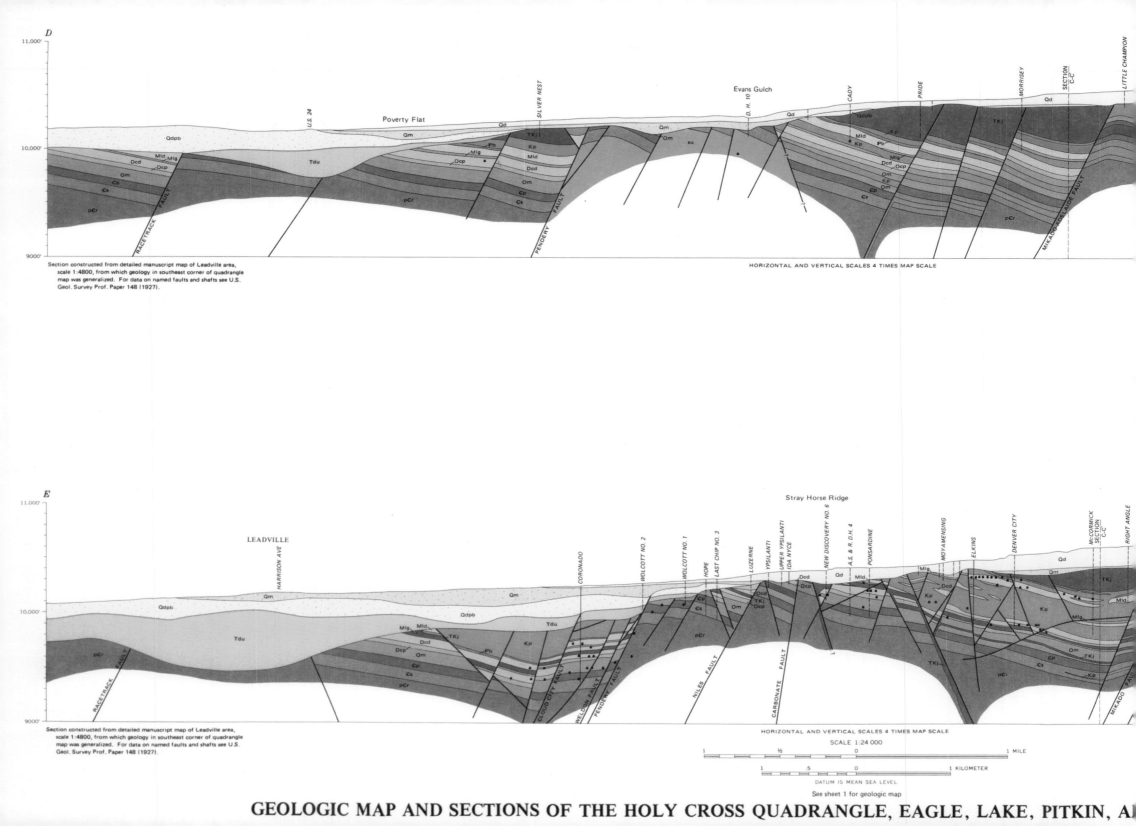

GEOLOGIC MAP AND SECTIONS OF THE HOLY CROSS QUADRANGLE, EAGLE, LAKE, PITKIN, A...

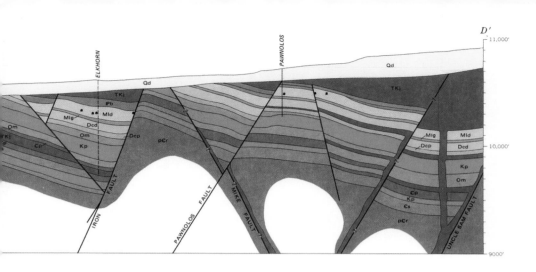

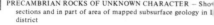

ly about 15 feet thick but swell in places to 40 feet. Base of member is about 3,700 feet above base of Minturn

IPmh Hornsilver Dolomite Member – Light-weathering gray dolomite bed 20–30 feet thick; distinctive in appearance because lower two-thirds is massive and upper part is thin bedded. On Hornsilver Mountain merges into dolomite reef that also has other, less persistent, dolomite beds branching from it. About 2,900 feet above base of formation

IPmw Wearyman Dolomite Member – Massive, light-gray to yellowish-gray, porous, crystalline, reef dolomite. Consists of coalescing algal domes, and pinches and swells from 15 to 75 feet thick. About 2,600 feet above base of Minturn

j8 Jack 8 bed of local usage – Mottled red, green, and buff bed of coarse-grained, vuggy dolomite that contains abundant varicolored chert or jasperoid. 2–5 feet thick. About 500 feet above base of Minturn in Resolution Creek area. Similar material above intrusive bodies in Chicago Ridge area may be at higher stratigraphic level

d Dolomite bed or reef

ls Limestone bed

IPb BELDEN FORMATION (MIDDLE PENNSYLVANIAN) – Interbedded gray to black shale and thin-bedded dark limestone and sandstone. About 200 feet thick near north edge of quadrangle; thins southeastward and then thickens again at Leadville. Intruded by sills almost everywhere; sills assimilated or mobilized shales in the Belden, causing a general thinning as well as many local variations in thickness, and a residual concentration of sandstone. Fossils in type section at Gilman, 2 miles north of quadrangle, are of Atoka age. Yellow to brown regolithic cherty silt and clay of Pennsylvanian Molas Formation is present in places beneath the Belden and was mapped with Belden. This material lies on uneven karst erosional surface at top of underlying Leadville Dolomite; generally only a few inches to a few feet thick, but as much as 50 feet in local sinkholes in karst surface

Ml LEADVILLE DOLOMITE (LOWER MISSISSIPPIAN) – Massive gray to blue-black dolomite and a basal sandy unit. Irregularities in thickness of Leadville are caused by uneven erosion below karst surface; in Leadville district this surface locally extends down to Gilman Sandstone Member. Leadville Dolomite is the principal host rock of ore deposits at Leadville and neighboring lead-zinc-silver districts. Total thickness 12–150 feet

Mld Dolomite member – Upper part is gray, noncherty, and in many places was hydrothermally altered to coarse-grained, porous facies. Lower 75–80 feet is black, finely crystalline, cherty dolomite. Shown in sections D-D' and E-E' only. 0–120 feet thick

Mlg Gilman Sandstone Member – Gray to yellow-gray sandstone, sandy and cherty dolomite, and chert breccia in lenticular beds. Shown in sections D-D' and E-E' only. 12–30 feet thick

Dc CHAFFEE FORMATION (UPPER DEVONIAN) – Consists of two dissimilar members: the Dyer Dolomite, 60–90 feet thick, and underlying Parting Quartzite, 25–60 feet thick. These members are distinguished locally on map, and in sections D-D' and E-E'

Dcd Dyer Dolomite Member – Thin-bedded dark-gray to black dolomite; weathers light yellow gray in upper part. Contact with Parting Member is sharp in most places but locally is gradational. Dyer is an important host rock of ore deposits at Leadville; it and Leadville Dolomite constitute the "Blue limestone" of old usage at Leadville

Dcp Parting Quartzite Member – White to tan crossbedded coarse-grained quartzite and quartz-pebble conglomerate. At Leadville, a few feet of red, green, and purple shale at base. Lies unconformably on Manitou Dolomite in south half of quadrangle, and on Harding, Manitou, or Peerless in north half

NOTE: For cross sections of northeastern and east-central parts of quadrangle see Tweto (1953 and 1956).

old as migmatite and some is younger than metalamprophyre. pegmatite mapped is white, coarse-grained, and feldspathic, ar distinctive "mashed" appearance. Most of the large pegmatite zones on valley wall northwest of Homestake Creek are pink a principally of potassium feldspar; quartz and muscovite are su constituents and are erratically distributed. Many of the dikes mically banded texturally, from nearly aplitic to coarse pegma pegmatites are undeformed or only slightly sheared and are yo the mylonitic shear zones in which they lie. Pegmatites in and the St. Kevin Granite are characterized by muscovite and by s tourmaline; in a few places they contain small crystals of bery

pCr PRECAMBRIAN ROCKS OF UNKNOWN CHARACTER – Sho sections and in part of area of mapped subsurface geology in l district

CONTACT – Showing dip. Solid where accurately located in sed and intrusive rocks, and where approximately located or grada Precambrian rocks and surficial units; dashed where approxima cated in sedimentary and intrusive rocks; dotted where concea where probable

FAULT – Showing dip and direction and amount of displacement Dashed where approximately located; short dashed where follo dike; dotted where concealed; queried where conjectural. U, u side; D, downthrown side

LANDSLIP FAULT – Mostly concealed; location approximate. ll thrown side

INFERRED CONCEALED FAULT OF ARKANSAS VALLEY G SYSTEM (Tweto, 1961; 1968; Tweto and Case, 1972) – Loca approximate or conjectural. From subsurface data and from a posures south of quadrangle faults are known to displace bedro strata of the concealed upper Tertiary Dry Union Formation, a of the older Pleistocene units such as pre-Bull Lake glacial drift and Malta Gravel (Qm). D, downthrown side

PRECAMBRIAN SHEAR ZONE – Showing dip. Dashed where a imately located; queried where conjectural; dotted where conce Broad belt of shear zones in northwest part of quadrangle cons Homestake shear zone (Tweto and Sims, 1963). Curved low-di shear zones near Homestake Peak and head of Bennett Gulch, i central part of quadrangle, are elements of a Precambrian thrus system. Collectively, the shear zones contain a wide variety of clastic rocks: blastomylonites containing large proportions of r eralized-recrystallized materials, phyllonites, ultramylonites, my pseudotachylite, mylonite gneisses, protomylonite, breccias, re rocks, and gouge. Many individual shear zones are polycataclas gins, 1971). Shear zones pinch to very narrow movement zone "faults" in places. In various places, shear zones are intruded b tite, unclassified granite (ug), hornblendite, hornblende diorite metalamprophyre. Relations to various Precambrian rocks and range in cataclastic products indicate long history of movement shear zones

cg Cataclastically foliated gneisses

MINOR SHEAR ZONE NOT RELATED TO HOMESTAKE SHE Precambrian or younger in age

STRIKE AND DIP OF BEDS

Inclined

Vertical

SUMMIT COUNTIES, COLORADO

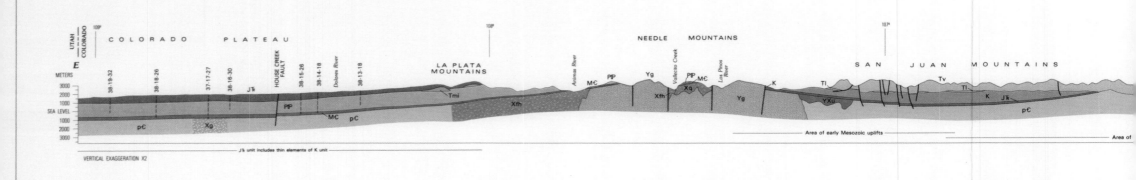

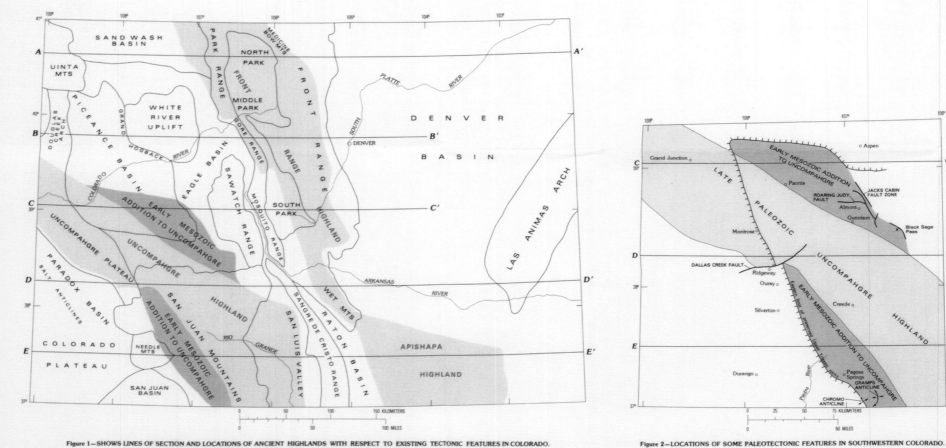

Figure 1—SHOWS LINES OF SECTION AND LOCATIONS OF ANCIENT HIGHLANDS WITH RESPECT TO EXISTING TECTONIC FEATURES IN COLORADO. YELLOW, AREAS OF LATE PALEOZOIC UPLIFTS; GREEN, AREAS OF ADDITIONAL UPLIFT IN EARLY MESOZOIC.

Figure 2—LOCATIONS OF SOME PALEOTECTONIC FEATURES IN SOUTHWESTERN COLORADO.

The geologic sections presente
1979a). As shown by the sections
tervening or bordering structural
demonstrate that the uplifts and bas
were products of the Laramide oro
them, however, were created in the
and basins that were created as part
of recurrent tectonism in the early N
sidered briefly in the text that follo

Locations of the main uplifts a
on figure 1, as well as the locations
Mesozoic. Geology shown at the su
to the small scale, surficial deposits
at the surface are necessarily includ
face geology is based on stratigraph
and in some small areas, on publis
from a map (Tweto, 1980a, fig. 1)
position, structure, and configurati

LATE PA

Three major uplifts, known as
(fig. 1), rose in Colorado in the la
Early Pennsylvanian. The locations
ly by several authors (Melton, 1925;
daries were better defined later, follo
and Collins, 1953; J. D. Howard, 19

The old highlands are identified
Paleozoic rocks wedge out by eros
off by faults that border the highla
wedge out against the highlands by
glomerate characterize the Pennsylv
old highlands, a feature emphasize
tional structures in the sediments ir
Howard, 1966). Upper Permian roc
(section E–E'), and Upper Triassic
rocks of the Front Range and Uncor
or Triassic rocks lie on Precambrian
extensive parts of the highlands an
Consequently, the upper Paleozoic r
on the flanks of parts of the highla
before a cover of Triassic or Jurass

Along much of their lengths, the
bounded on their southwest sides b
east sides (Tweto, 1980b). An exce
compahgre highland that is now hid
This part was called the San Luis hig
in the Permian and Pennsylvanian
immediately east of the valley, sugs
steep, as noted by Heaton (1933)

The Apishapa highland of so
west sides (section E–E') and also
irregularly into the Sierra Grande h
highland are capped by Upper Perm
the Early Permian.

The late Paleozoic highlands w
in which thick Pennsylvanian and P
Paradox basins (sections B–B', D

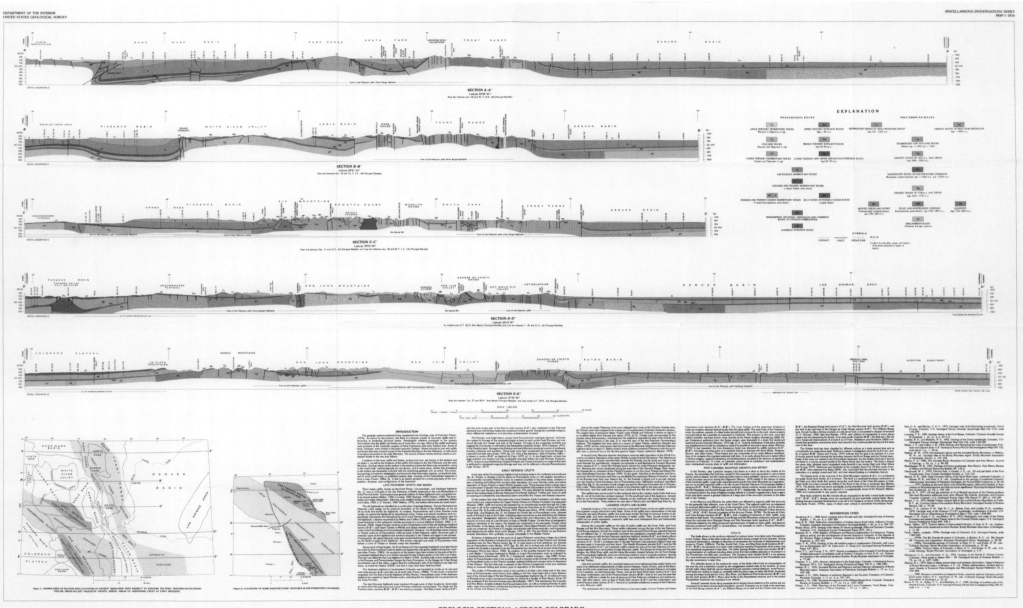

GEOLOGIC SECTIONS ACROSS COLORADO

By

Ogden Tweto

1983

47 Geologic Sections Across Colorado

Department of the Interior, United States Geological Survey,
Miscellaneous Investigation Series, Map I-1416, Ogden Tweto,
Colorado, 1983

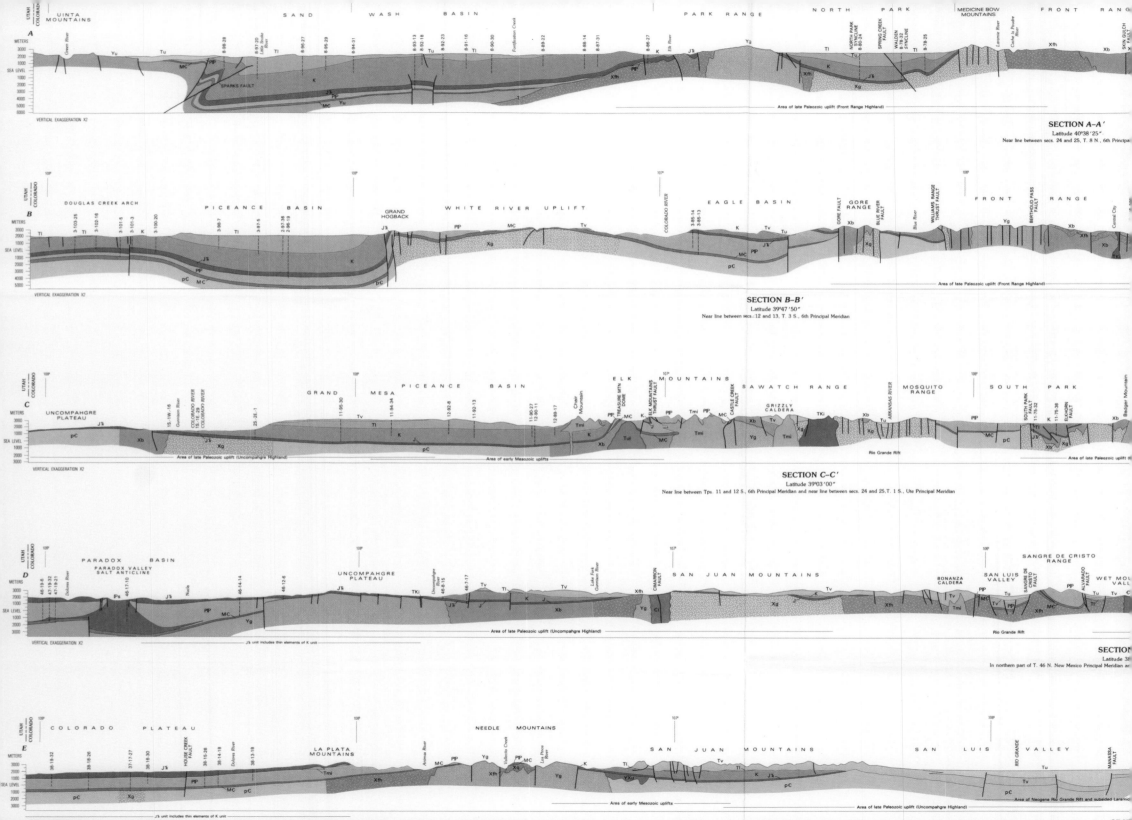

SECTION A–A'
Latitude 40°38'25".
Near line between secs. 24 and 25, T. 8 N., 6th Principal

SECTION B–B'
Latitude 39°47'50"
Near line between secs. 12 and 13, T. 3 S., 6th Principal Meridian

SECTION C–C'
Latitude 39°03'00"
Near line between Tps. 11 and 12 S., 6th Principal Meridian and near line between secs. 24 and 25, T. 1 S., Ute Principal Meridian

SECTION
Latitude 38
In northern part of T. 46 N. New Mexico Principal Meridian an

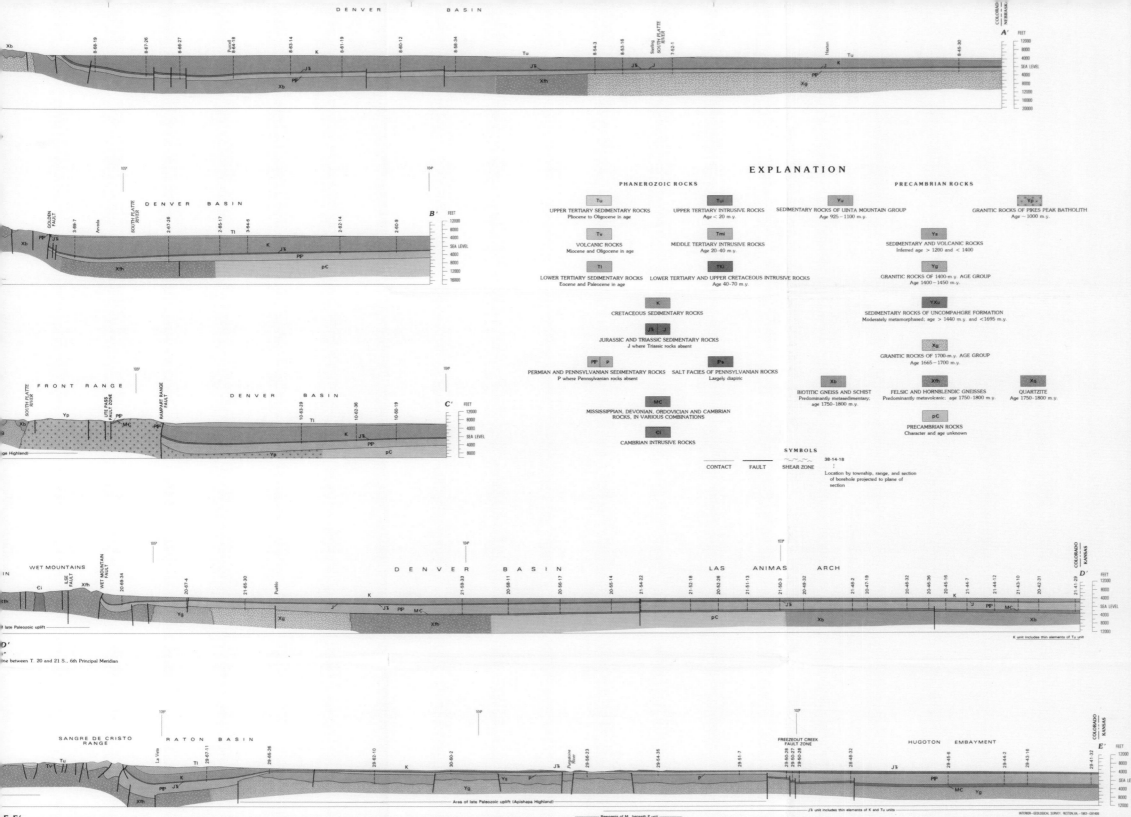

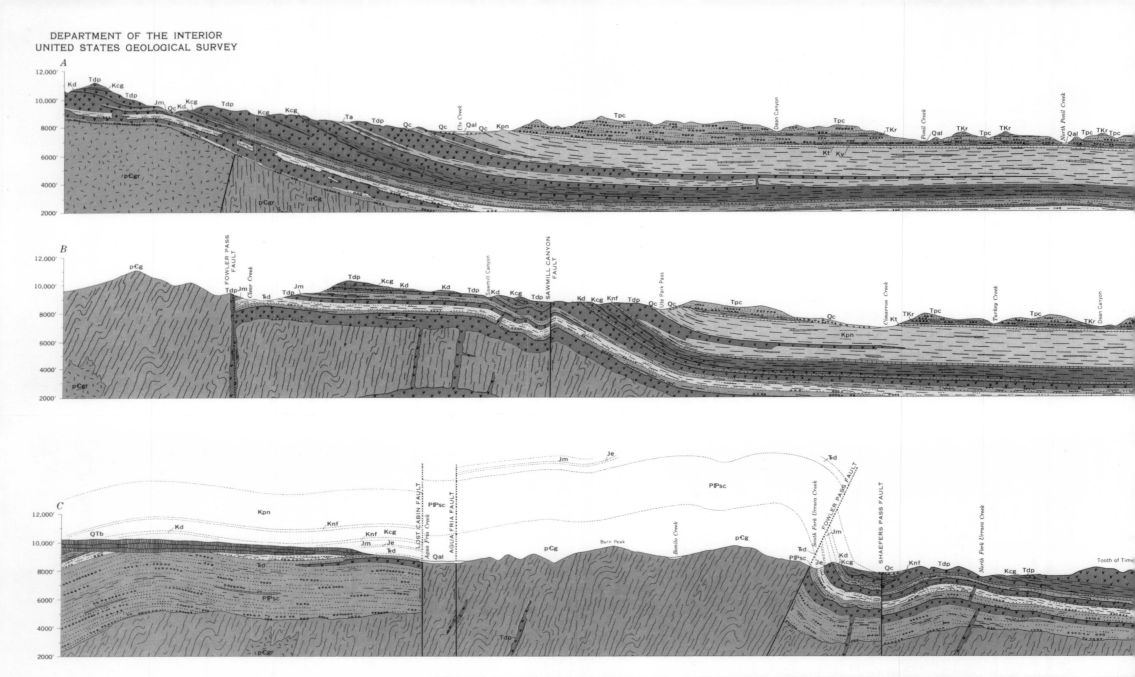

GEOLOGIC SECTIONS OF THE PHILMONT RANCH REGION, NEW

By
A. A. Wanek, C. B. Read, G. D. Robinson,
W. H. Hayes, and Malcolm McCallum

SCALE 1:48,000
1 INCH = 4000 FEET

1 ½ 0 1 2 3 4 5 MILES

1 .5 0 1 2 3 4 5 KILOMETERS

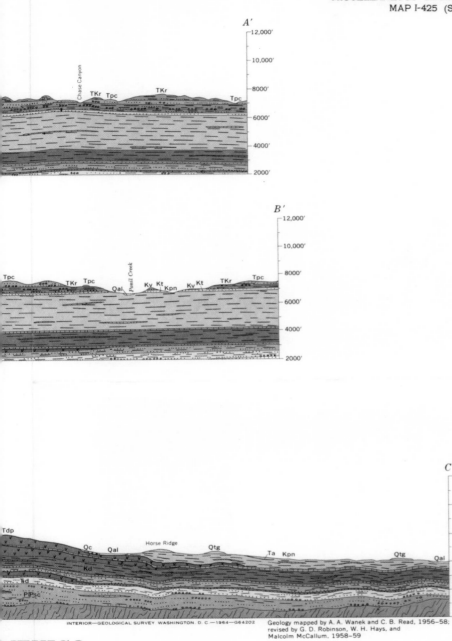

EXPLANATION

ROCK TYPES

Landslide

Conglomerate

Sand and gravel

Sandstone

Shale

Limestone

Gneiss and schist

Basalt

Dacite porphyry

Porphyritic andesite

Granodiorite

See sheet 1 for explanation
of geologic symbols

INTERIOR—GEOLOGICAL SURVEY WASHINGTON. D. C.—1964—G64202

Geology mapped by A. A. Wanek and C. B. Read, 1956–58;
revised by G. D. Robinson, W. H. Hays, and
Malcolm McCallum, 1958–59

MEXICO

48 **Geological Sections of the Philmont Ranch Region, New Mexico**

Department of the Interior, United States Geological Survey, Miscellaneous Investigation Series,
Map I-425 (sheet 2 of 2), Geology Mapped by A. A. Warnek and C. B. Read, 1956–58;
Revised by G. D. Robinson, W. H. Hays, and Malcolm McCallum, 1958–59, New Mexico, 1964

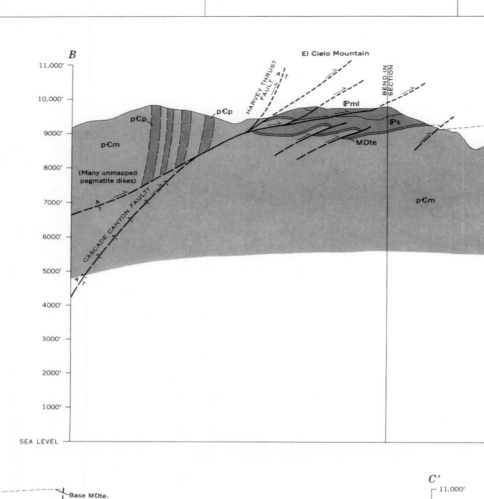
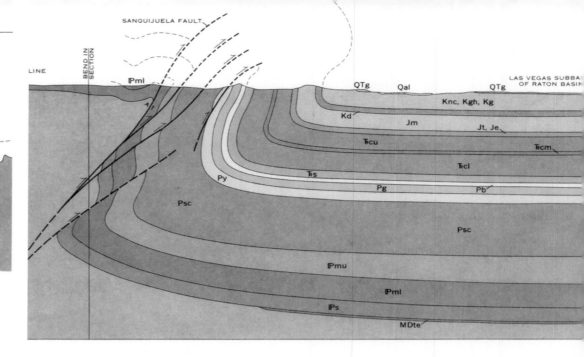
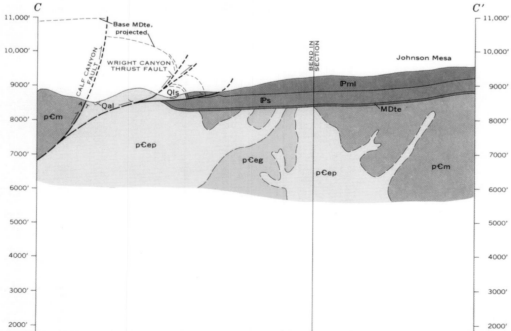
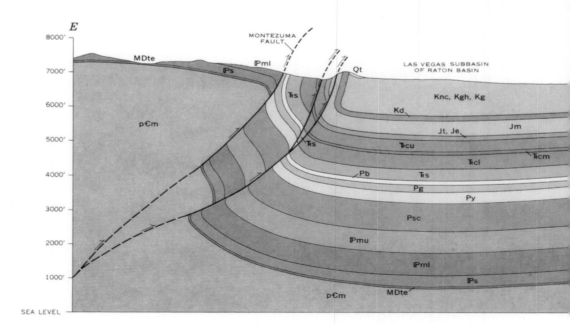

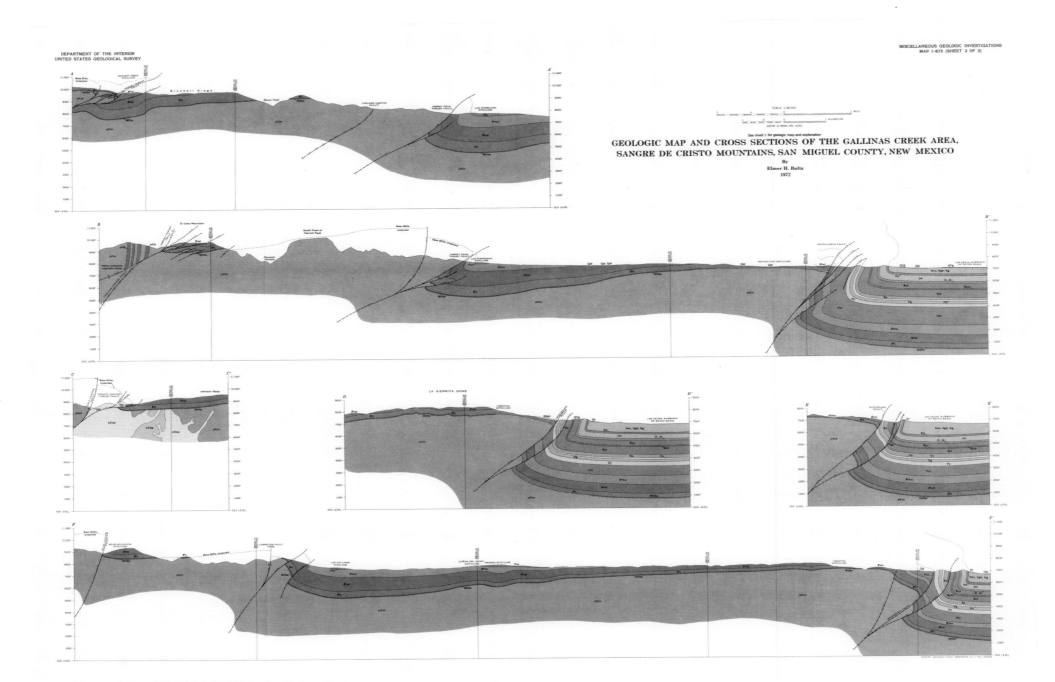

MISCELLANEOUS GEOLOGIC INVESTIGATIONS
MAP I-673 (SHEET 2 OF 2)

GEOLOGIC MAP AND CROSS SECTIONS OF THE GALLINAS CREEK AREA,
SANGRE DE CRISTO MOUNTAINS, SAN MIGUEL COUNTY, NEW MEXICO
By
Elmer H. Baltz
1972

49 Geologic Map and Cross Section of the Gallinas Creek Area,
Sangre de Cristo Mountains, San Miguel County, New Mexico

Department of the Interior, United States Geological Survey, Miscellaneous Investigation Series,
Map I-673 (sheet 2 of 2), Elmer H. Baltz, New Mexico, 1972

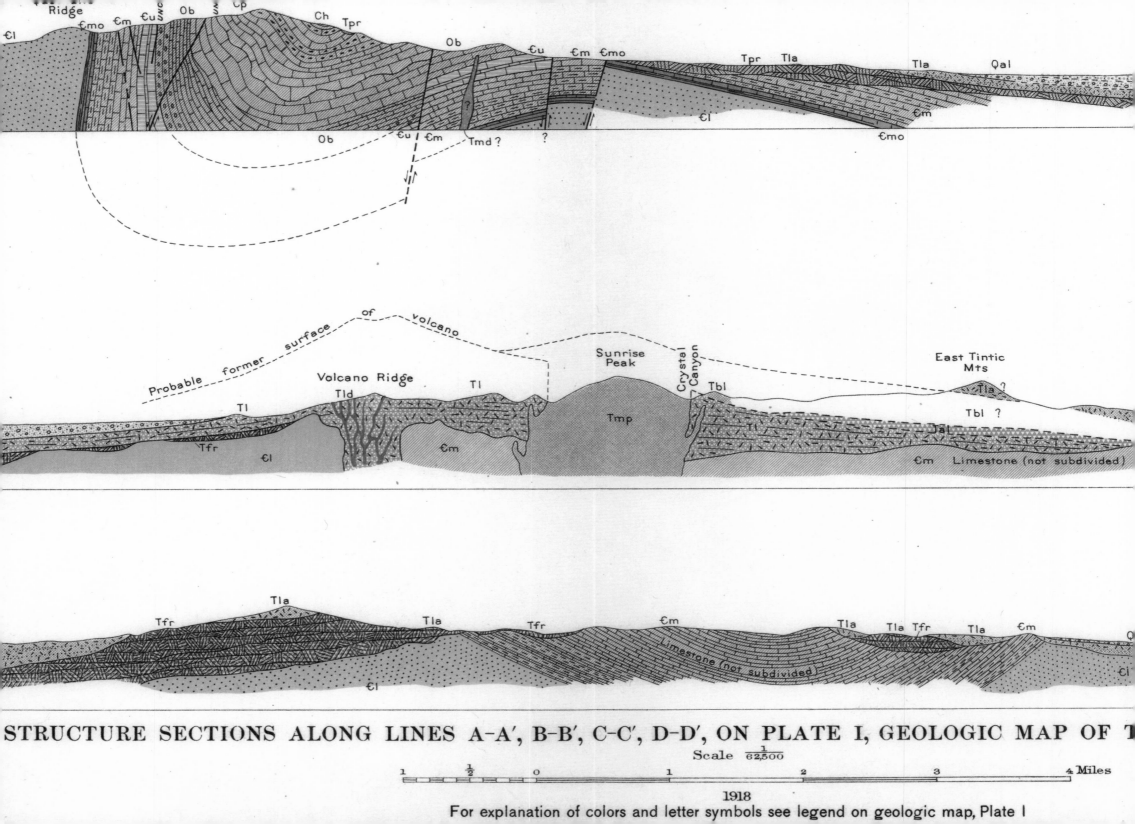

STRUCTURE SECTIONS ALONG LINES A-A′, B-B′, C-C′, D-D′, ON PLATE I, GEOLOGIC MAP OF T

Scale $\frac{1}{62,500}$

1 ½ 0 1 2 3 4 Miles

1918

For explanation of colors and letter symbols see legend on geologic map, Plate I

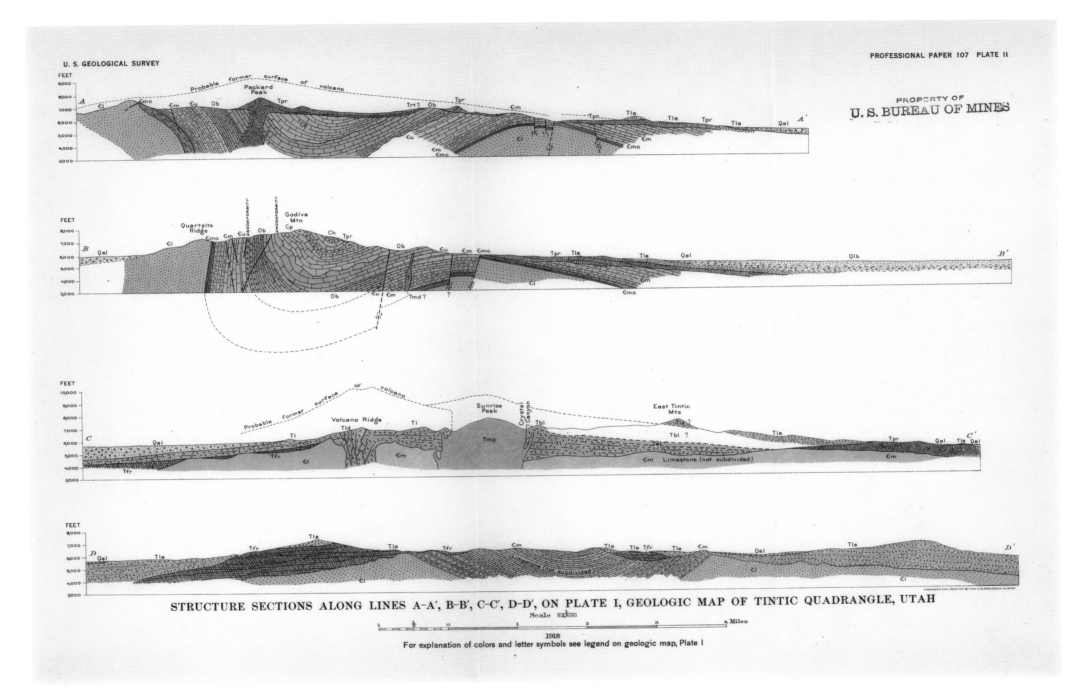

STRUCTURE SECTIONS ALONG LINES A-A', B-B', C-C', D-D', ON PLATE I, GEOLOGIC MAP OF TINTIC QUADRANGLE, UTAH

Scale 125000

1918

For explanation of colors and letter symbols see legend on geologic map, Plate I

50 Structure Sections Along Lines A-A', B-B', C-C', D-D', on Plate I, Geologic Map of Tintic Quadrangle, Utah

U. S. Geological Survey, Professional Paper 107, Plate II, Utah, 1918

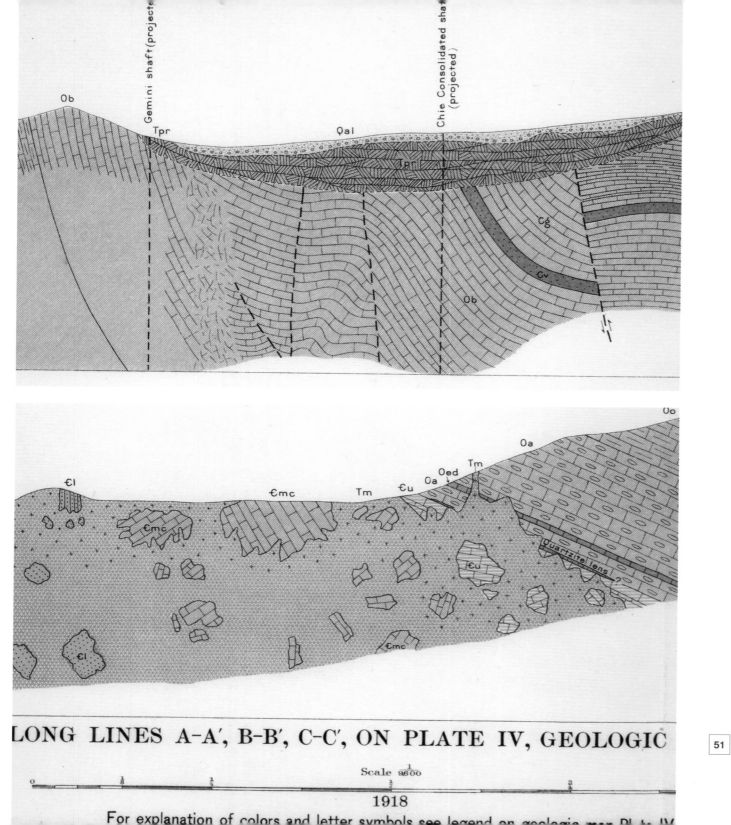

LONG LINES A-A', B-B', C-C', ON PLATE IV, GEOLOGIC

Scale $\frac{1}{9600}$

0 ⅛ ¼ ½ ¾

1918

For explanation of colors and letter symbols see legend on geologic map Plate IV

51 **Structure Sections Along Lines A-A', B-B', C-C', on Plate IV, Geologic Map of Tintic District, Utah**

U. S. Geological Survey, Professional Paper 107, Plate V, Utah, 1918

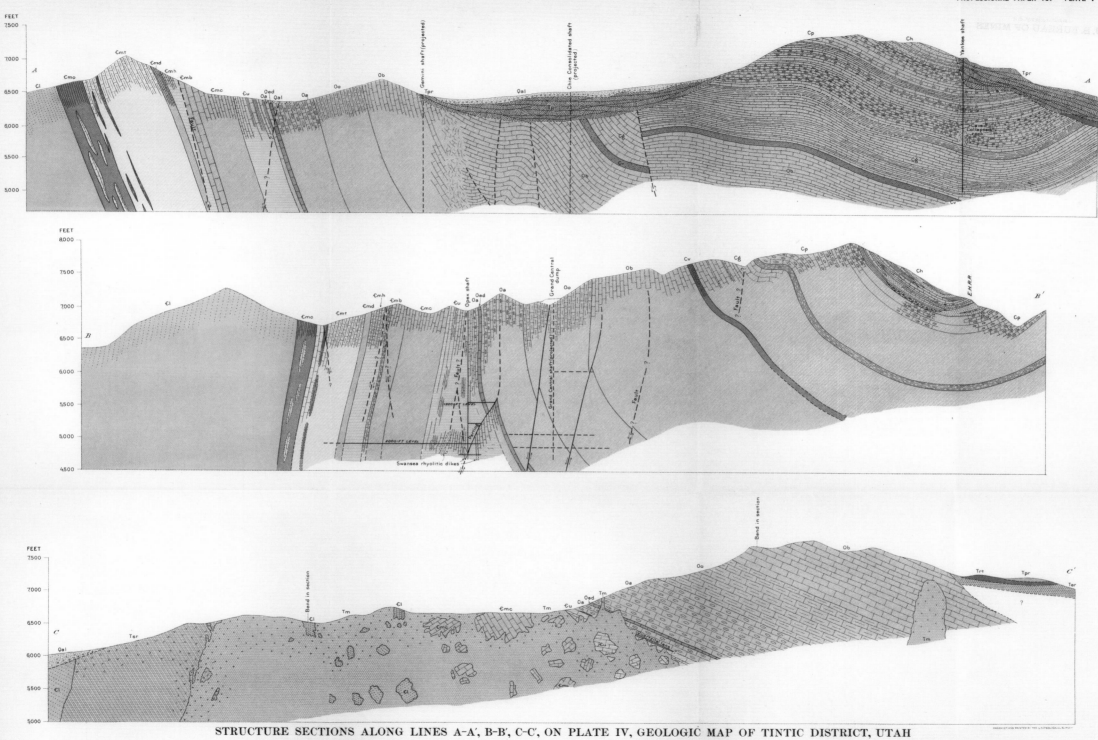

STRUCTURE SECTIONS ALONG LINES A-A', B-B', C-C', ON PLATE IV, GEOLOGIC MAP OF TINTIC DISTRICT, UTAH

Scale ₆₀₀₀

1918

For explanation of colors and letter symbols see legend on geologic map, Plate IV

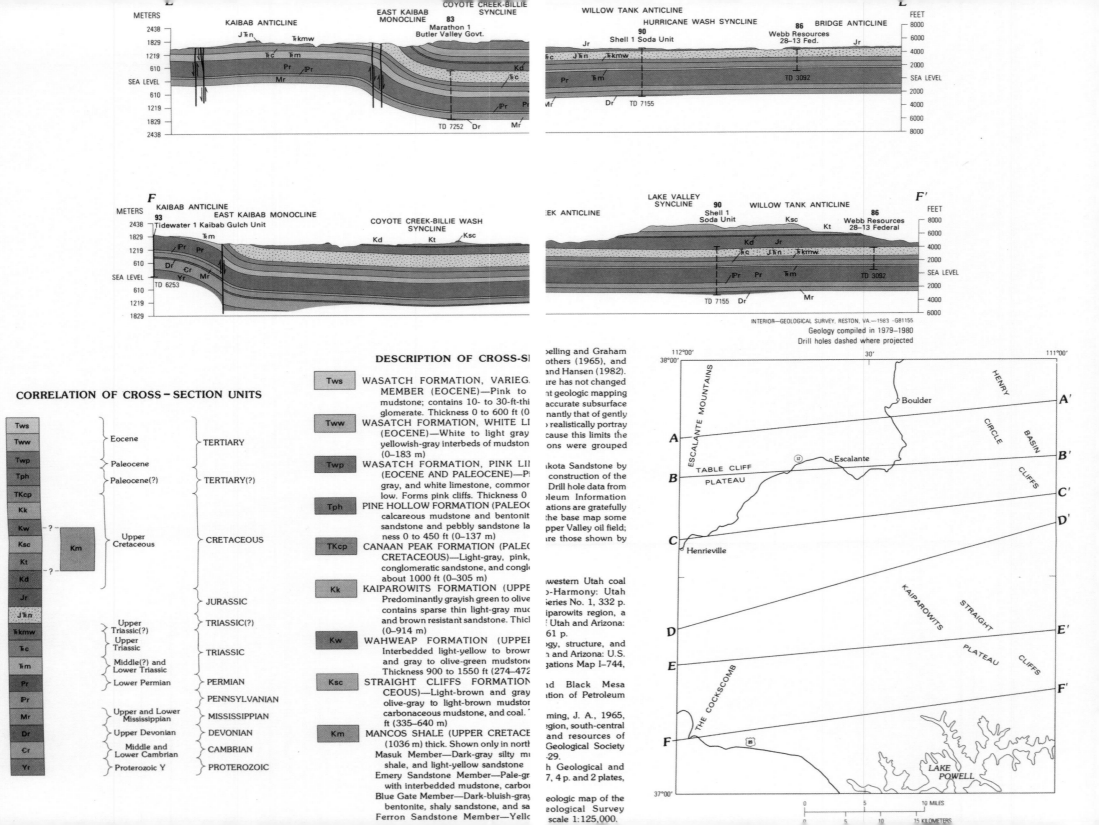

INTERIOR—GEOLOGICAL SURVEY, RESTON, VA.—1983—G81155
Geology compiled in 1979–1980
Drill holes dashed where projected

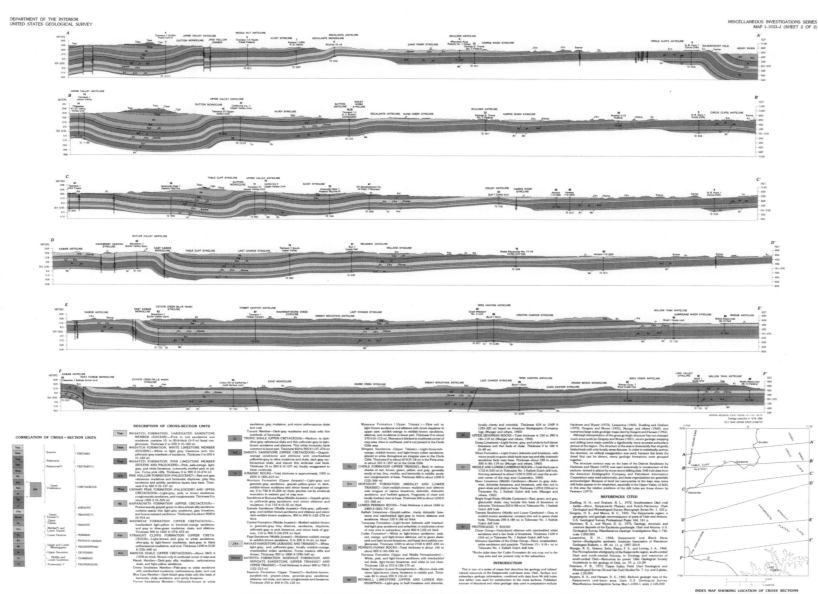

GEOLOGIC CROSS SECTIONS OF THE KAIPAROWITS COAL-BASIN AREA, UTAH

By

D. J. Lidke and K. A. Sargent

1983

Geological Cross Sections of the Kaiparowits Coal-Basin Area, Utah

Department of the Interior, United States Geological Survey, Miscellaneous Investigations Series,
Map I-1033-J (sheet 2 of 2), D. J. Lidke and K. A. Sargent, Utah, 1983

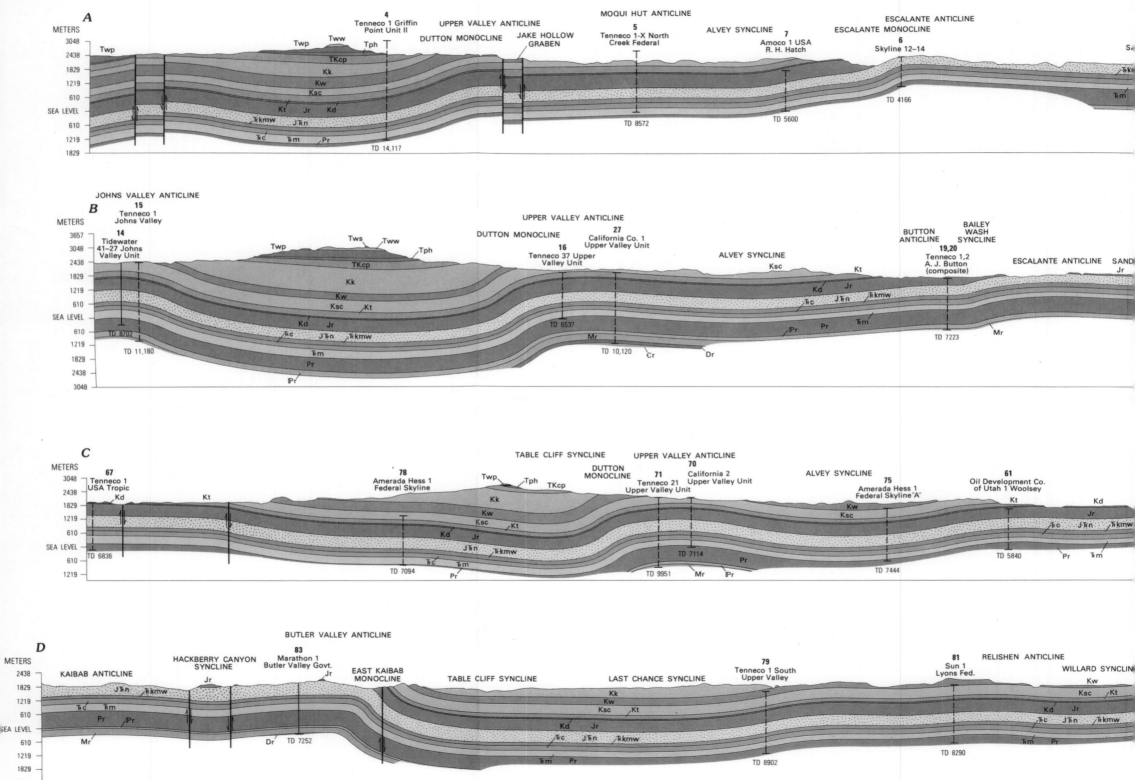

A

METERS

3048 — Twp — Tww — Tph — **4** Tenneco 1 Griffin Point Unit II — UPPER VALLEY ANTICLINE — MOQUI HUT ANTICLINE — ALVEY SYNCLINE — ESCALANTE ANTICLINE — ESCALANTE MONOCLINE

2438 — TKcp — DUTTON MONOCLINE — JAKE HOLLOW GRABEN — **5** Tenneco 1-X North Creek Federal — **7** Amoco 1 USA R. H. Hatch — **6** Skyline 12–14

1829 — Kk

1219 — Kw — Ksc

610 — Kt Jr Kd

SEA LEVEL — Ŧkmw — JŦn — TD 4166

610 — Ŧc — Ŧm — Pr — TD 5600

1219 — TD 8572

1829 — TD 14,117

B — JOHNS VALLEY ANTICLINE

15 Tenneco 1 Johns Valley

METERS

3657 — **14** Tidewater 41–27 Johns Valley Unit — UPPER VALLEY ANTICLINE — BUTTON ANTICLINE — BAILEY WASH SYNCLINE

3048 — Twp — Tws — Tww — Tph — DUTTON MONOCLINE — **27** California Co. 1 Upper Valley Unit — **19,20** Tenneco 1,2 A. J. Button (composite)

2438 — TKcp — **16** Tenneco 37 Upper Valley Unit — ALVEY SYNCLINE — Ksc — Kt — ESCALANTE ANTICLINE — SAND

1829 — Kk — Kd Jr

1219 — Kw — Ksc Kt — Ŧc JŦn Ŧkmw

610 — Kd Jr — Pr Pr Ŧm

SEA LEVEL — Ŧc JŦn Ŧkmw — TD 6537 — TD 7223 — Mr

610 — TD 8702 — Mr

1219 — TD 11,180 — Ŧm — TD 10,120 — Cr — Dr

1829 — Pr

2438 — Pr

3048

C — TABLE CLIFF SYNCLINE — UPPER VALLEY ANTICLINE

METERS

3048 — **67** Tenneco 1 USA Tropic — **78** Amerada Hess 1 Federal Skyline — Twp — Tph — TKcp — DUTTON MONOCLINE — **70** California 2 Upper Valley Unit — ALVEY SYNCLINE — **61** Oil Development Co. of Utah 1 Woolsey

2438 — **71** Tenneco 21 Upper Valley Unit — **75** Amerada Hess 1 Federal Skyline "A"

1829 — Kd — Kt — Kk — Kw

1219 — Kw — Ksc Kt — Kw Ksc — Kt — Kd

610 — Jr — Kd Jr — Ŧc JŦn Ŧkmw

SEA LEVEL — Ŧc JŦn Ŧkmw — JŦn Ŧkmw — Pr — Pr Ŧm

610 — TD 6836 — Ŧc Ŧm — TD 7114 — TD 5840

1219 — TD 7094 — Pr — TD 9951 — Mr Pr — TD 7444

D — BUTLER VALLEY ANTICLINE

METERS

2438 — KAIBAB ANTICLINE — HACKBERRY CANYON SYNCLINE — **83** Marathon 1 Butler Valley Govt. — EAST KAIBAB MONOCLINE — TABLE CLIFF SYNCLINE — LAST CHANCE SYNCLINE — **79** Tenneco 1 South Upper Valley — **81** Sun 1 Lyons Fed. — RELISHEN ANTICLINE

1829 — JŦn Ŧkmw — Jr — Jr — Kk — WILLARD SYNCLIN — Kw

1219 — Ŧc Ŧm — Jr — Kw — Ksc Kt

610 — Pr Pr — Ŧkmw — Ksc Kt — Kd Jr

SEA LEVEL — Kd Jr — Ŧc JŦn — Ŧkmw

610 — Mr — Dr TD 7252 — Ŧc JŦn Ŧkmw — Ŧm Pr

1219 — Ŧm Pr — TD 8902 — TD 8290

1829

2438

MAP I-1033-J (S

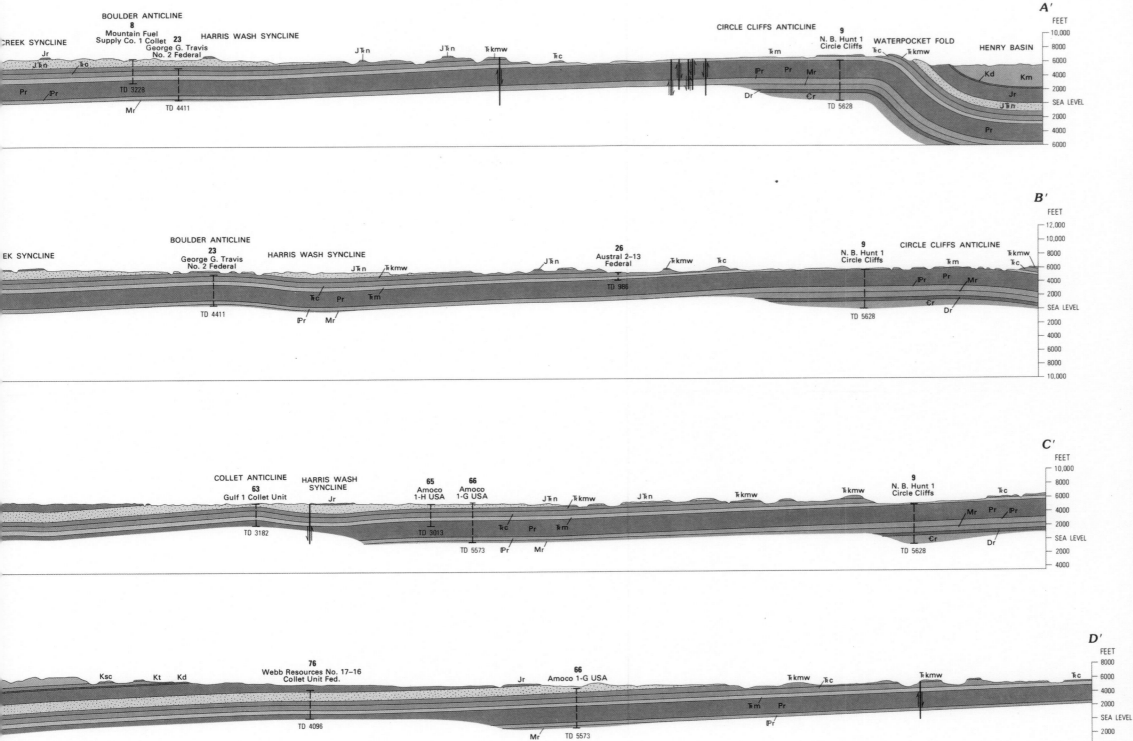

A'

BOULDER ANTICLINE
CREEK SYNCLINE
8
Mountain Fuel
Supply Co. 1 Collet **23**
George G. Travis
No. 2 Federal
HARRIS WASH SYNCLINE

CIRCLE CLIFFS ANTICLINE
9
N. B. Hunt 1
Circle Cliffs
WATERPOCKET FOLD
HENRY BASIN

FEET
10,000
8000
6000
4000
2000
SEA LEVEL
2000
4000
6000

Jr
JŦn
Ŧo
Pr
ℙr
Mr
TD 3228
TD 4411

JŦn
JŦn
Ŧkmw
Ŧc

Ŧm
ℙr
Pr
Mr
Dr
Ŧc
Ŧkmw
Ŧc
Kd
Km
Jr
JŦn
Pr
Ŧr
TD 5628

B'

EK SYNCLINE
BOULDER ANTICLINE
23
George G. Travis
No. 2 Federal
HARRIS WASH SYNCLINE

26
Austral 2–13
Federal

9
N. B. Hunt 1
Circle Cliffs
CIRCLE CLIFFS ANTICLINE

FEET
12,000
10,000
8000
6000
4000
2000
SEA LEVEL
2000
4000
6000
8000
10,000

TD 4411
Ŧc
ℙr
Pr
Mr
Ŧm
JŦn
Ŧkmw
JŦn
Ŧkmw
Ŧc
TD 986
Ŧkmw
Ŧc
ℙr
Pr
Mr
Cr
Dr
Ŧm
TD 5628

C'

COLLET ANTICLINE
63
Gulf 1 Collet Unit
HARRIS WASH
SYNCLINE

65
Amoco
1-H USA
66
Amoco
1-G USA

9
N. B. Hunt 1
Circle Cliffs
CIRCLE CLIFFS ANTICLINE

FEET
10,000
8000
6000
4000
2000
SEA LEVEL
2000
4000

TD 3182
Jr
JŦn
Ŧkmw
JŦn
Ŧkmw
Ŧkmw
Ŧc
TD 3013
Ŧc
Pr
ℙr
Mr
Ŧm
TD 5573
Mr
Pr
ℙr
Cr
Dr
TD 5628

D'

76
Webb Resources No. 17–16
Collet Unit Fed.

66
Amoco 1-G USA

FEET
8000
6000
4000
2000
SEA LEVEL
2000
4000
6000
8000

Ksc
Kt
Kd
Jr
Ŧkmw
Ŧc
Ŧkmw
Ŧc
TD 4096
Ŧm
Pr
ℙr
Mr
TD 5573

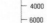

1. Bench Creek
2. East Fork Wind River
3. Phillips Petroleum Co. Austral 1
4. Ethete
5. Hudson
6. Stanolind Oil and Gas Co. Johnson 1
7. Alkali Butte
8. Conant Creek
9. Castle Gardens
10. Rattlesnake Hills
11. Cities Service Oil Co. Govt. C–1
12. Casper Canal
13. Shotgun Butte
14. Phillips Petroleum Co. Boysen 1
15. Shell Oil Co. Howard Ranch 23–15
16. Sinclair-Wyoming Oil Co. Lysite 1
17. Pure Oil Co. Badwater 1
18. Waltman
19. British-American Oil Producing Co. Eccles 1
20. Pure Oil Co. West Poison Spider 1
21. Gulf Oil Corp. Mae Rhodes 1
22. Phillips Petroleum Co. Missouri 1
23. Superior Oil Co. Fuller Reservoir 1–26
24. Humble Oil and Refining Co. Govt.-Walker 1
25. Continental Oil Co. Squaw Buttes 28–1
26. California Co. Cooper Reservoir 2
27. Continental Oil Co. Moneta Hills 11–1
28. California Co. Madden 1

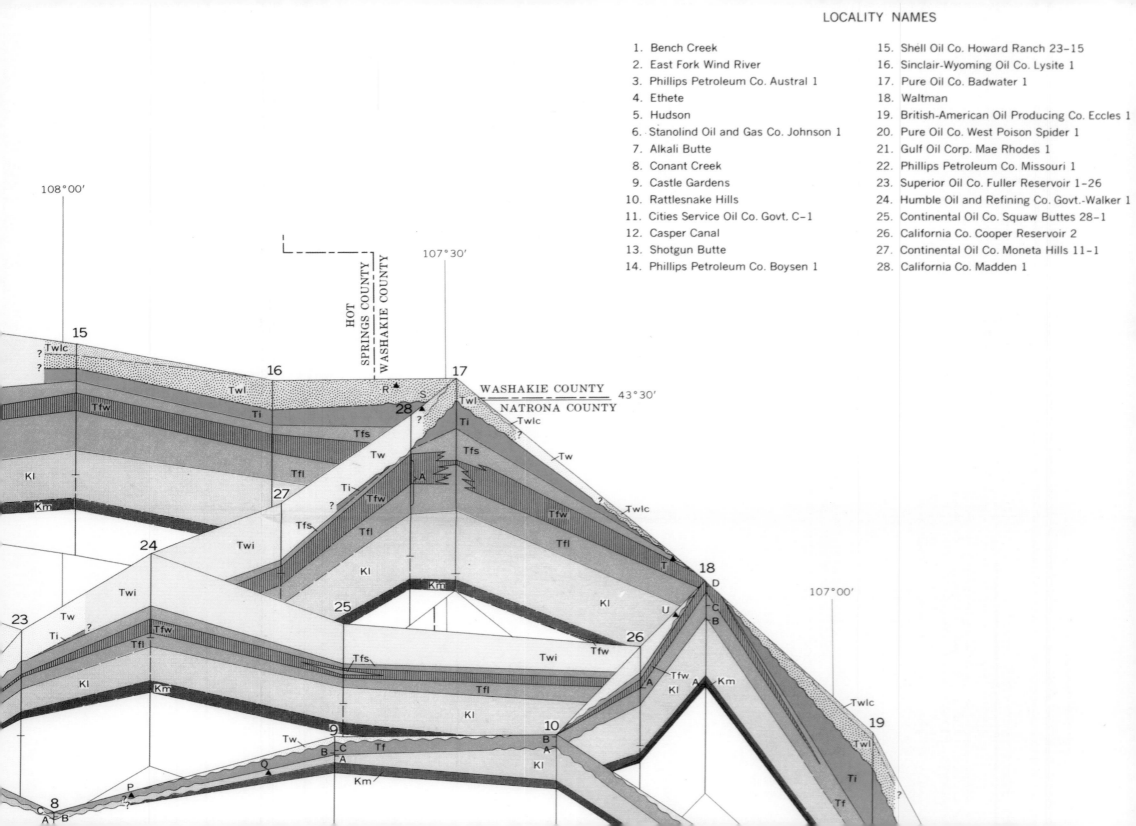

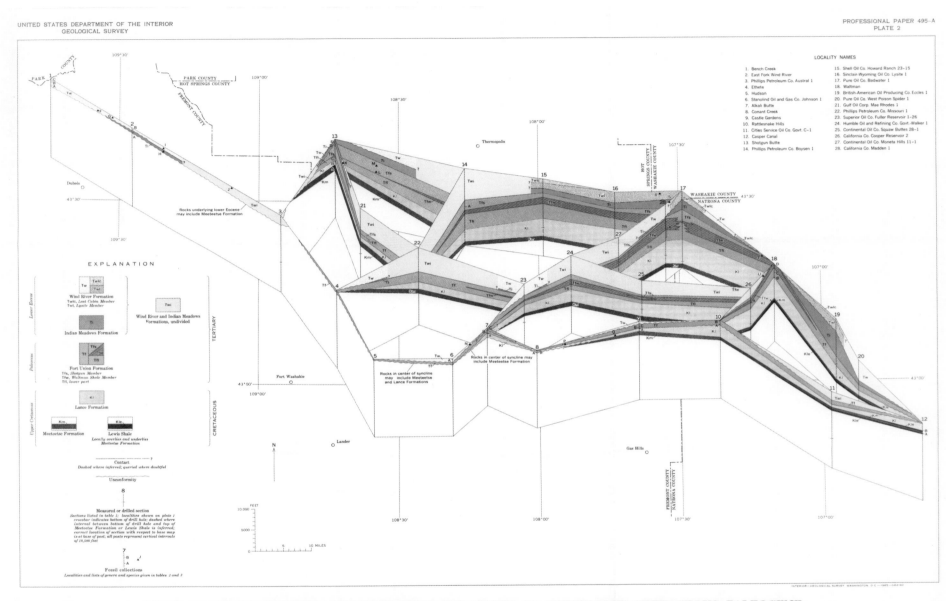

UNITED STATES DEPARTMENT OF THE INTERIOR
GEOLOGICAL SURVEY

PROFESSIONAL PAPER 495-A
PLATE 2

FENCE DIAGRAM SHOWING STRATIGRAPHIC RELATIONS OF UPPERMOST CRETACEOUS, PALEOCENE
AND LOWER EOCENE ROCKS IN THE WIND RIVER BASIN, WYOMING

53 | **Fence Diagram Showing Stratigraphic Relations of Uppermost Cretaceous,
Paleocene and Lower Eeocene Rocks in the Wind River Basin, Wyoming**

United States Department of the Interior Geological Survey, Professional Paper 495-A, Plate 2,
Interior-Geological Survey Washington D. C., G64182, Wyoming, 1965

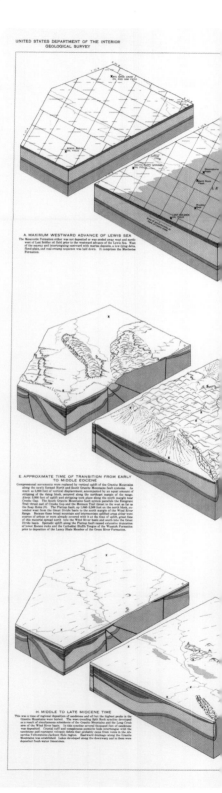

UNITED STATES DEPARTMENT OF THE INTERIOR
GEOLOGICAL SURVEY

A. MAXIMUM WESTWARD ADVANCE OF LEWIS SEA

E. APPROXIMATE TIME OF TRANSITION FROM EARLY
TO MIDDLE EOCENE

H. MIDDLE TO LATE MIOCENE TIME

**Maps of Granite Mountains Area, Central Wyoming,
During Successive Stages of Structural Development**

United States Department of the Interior Geological Survey, Professional Paper 495-C, Plate 10,
Prepared in Cooperation with the Geological Survey of Wyoming and the Department of Geology
of the University of Wyoming as Part of a Program of the Department of the Interior for the
Development of the Missouri River Basin, Geology by J. D. Love, Wyoming, 1965

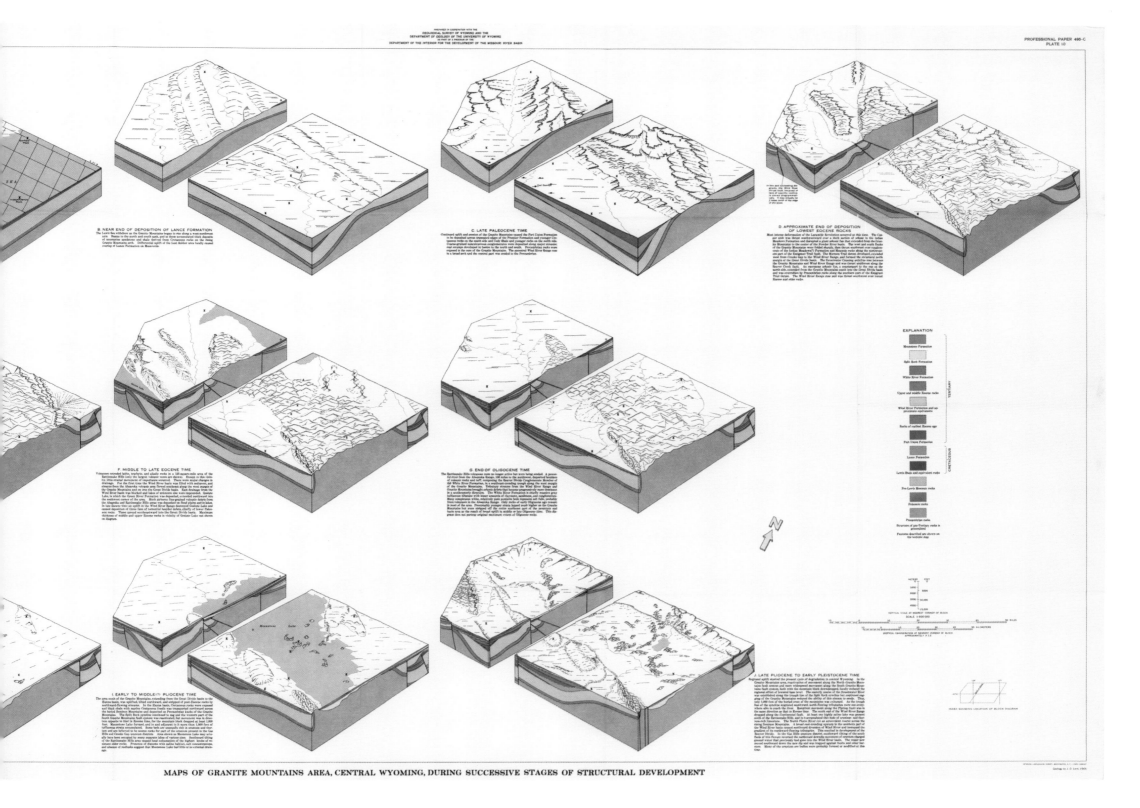

MAPS OF GRANITE MOUNTAINS AREA, CENTRAL WYOMING, DURING SUCCESSIVE STAGES OF STRUCTURAL DEVELOPMENT

A. MAXIMUM WESTWARD ADVANCE OF LEWIS SEA

The Mesaverde Formation either was not deposited or was eroded away west and northwest of Lost Soldier oil field prior to the westward advance of the Lewis Sea. West of the seaway and intertonguing eastward with marine deposits, a low-lying delta, flood-plain, and coal-swamp sequence was laid down. It comprises the Meeteetse Formation.

B. NEAR END OF DEPOSITION OF LANCE FORMATION

The Lewis Sea withdrew as the Granite Mountains began to rise along a west-northwest axis. Basins to the north and south sank, and in them accumulated thick deposits of nonmarine sandstone and shale derived from Cretaceous rocks on the rising Granite Mountains arch. Differential uplift of the Lost Soldier area locally caused overlap of Lance Formation on Mesaverde.

E. APPROXIMATE TIME OF TRANSITION FROM EARLY TO MIDDLE EOCENE

Compressional movements were replaced by vertical uplift of the Granite Mountains along the newly formed North and South Granite Mountains fault systems. As much as 5,000 feet of vertical displacement, accompanied by an equal amount of stripping of the rising block, occurred along the southeast margin of the range. About 3,000 feet of uplift and stripping took place along the south margin near Crooks Gap. The South Granite Mountains fault system parallels the Emigrant Trail thrust east of Crooks Gap and the Mormon Trail thrust to the west as far as the Soap Holes (A). The Flattop fault, up 1,000–2,500 feet on the north block, extended west from the Great Divide basin to the south margin of the Wind River Range. Because these broad mountain and intermontane uplifted areas either were sources of arkose or were already covered with it at the time of uplift, great fans of this material spread north into the Wind River basin and south into the Great Divide basin. Sporadic uplift along the Flattop fault caused extensive truncation of lower Eocene rocks and the Cathedral Bluffs Tongue of the Wasatch Formation prior to deposition of the Laney Shale Member of the Green River Formation.

F. MIDDLE TO LATE EOCENE TIME

Volcanoes extruded latite, trachyte, and alkalic rocks in a 125-square-mile area of the Rattlesnake Hills (only the largest volcanic vents are shown). Except in this vicinity, little crustal movement of importance occurred. There were major changes in drainage. For the first time the Wind River basin was filled with sediment, and streams from the Absaroka volcanic area flowed southeast along the west margin of the Granite Mountains and on into the Great Divide basin. East drainage from the Wind River basin was blocked and lakes of unknown size were impounded. Gosiute Lake, in which the Green River Formation was deposited, extended northward into the southwest corner of the area. Much airborne fine-grained volcanic debris from the Absaroka and Rattlesnake Hills areas was deposited on flood plains and in lakes. In late Eocene time an uplift in the Wind River Range destroyed Gosiute Lake and caused deposition of three fans of torrential boulder debris, chiefly of lower Paleozoic rocks. These spread southeastward into the Great Divide basin. Maximum thickness of middle and upper Eocene rocks in vicinity of Gosiute Lake not shown on diagram.

C. LATE PALEOCENE TIME

Continued uplift and erosion of the Granite Mountains caused the Fort Union Formation to be deposited across truncated edges of the Frontier Formation and younger Cretaceous rocks on the south side and Cody Shale and younger rocks on the north side. Coarse-grained noncalcareous conglomerates were deposited along major streams; coal swamps developed in basins to the north and south. Precambrian rocks were exposed in the core of the Granite Mountains. The ancestral Wind River Range rose in a broad arch and the central part was eroded to the Precambrian.

D. APPROXIMATE END OF DEPOSITION OF LOWEST EOCENE ROCKS

Most intense deformation of the Laramide Revolution occurred at this time. The Casper arch was thrust southwestward over a thick section of arkose in the Indian Meadows Formation and disrupted a giant arkosic fan that extended from the Granite Mountains to the center of the Powder River basin. The west and south flanks of the Granite Mountains were folded sharply, then thrust southwest over conglomerate of the Indian Meadows(?) Formation and Mesozoic rocks along the northwestern part of the Emigrant Trail fault. The Mormon Trail thrust developed, extended west from Crooks Gap to the Wind River Range, and formed the structural north margin of the Great Divide basin. The Sweetwater Crossing anticline rose between the Granite Mountains and Wind River Range and was thrust southwest along the Beaver Creek fault. An enormous arkosic fan, a counterpart to the one on the north side, extended from the Granite Mountains south into the Great Divide basin and was overridden by Precambrian rocks along the southern part of the Emigrant Trail thrust. The Wind River Range rose and was thrust southwest over lowest Eocene and older rocks.

G. END OF OLIGOCENE TIME

The Rattlesnake Hills volcanoes were no longer active but were being eroded. A powerful river from the Absaroka Range, 100 miles to the northwest, deposited boulders of volcanic rocks and tuff, composing the Beaver Divide Conglomerate Member of the White River Formation, in a southeast-trending trough along the west margin of the Granite Mountains. Tributary streams from the Wind River Range and Granite Mountains brought arkosic debris that became progressively more dominant in a southeasterly direction. The White River Formation is chiefly massive gray tuffaceous siltstone with lesser amounts of claystone, sandstone, and conglomerate. Many conspicuous white, relatively pure pumicite beds represent ash falls, probably from volcanoes in the Absaroka Range. Only rocks of early Oligocene age remain in most of the area. Presumably younger strata lapped much higher on the Granite Mountains but were stripped off the entire southeast part of the mountain and basin area as the result of broad uplift in middle or late Oligocene time. This diagram does not portray original maximum extent of Oligocene rocks.

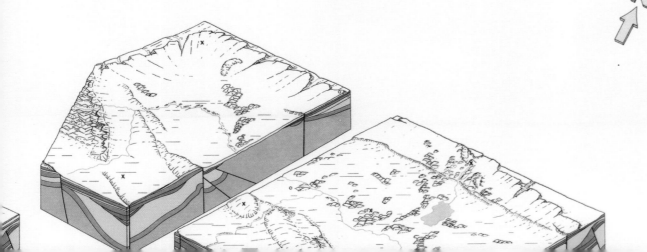

EXPLANATION

Moonstone Formation

Split Rock Formation

White River Formation

Upper and middle Eocene rocks

Wind River Formation and approximate equivalents

Rocks of earliest Eocene age

Fort Union Formation

TERTIARY

Lance Formation

Lewis Shale and equivalent rocks

CRETACEOUS

Pre-Lewis Mesozoic rocks

Paleozoic rocks

Precambrian rocks

Structure of pre-Tertiary rocks is generalized

Features described are shown on the tectonic map

N

METERS FEET
0 — 0
1000
— 5000
2000
3000 — 10,000
4000
— 15,000

VERTICAL SCALE AT NEAREST CORNER OF BLOCK

SCALE 1:500 000

10 0 10 20 30 40 50 MILES

10 0 10 20 30 40 50 KILOMETERS

VERTICAL EXAGGERATION AT NEAREST CORNER OF BLOCK
APPROXIMATELY X 3.5

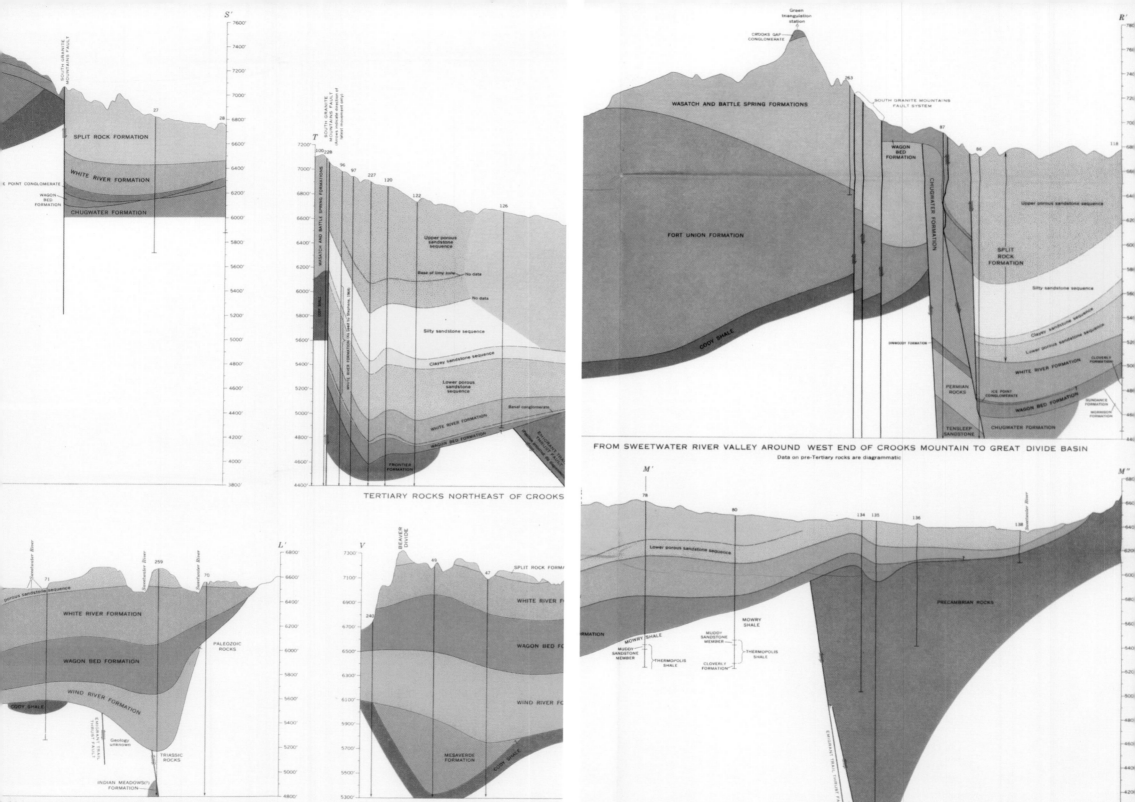

TERTIARY ROCKS NORTHEAST OF CROOKS

FROM SWEETWATER RIVER VALLEY AROUND WEST END OF CROOKS MOUNTAIN TO GREAT DIVIDE BASIN

Data on pre-Tertiary rocks are diagrammatic

RANT TRAIL THRUST FAULT NEAR SWEETWATER RIVER

FROM SOUTH SAND DRAW OIL AND GAS
ACROSS BEAVER DIVIDE TO LONG CR

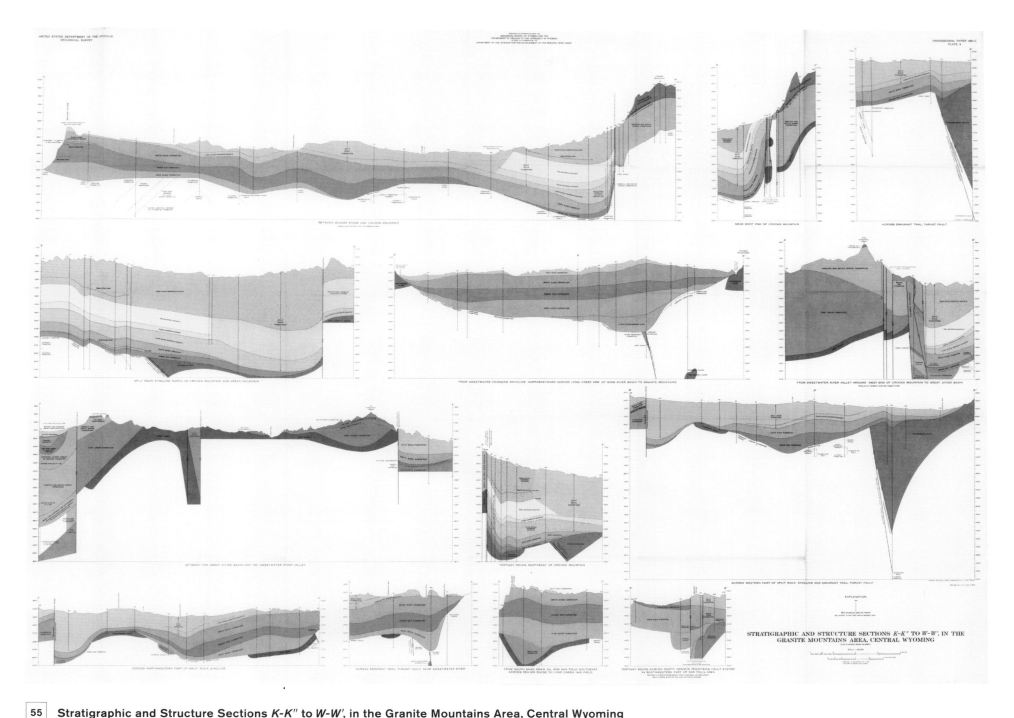

55 **Stratigraphic and Structure Sections *K-K″* to *W-W′*, in the Granite Mountains Area, Central Wyoming**

United States Department of the Interior Geological Survey, Professional Paper 495-C, Plate 4, Prepared in Cooperation with the Geological Survey of Wyoming and the Department of Geology
of the University of Wyoming as Part of a Program of the Department of the Interior for the Development of the Missouri River Basin, Geology by J. D. Love, Wyoming, 1965

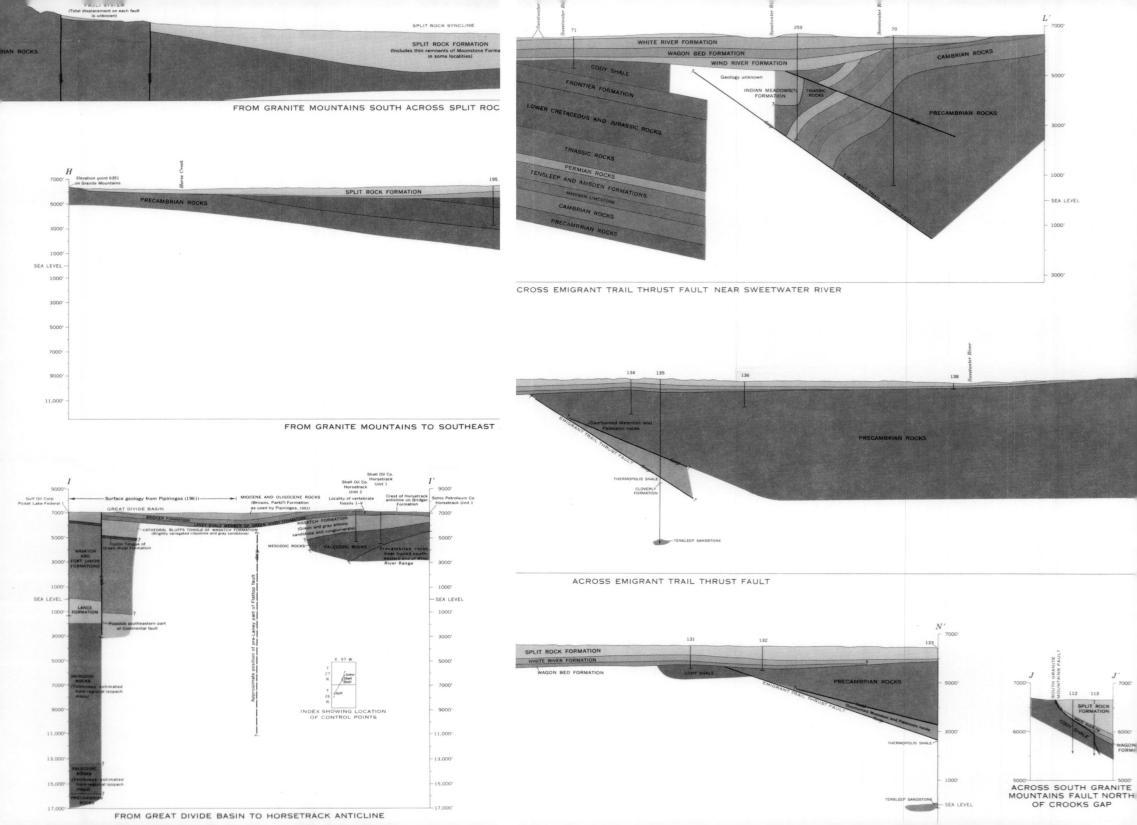

FAULT SYSTEM
(Total displacement on each fault is unknown)

SPLIT ROCK SYNCLINE

SPLIT ROCK FORMATION
(Includes thin remnants of Moonstone Formation in some localities)

BRIAN ROCKS

FROM GRANITE MOUNTAINS SOUTH ACROSS SPLIT ROC

WHITE RIVER FORMATION
WAGON BED FORMATION
WIND RIVER FORMATION
CODY SHALE
FRONTIER FORMATION
LOWER CRETACEOUS AND JURASSIC ROCKS
TRIASSIC ROCKS
PERMIAN ROCKS
TENSLEEP AND AMSDEN FORMATIONS
MADISON LIMESTONE
CAMBRIAN ROCKS
PRECAMBRIAN ROCKS

Geology unknown
INDIAN MEADOWS(?) FORMATION
TRIASSIC ROCKS
CAMBRIAN ROCKS
PRECAMBRIAN ROCKS

CROSS EMIGRANT TRAIL THRUST FAULT NEAR SWEETWATER RIVER

H
Elevation point 6351 on Granite Mountains
PRECAMBRIAN ROCKS
SPLIT ROCK FORMATION
195
7000'
5000'
3000'
1000'
SEA LEVEL
1000'
3000'
5000'
7000'
9000'
11,000'

FROM GRANITE MOUNTAINS TO SOUTHEAST

134 135 136 138
Overturned Mesozoic and Paleozoic rocks
PRECAMBRIAN ROCKS
EMIGRANT TRAIL THRUST FAULT
THERMOPOLIS SHALE
CLOVERLY FORMATION
TENSLEEP SANDSTONE

ACROSS EMIGRANT TRAIL THRUST FAULT

I I'
Gulf Oil Corp. Picket Lake-Federal 1
Surface geology from Pipiringos (1961)
MIOCENE AND OLIGOCENE ROCKS (Browns, Park(?) Formation as used by Pipiringos, 1961)
Shell Oil Co. Horsetrack Unit 2
Shell Oil Co. Horsetrack Unit 1
Crest of Horsetrack anticline on Bridger Formation
Sohio Petroleum Co. Horsetrack Unit 1
GREAT DIVIDE BASIN
BRIDGER FORMATION
LANEY SHALE MEMBER OF GREEN RIVER FORMATION
CATHEDRAL BLUFFS TONGUE OF WASATCH FORMATION
WASATCH FORMATION (Green and gray arkosic sandstone and conglomerate)
Locality of vertebrate fossils I-V
Tipton Tongue of Green River Formation
(Brightly variegated claystone and gray sandstone)
MESOZOIC ROCKS
PALEOZOIC ROCKS
Precambrian rocks near buried southeastern end of Wind River Range
WASATCH AND FORT UNION FORMATIONS
LANCE FORMATION
Possible southeastern part of Continental fault
Approximate position of pre-Laney part of Flattop fault
MESOZOIC ROCKS (Thickness estimated from regional isopach maps)
PALEOZOIC ROCKS (Thickness estimated from regional isopach maps)
PRECAMBRIAN ROCKS
9000'
7000'
5000'
3000'
1000'
SEA LEVEL
1000'
3000'
5000'
7000'
9000'
11,000'
13,000'
15,000'
17,000'

R. 97 W.
T 27 N
T 26 N
Sohio Shell
Shell
Gulf
INDEX SHOWING LOCATION OF CONTROL POINTS

FROM GREAT DIVIDE BASIN TO HORSETRACK ANTICLINE

N'
SPLIT ROCK FORMATION
WHITE RIVER FORMATION
WAGON BED FORMATION
131 132 133
CODY SHALE
PRECAMBRIAN ROCKS
EMIGRANT TRAIL THRUST FAULT
Overturned Mesozoic and Paleozoic rocks
THERMOPOLIS SHALE
TENSLEEP SANDSTONE
7000'
5000'
3000'
1000'
SEA LEVEL

J J'
SOUTH GRANITE MOUNTAINS FAULT
112 113
SPLIT ROCK FORMATION
CODY SHALE
WAGON FORMA
7000'
6000'
5000'

ACROSS SOUTH GRANITE MOUNTAINS FAULT NORTH OF CROOKS GAP

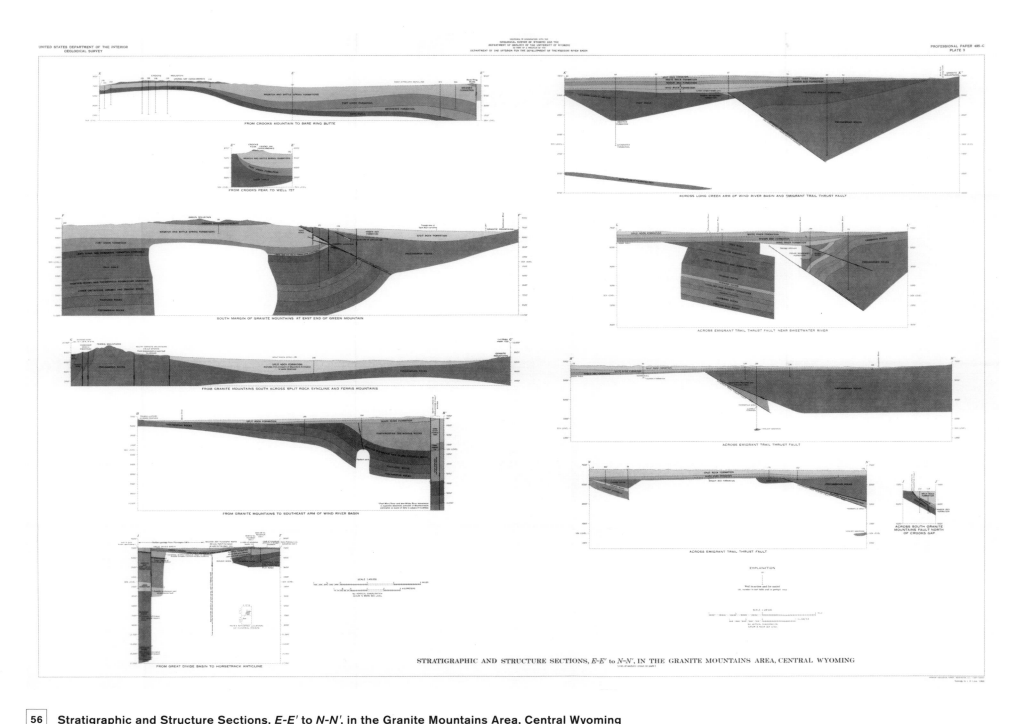

STRATIGRAPHIC AND STRUCTURE SECTIONS, *E-E'* to *N-N'*, IN THE GRANITE MOUNTAINS AREA, CENTRAL WYOMING

56 | **Stratigraphic and Structure Sections, *E-E'* to *N-N'*, in the Granite Mountains Area, Central Wyoming**

United States Department of the Interior Geological Survey, Professional Paper 495-C, Plate 3, Prepared in Cooperation with the Geological Survey of Wyoming and the Department of Geology of the University of Wyoming as Part of a Program of the Department of the Interior for the Development of the Missouri River Basin, Geology by J. D. Love, Wyoming, 1966

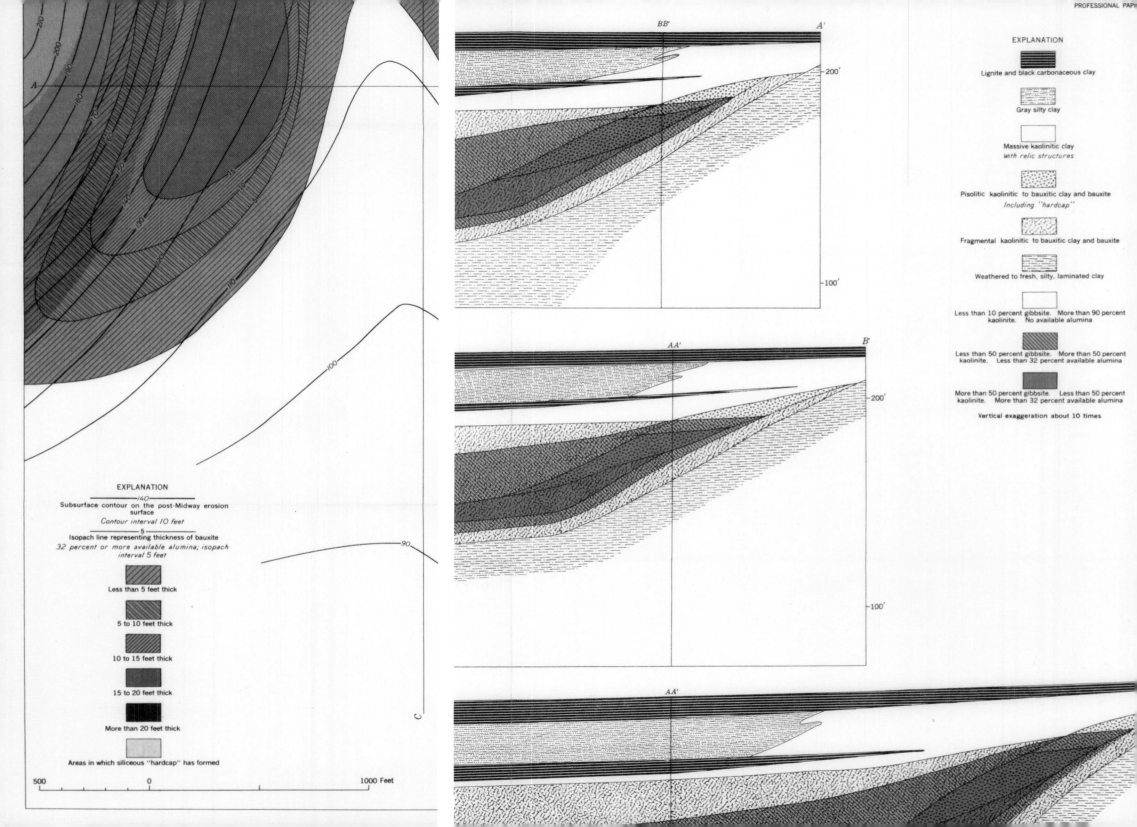

EXPLANATION

Subsurface contour on the post-Midway erosion surface

Contour interval 10 feet

Isopach line representing thickness of bauxite

32 percent or more available alumina; isopach interval 5 feet

Less than 5 feet thick

5 to 10 feet thick

10 to 15 feet thick

15 to 20 feet thick

More than 20 feet thick

Areas in which siliceous "hardcap" has formed

500 0 1000 Feet

EXPLANATION

Lignite and black carbonaceous clay

Gray silty clay

Massive kaolinitic clay
with relic structures

Pisolitic kaolinitic to bauxitic clay and bauxite
Including "hardcap"

Fragmental kaolinitic to bauxitic clay and bauxite

Weathered to fresh, silty, laminated clay

Less than 10 percent gibbsite. More than 90 percent
kaolinite. No available alumina

Less than 50 percent gibbsite. More than 50 percent
kaolinite. Less than 32 percent available alumina

More than 50 percent gibbsite. Less than 50 percent
kaolinite. More than 32 percent available alumina

Vertical exaggeration about 10 times

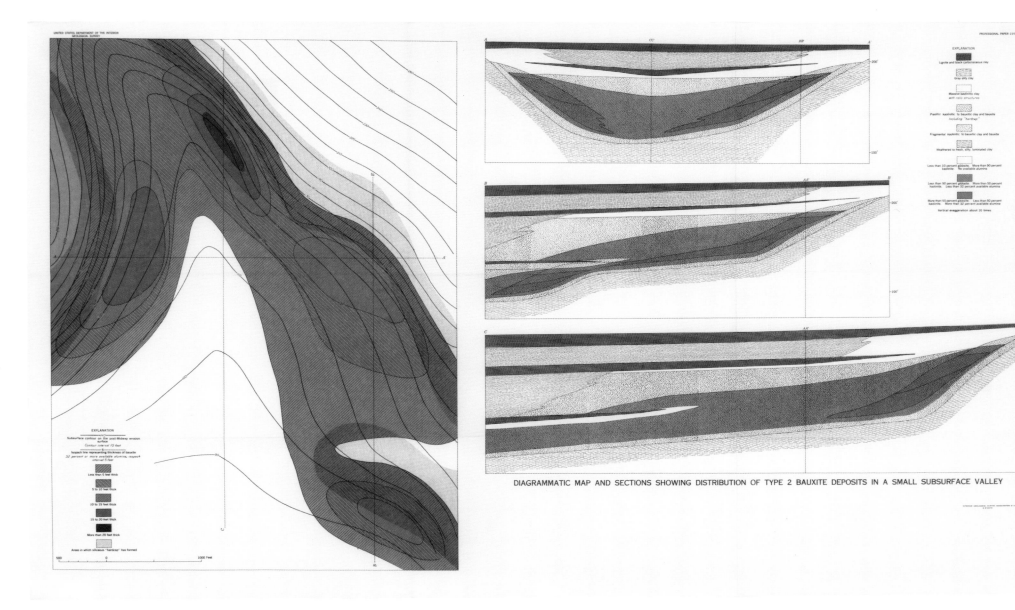

DIAGRAMMATIC MAP AND SECTIONS SHOWING DISTRIBUTION OF TYPE 2 BAUXITE DEPOSITS IN A SMALL SUBSURFACE VALLEY

57 **Diagrammatic Map and Sections Showing Distribution of Type 2 Bauxite Deposits in a Small Subsurface Valley**

United States Department of the Interior Geological Survey,
Professional Paper 299, Plate 15, Arkansas, 1958

Published by
Princeton Architectural Press
202 Warren Street
Hudson, New York 12534
www.papress.com

ISBN 978-1-61689-831-1

Editor: Kristen Hewitt
Designer: Benjamin English

Photographs of original cross sections
and diagrams: Etienne Frossard

Library of Congress Control Number:
2020936532

Editor's Note

The plate section of this book is organized into regions established by the United States Geological Survey. Within these areas, the illustrations are ordered alphabetically by state and, when available, by date. The majority of the diagrams are cross sections, but other forms of visual representation are included in the collection, among them the isometric block diagram featured on pages 62–63.

For writing an introduction that brings exceptional clarity and insight to the history of the geologic cross section and thus the work of the geologist, both above and below ground, special thanks to Professor Emerita Joanne Bourgeois.

Thanks also go to Archivist & Records Manager Caroline Lam and User Services Librarian Michael McKimm of the Geological Society of London for their kind efforts to provide William Smith's geological section on page 10.

Acknowledgments

I hold deep appreciation and am thankful to the former and current staff at Princeton Architectural Press. In particular, Kevin Lippert and Abby Bussel for the inspiration of turning this project into a book and making that happen. I thank Brenda Wiard for helping me find some of the wide variety of diagrams that make up this book. Thanks to Etienne Frossard (@etienne_fro) for his excellent two-dimensional photographic skills. I also thank Michelle Conrad and my children, Lucy and Sam, for providing the right mixture of indulgence and time to pursue all manner of enthusiasms. I also thank my parents, who, as it turned out, made the right choices.
—David Kassel

Contributors

David Kassel is an artist and owner of ILevel, an art installation firm established in New York City in 1990. Previously, he held positions at the Guggenheim Museum of Art and the Neuberger Museum. He holds a BFA from Purchase College. He and his family divide their time between New York City and the Hudson Valley.

Joanne Bourgeois is professor emerita in the University of Washington's College of the Environment. Her areas of interest are sedimentology and stratigraphy, paleoseismology, and neotectonics; her research focuses on environmental and process analysis of clastic sediments and sedimentary rocks; interpretation of sedimentary structures; and tectonics and sedimentation. She also teaches and conducts research in the history of geology. Bourgeois served a two-year term as a program director in the Division of Earth Sciences of the National Science Foundation. She is a Fellow of the Geological Society of America and holds a Ph.D. in geology from the University of Wisconsin.

Notes from the Introduction

1 Michele Aldrich, "American State Geological Surveys, 1820–1845," in C. J. Schneer, ed., *Two Hundred Years of Geology in America*, Univ. New Hampshire Press, pp. 133–143 (1979). Mary C. Rabbitt, *Minerals, Lands and Geology for the Common Defence and General Welfare, Volume 1, Before 1879* (1979) and *Volume 2, 1879-1904* (1980). US Geological Survey, US Printing Office. Also see G. P. Merrill, *The First One Hundred Years of American Geology*, New York and London, Hafner (1969).

2 John Strachey, "A curious description of the strata observ'd in the coal mines of Mendip in Somersetshire" (communication), Philosophical Transactions of the Royal Society, no. 360, pp. 968–973 plus Figure. (1719); and *Observations on the Different Strata of Earths and Minerals* (booklet) (1727). Strachey did attempt some map-making but with little success. https://doi.org/10.1093/ref:odnb/26622

3 T. Ell, Two letters of Signor Giovanni Arduino, concerning his natural observations: first full English translation. Part 1. *Earth Sciences History*, 30 (2), pp. 267–286 (2011).

4 See, e.g., Rachel Laudan, *From Mineralogy to Geology, The Foundations of a Science 1650–1830*. University of Chicago Press (1987).

5 Lucyna Szaniawska, "Lithological maps visualizing the achievements of geological sciences in the first half of the nineteenth century," *Polish Cartographical Review*, v. 50 (2), p. 87–109 (2018).

6 V. A. Eyles, "Mineralogical maps as forerunners of modern geological maps," *The Cartographic Journal*, 9:2, pp. 133–135 (1972).

7 See, e.g., Rhoda Rappaport, 1969. "The Geological Atlas of Guettard, Lavoisier, and Monnet: Conflicting Views of the Nature of Geology," in *Toward a History of Geology*, ed. C. Schneer, M.I.T. Press, Cambridge, MA, and London, pp. 272–287 (1969); also R. Rappaport, "Lavoisier's geologic activities, 1763–1792." Isis, v. 58 (3), pp. 375–384 (1967).

8 L. Szaniawska, note 2; except for von Buch, this is a well-known and well-told story.

9 William Smith's *MAPS–Interactive*, UKOGL–UK Onshore Geophysical Library, http://www.strata-smith.com/ last accessed 20 Sept 2019.

10 "Selection of Colors and Patterns for Geologic Maps of the U.S. Geological Survey," Techniques and Methods 11–B1; https://ngmdb.usgs.gov/fgdc_gds/geolsymstd/download.php; (International) Standard Color Codes for the Geological Time Scale, https://timescalefoundation.org/charts/rgb.html, each accessed 21 Sept 2019.

11 William Maclure, "Observations on the geology of the United States, explanatory of a geological map." *Transactions of the American Philosophical Society*, 6, pp. 411–428 (1809). See also J. W. Wells, "Notes on the earliest geological maps of the United States, 1756–1832." *Journal of the Washington Academy of Sciences*, 49 (7), pp. 198–204 (1959). Wells notes that an earlier map, in rare cases colored, but intended to be colored, could be credited to Constantin-François Chasseboeuf, later Comte de Volney, based on earlier work by Samuel Mitchell. Also see G. P. Merrill, note 1.

12 William Maclure, *Observations on the Geology of the United States of North America: With Remarks on the Probable Effects that May be Produced by the Decomposition of the Different Classes of Rocks on the Nature and Fertility of Soils: Applied to the Different States of the Union, Agreeably to the Accompanying Geological Map* (Vol. 1, No. 1). A. Small (1818), following a version presented in 1817 to the American Philosophical Society.

13 The "Old Red Sandstone" of Maclure's map is not, we now recognize, equivalent to that of Europe, which is Devonian in age; in North America, these red beds are now mapped as Jura-Triassic strata and associated basalt sills and flows. However, there are Devonian red beds, e.g. in the Catskills of New York State, not mapped by Maclure.

14 Amos Eaton, *An Index to the Geology of the Northern States, with Transverse Sections, Extending from Susquehanna River to the Atlantic, Crossing Catskill Mountains, to which is prefixed a geological grammar*. Troy, NY: William S. Parker (1818, revised in 1820).

15 *Geological profile extending from the Atlantic to Lake Erie, Running near the 43° N.L. and embracing 9 degrees of Longitude. Taken 1822 & 3 under the direction of the Hon. Stephen Van Rensselaer*, by Amos Eaton (1825).

16 Amos Eaton, *Colored map exhibiting a general view of the economic geology of New York and part of the adjoining states*, in *Geological Text-book: Prepared for Popular Lectures on North American Geology; with Applications to Agriculture and the Arts*. Websters and Skinners (1830).

17 Edward Hitchcock, "Remarks on the Geology and Mineralogy of a section of Massachusetts on Connecticut River, with a part of New-Hampshire and Vermont." *American Journal of Science*, v. 1 (2), p. 105–116 (1818–1819).

18 Edward Hitchcock, *A geological map of Massachusetts*, to accompany *Report on the Geology, Mineralogy, Botany and Zoology of Massachusetts*. Amherst, MA, press of J. S. and C. Adams (1833). A high resolution scan of this map and several other maps and cross sections mentioned herein are available via the Princeton University Library https://lib-dbserver.princeton.edu/visual_materials/maps/websites/thematic-maps/quantitative/geology/geology.html

19 H. D. and W. B. Rogers, "Mountain building forces exemplified by the Appalachian System," *Transactions of the Association of American Geologists and Naturalists*, v. 1, pp. 474–531 (1840–1842).

20 R. H. Dott, Jr., "The geosyncline—first major concept 'Made in America'" in C. J. Schneer, ed., *Two Hundred Years of Geology in America*, Univ. New Hampshire Press, pp. 239–264 (1979).

21 James Hall, *The map extends from the Mississippi River to the Atlantic Ocean and from the Straits of Michilimackinac (Michillimaoinac) and Montreal, Canada to Virginia, Kentucky, and Missouri by James Hall* was published in the 1843 edition of Hall's *Geology of New York. Part IV. Comprising the Survey of the Fourth Geological District*.

* John Strachey, 1719. *A curious description of the strata observ'd in the coal-mines of Mendip in Somersetshire; being a letter of John Strachey Esq; to Dr. Robert Welsted, M. D. and R. S. Soc. and by him communicated to the Society*. Philosophical Transactions. 968–973.

† https://lib-dbserver.princeton.edu/visual_materials/maps/websites/thematic-maps/quantitative/geology/geology.html

‡ *The Classroom Drawings of Orra White Hitchcock, CA: Palatino Press*, 2014. Images have no copyright. Scans of originals at: https://acdc.amherst.edu/browse/partOf/Orra+White+Hitchcock+Classroom+Drawings